Introduction to Aegean Art

Philip P. Betancourt

Published by
INSTAP Academic Press
Philadelphia, PA
2007

Design and Production
INSTAP Academic Press

Printing
CRWGraphics, Pennsauken, New Jersey

Binding
McCormick's Bindery, Inc., Pennsauken, New Jersey

Library of Congress Cataloging-in-Publication Data

Betancourt, Philip P., 1936-
 Introduction to Aegean art / Philip P. Betancourt.
 p. cm.
 Includes bibliographical references and index.
 ISBN 978-1-931534-21-5 (pbk. : alk. paper)
 1. Art, Aegean. 2. Aegean Sea Region—Antiquities. I. Title.
 N5640.B48 2007
 709.39'1—dc22

 2007011228

Contents

List of Figures

List of Color Plates

Preface

The history of art during the Bronze Age in the region that would later be called Greece provides modern eyes with a rich assemblage of objects. The period has received some careful attention in the past because its art played an important role in the 19th and early 20th century view that traced the "origins of the Western World" from Mesopotamia and Egypt to Minoan Crete, from there to Mycenae, Classical Greece, and Rome, and then on to modern Europe and the Western Hemisphere. In this linear theory, the Aegean Bronze Age was seen as a vital link between the older civilizations of the East and later developments in Europe, transmitting the ideas of writing, mathematics, monumental art, and complex urban living to later history. More modern approaches have either modified or firmly rejected this view because it is too simplistic. Extreme views of diffusion are quite out of fashion, and we have learned to appreciate both local inventions and the influential roles of cultures that had little or nothing to do with any "Egypt-Crete-Mycenae-Greece-Rome" strand of ancient history. In the great explosion of archaeological knowledge that has taken place in the late 20th and early 21st centuries, historical progress has come to be seen as an infinitely complex interweaving of many different influences. Within this development, the Aegean Bronze Age has emerged as a richer and more diverse culture than was previously thought. It is also rather different from later developments—to paraphrase the British historian Leonard Palmer, if the poet Homer could have actually witnessed the world of the Trojan War about which he was singing, he would not have recognized it.

Studying the world before smelting iron became common around 1200 B.C. is difficult because too many gaps exist in our knowledge: writing is scarce, and much of it is not deciphered; the chronology is often disputed; many categories of objects, especially among perishable goods, are mostly vanished; and looting continues to destroy many of the finest of the archaeological sites. Because of these problems and others, people have interpreted many art objects in different ways.

This book tries to present what the author regards as the mainstream opinions within the discipline as they are understood in the early 21st century. It is intended as a short explanation of visual communication from the beginning of the third millennium B.C. until the end of the second millennium B.C. in the region encompassed by modern Greece including Crete and the Aegean Islands. In order to act as an introduction to such a large subject, the book is rigorously selective. The emphasis is on the history of ideas with a few examples to illustrate them rather than on trying to cover the rich field of Aegean art in detail. For more information, the reader is referred to the bibliography at the end of each chapter.

Many people have contributed help to the writer, and thanks are especially extended to the following: Christos Doumas, for information and images from Acrotiri, Erik Hallager for material from Chania; Robert Koehl, for images of rhyta; the late Ione Mylonas Shear, for information and images from Mycenae; Peter Warren, for many helpful discussions and for images of Myrtos and of stone vases; Carol Hershenson, for assistance and permissions for images from the excavations of the University of Cincinnati at Pylos, Troy, and Keos; Vassos Karageorghis for information and images from Cyprus; Katie Demakopoulou for information and images of objects in the National Museum, Athens; Yannis Tzedakis, Alexandra Karetsou, and Nota Dimopoulou for images of objects in the Herakleion Archaeological Museum; Maria Vlazaki for images from the Chania Archaeological Museum; Costis Davaras and Stavroula Apostolakou for images of objects in the Hagios Nikolaos Archaeological Museum and the Siteia Archaeological Museum.

The book is planned as an introduction to the subject of Minoan, Mycenaean, and Cycladic art for students and the general public. The author is grateful for a grant from Temple University to support the inclusion of color plates. He does not receive any royalties from the volume (future profits, if any, are donated to the Institute for Aegean Prehistory Academic Press so that it can publish more books on the subject of Aegean prehistory).

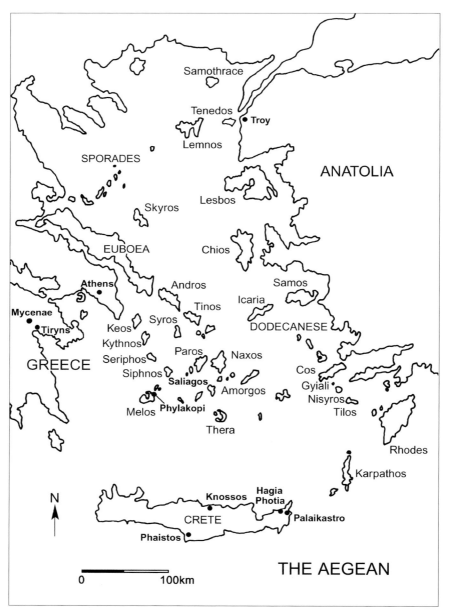

Figure 1.1. Map of the Aegean.

1

Introduction to Aegean Bronze Age Art

The art of the Aegean Bronze Age is an important chapter in the early expression of ideas through visual metaphors. The development of complex urban societies, which increased in intensity in the southeast parts of Europe during the third and second millennia B.C., resulted in a major expansion of the visual aspects of human interaction and communication. The arts flourished, and the examples that survive into modern times present us with images in many media—monumental wall paintings, stone architecture at large scale, elite objects of gold, silver, and other metals, interesting sculptures, and thousands of fine small pieces in many styles. This stage in the prehistory of the Aegean region lasted for more than 2,000 years, from roughly 3500/3200 B.C. to 1200 B.C. Its art had a role in the foundations for the visual arts of Classical Greece and Rome, and without its long centuries of experimentation and innovation, those later traditions would surely have traveled other paths.

On the other hand, some of the Aegean Bronze Age art is surprisingly different—even shockingly different—from what came later. The rich culture we call Minoan (for we have no idea what the Bronze Age people of Crete called themselves) presents us with experiences that are very foreign to Classical Greek and Roman ideas. The Minoan visions of lush landscapes with no human presence, of elegant visual displays based on interlocking and opposed curved lines, and of flowers and animals and beautifully costumed women in gentle movement can make some of what came later seem stiff and formal, and some of the Minoan images use

concepts that are also quite alien to the ones that guided many other traditions of this part of the world.

Aegean art is important for two reasons. First, it stands at the beginning of a long later history that can neither be understood nor appreciated without at least a passing acquaintance with its first chapter. Second, Minoan, Cycladic, and Mycenaean visual communication is important for its own sake. It presents some ideas in ways that have not been explored in the same fashion anywhere else, either before or since. People who examine the art of the Aegean cultures for the first time are often surprised because of its range. The art can be creative and beautiful, but it can also be repetitive and mundane; it can present dazzling displays of exotic and fanciful landscapes, and it can portray the human body with unusually accurate muscular detail, but it can also be so abstract and schematic that theoretical principles of design guide the compositions more that human actions.

For ease in modern study, the history of the Aegean has traditionally been divided into three parts both geographically (Fig. 1.1) and chronologically (Fig. 1.2). The three geographic parts have distinct topographic features:

The Helladic region. Mainland Greece, called the Helladic region, consists of the Greek peninsula. It always had more interactions with the north than the more isolated nearby islands. The Greek peninsula was the homeland of the Mycenaean society.

The Cycladic region. The Early Bronze Age in the Aegean islands includes the Cyclades, the islands of the Dodecanese, and slightly more distant groups. Although the islands in the Aegean Sea have fewer resources than the other two regions, they managed to attract a substantial population during some periods.

The Minoan region. The island of Crete is called the Minoan region after the legendary King Minos of Classical Greek mythology. Crete's palatial civilization began by the Middle Bronze Age and gradually became more important during the early phases of the Late Bronze Age.

The Aegean is also divided into three parts chronologically. The chart in Figure 1.2 shows the main subdivisions. They are based on changes in pottery styles, and they allow people to discuss periods and stylistic changes through time even when the exact calendar dates assigned to them are not known. The pottery periods are often abbreviated for convenience: EM, MM, and LM for Early Minoan, Middle Minoan, and Late Minoan; EH, MH, and LH for Early Helladic, Middle Helladic, and Late Helladic; and

Traditional Chronology Dates B.C.	High Chronology Dates B.C.	Crete	Greek Peninsula	Aegean Islands
Before 3000 to about 2000		EM I	EH I	Grotta-Pelos Group
				Kampos Group
		EM IIA	EH II	Keros-Syros Group
		EM IIB		Kastri Group
		EM III	EH III	Phylakopi I Group
2000–1625	2000–1725	MM IA	MH	MC
		MM IB		
		MM IIA		
		MM IIB		
		MM IIIA		
		MM IIIB		
1625–1525	1725–1625	LM IA	LH I	LC IA
1525–1450	1625–1500	LM IB	LH IIA	LC IB
1450–1425	1500–1425	LM II	LH IIB	LC II
1425–1300	1425–1300	LM IIIA	LH IIIA	LC IIIA
1300–1200	1300–1200	LM IIIB	LH IIIB	LC IIIB
1200–1125	1200–1125	LM IIIC	LH IIIC	LC IIIC

Figure 1.2. Chronology chart for the Aegean Bronze Age.

EC, MC, and LC for Early Cycladic, Middle Cycladic, and Late Cycladic. Some of the periods are subdivided into shorter components.

Some writers divide Cretan history by architectural phases at the large Minoan palaces at Knossos, Phaistos, Malia, Zakros, and Chania. The period until Middle Minoan IA is the Prepalatial period. From MM IB to MM IIIA is the Protopalatial period. The Neopalatial period is from MM IIIB to LM IB. Terms for later periods vary from writer to writer.

Two chronologies are given in the chart, a high chronology and a traditional chronology. The high chronology is based on radiocarbon dating of carbonized wood in the Aegean. The traditional chronology is based on imports and exports between the Aegean and various places in the East Mediterranean, especially Egypt. The Egyptian dates, based on astronomical observations noted in ancient Egyptian texts, should be an independent check on dates calculated by other means. Unfortunately, the two systems are not in agreement, and radiocarbon measurements suggest that the dates for the beginning of the Late Bronze Age in the Aegean should be raised (pushed back in time) by about a century. Specialists are in each camp, and they do not agree with one another.

In all these periods, the ancient Aegean artists approached their imagery by simplifying what they observed and translating it into artistic representations. They eliminated details for many different reasons, and the ways that they simplified their subjects say a great deal about their motivations. The point is illustrated by the three images in Figures 1.3 to 1.5.

The swallows from Thera (Fig. 1.3) are simplified to show movement. With the image reduced to lines, the feathers and other details are completely eliminated in order to emphasize the fluid motion of birds in flight. The wings that curve away from the viewer are even shown in perspective to suggest the glimpse into three-dimensional space. Along with the extreme simplification, the sense of suspended motion is captured by opposed curved lines that balance one another and lead the eye of the viewer to the center, suggesting that the birds are poised in flight as their beaks touch in midair.

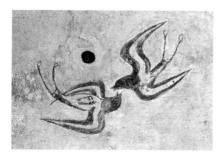

Figure 1.3. Detail of a wall painting from Acrotiri on the island of Thera showing an adult swallow feeding a young bird. LC IA.

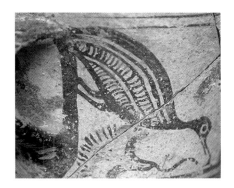

Figure 1.4. Abstract image of a bird on a mug from Palaikastro, Crete. LM IIIA.

The somewhat later water bird from Palaikastro (Fig. 1.4) is also simplified, but the intent is to make it a two-dimensional design, a fitting image for the smooth surface of the cup on which it is painted. While the swallows from Thera suggest volumetric space, the bird from Palaikastro has been rendered as flat. All the details of form and feathers are reduced to a two-dimensional design composed of lines and interesting flat shapes.

The jug in Figure 1.5 is designed with completely different concepts. It plays with the viewer's imagination by including contradictory clues to its identification. The vase is a container for liquid, but is the viewer also expected to think of a bird, as suggested by the high beak-like spout, or a woman, as suggested by the necklace and breasts, or both? The spouted vase combines aspects that pull the viewer's imagination in more than one direction. It is a religious vessel that asks the worshipper to ponder the question of vessel as woman or woman as vessel, an interesting concept for a belief-system that was surely grounded in fertility.

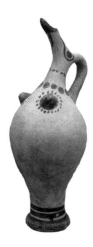

Figure 1.5. Jug from Acrotiri, Thera with a high beak-like spout with added eyes, necklace, and nipples. LC IA.

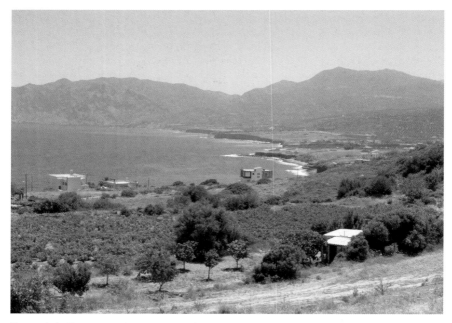
Figure 1.6. The mountainous region of East Crete with its many tiny inlets and harbors on the coast.

This range of ideas was at least partly a result of the region's penchant for seafaring. None of the settlements shown in Figure 1.1 was very far from the sea, and the mountainous landscape created rugged coastlines with thousands of small sheltered harbors (Fig. 1.6). Aegeans used the sea to travel on a routine basis, and this situation made it easy to visit even distant shores. The movement of people and goods occurred in all periods of ancient Aegean history. Because those who traveled also carried new ideas, the seafaring encouraged change and development. All aspects of Aegean society, including the artistic efforts, benefited from the constant influx of new concepts.

General Books on Aegean Bronze Age Art

Buchholz, H.-G. 1987. *Ägäische Bronzezeit*, Darmstadt.

Buchholz, H.-G., and V. Karageorghis. 1973. *Prehistoric Greece and Cyprus*, London.

Cullen, T., ed. 2001. *Aegean Prehistory: A Review*, Boston.

Demargne, P. 1964. *Aegean Art: The Origins of Greek Art*, London.

Dickinson, O. 1994. *The Aegean Bronze Age*, Cambridge, UK.

Higgins, R. 1951. *Minoan and Mycenaean Art*, London.

Hood, S. 1978. *The Arts in Prehistoric Greece*, Harmondsworth.

Groenewegen-Frankfort, H.A. 1951. *Arrest and Movement*, London.

Manning, S.W. 1995. *The Absolute Chronology of the Aegean Early Bronze Age*, Sheffield.

Marazzi, M. 1994. *La Società Micenea*, Rome.

Marinatos, S., and M. Hirmer. 1960. *Crete and Mycenae*, London

———. 1973. *Kreta, Thera und das mykenische Hellas*, Munich.

Matz, F. 1962. *Crete and Early Greece*, London.

Phylactopoulos, G., ed. 1974. *History of the Hellenic World: Prehistory and Protohistory*, Athens.

Preziosi, D., and A. Hitchcock. 1999. *Aegean Art and Architecture*, Oxford.

Tzedakis, Y., and H. Martlew. 1999. *Minoans and Mycenaeans: Flavours of Their Time*, Athens.

van Effenterre, H. 1986. *Les Égéens: aux origins de la Grèce, Chypre, Cyclades, Crète et Mycènes*, Paris.

Warren, P. 1975. *The Making of the Past: The Aegean Civilizations*, Oxford.

Warren, P.M., and V. Hankey. 1989. *Aegean Bronze Age Chronology*, Bristol, UK.

2

The Aegean Islands:
The Early Bronze Age

The Aegean Islands have often been regarded as stepping-stones because they are close enough together to act as easy points of reference for seafarers traveling across this part of the Mediterranean Sea (Fig. 1.1). They vary considerably in both size and character. Some of them, like Naxos and Melos, are large enough to support several towns and nearby farmland and pastures. At the other extreme, some small rocky islets have few resources of any type. One group of islands in the Aegean, located north of Crete, is called the Cyclades. The Cycladic culture is named after this group.

These waters were already being routinely visited to obtain obsidian from the island of Melos during the Mesolithic period, and several Cycladic Neolithic communities have been excavated. One of the Neolithic settlements was on the tiny island of Saliagos, near Paros. It was a permanent village using handmade pottery and both chipped and ground stone tools that suggest the residents were farmers and herders. Saliagos yielded a marble figurine of schematic style (Fig. 2.1a) and imports from as far away as Gyali, an island just north of Nisyros in the Dodecanese, indicating that the trade and travel that would be so important in this part of the world in later times had already begun.

The period we call the Neolithic formed the foundation for what would happen in later times. Important innovations like agriculture led inevitably to progress in other areas, such as an increased understanding of the processing of foods to make secondary products like oil, vinegar, and wine, and enough knowledge of astronomy to devise a calendar so seeds could

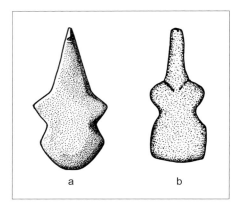

Figure 2.1. Marble figurines: a, from Saliagos. Late Neolithic period. Ht. 6.6 cm (2.6 in); b, from Paros. Grotta-Pelos Group. Ht. 7.7 cm (3.85 in).

be planted at the right time. Increased population created a need for more cooperation that led to governments and more complex social practices. The material culture of the Neolithic already included pottery, ships and boats, houses that were strong enough to survive substantial storms, and a long inventory of tools of many types. The Bronze Age began as a slow progress, not as an event.

The Early Bronze Age in the Greek islands is called the Early Cycladic period. In addition to the Cyclades, the term is often extended to include all the islands between modern Greece and Turkey (including, for example, the Sporades in the north) because many ancient cultures reached across modern geographic boundaries. The Early Bronze Age in the Aegean extends from before 3000 B.C. until about 2000 B.C. Several alternative systems have been used for subdividing this long period into chronological stages of development. A tripartite system (Early Cycladic I, II, and III) does not work very well, although it has been used in several publications. Dividing the long period by cultures rather than by chronological periods has some advantages, but it is difficult to be sure if differences in the material culture (especially pottery) are always indications of differences in ethnic populations or social culture or chronology. The present work divides Early Bronze Age history in the Cycladic region into five stages that are identified by the presence of specific assemblages of objects. The groups of objects are roughly sequential, but their earlier and later stages must have occasionally overlapped with the times when other classes of artifacts were being used. The nomenclature is borrowed from the division into cultural groups suggested by several authors (see especially the publications by Colin Renfrew and Christos Doumas in the bibliography at the end of this chapter).

The problems with exact chronological synchronisms stem partly from the nature of the evidence. Because many of the islands had limited

territory, communities seem to have often exhausted the available land and then moved elsewhere, resulting in many short-lived settlements instead of more permanent towns whose sequences could provide evidence for changes through time. Additional problems result from the extensive looting that has destroyed many sites so that it is often difficult to decide which phases have overlapping chronologies.

Some of the aspects of island life continued without a break throughout the third millennium B.C. Most people were farmers who raised crops and kept sheep and goats plus a few cattle and swine. They did some fishing, and they also engaged in trade. Pottery, stone figurines, and other items provided the Cycladic societies with both utilitarian products and aesthetic art objects that often incorporated both an attractive form and a substantial amount of symbolism.

The following groups are roughly sequential but with overlapping chronologies at some sites:

> The Grotta-Pelos Group
>
> The Kampos Group
>
> The Keros-Syros Group
>
> The Kastri Group
>
> The Phylakopi I Group

The Grotta-Pelos Group

A group of artifacts from the opening years of the third millennium B.C. has been named after a pair of early cemeteries. The objects include some simple clay jars, a useful class of container with a constricted neck called a bottle, schematic "fiddle-shaped" marble figurines (Fig. 2.1b), and a few other items. Metal seems to have been fairly rare during this phase, and marble vases were not made yet.

The Kampos Group

Several cemeteries and settlements belong to a phase that must have developed very smoothly from the phase that used artifacts in the Grotta-Pelos Group. Trade can be traced in greater detail than before thanks to the abundance of metal artifacts. Metallic shapes are fairly simple, consisting of copper pins, daggers, chisels, punches, and other tools. Lead isotope analysis has shown that much of the copper used for these products came

from deposits at Lavrion on the Greek mainland and on the islands of Kythnos and Seriphos in the Cyclades, so the trade was mainly within the Aegean itself rather than with outside areas.

The largest cemetery in this group is at Hagia Photia on the northeast coast of Crete. Other examples of the artifacts in this group are known from many islands in the Aegean as well as from a few sites on the coast of the Greek peninsula. The first marble vessels come from this phase, and the marble figurines have more anatomical details than the ones in the Grotta-Pelos Group.

The Keros-Syros Group

The largest cemetery in the Cyclades is at Chalandriani on the island of Syros, and most of the objects buried in its graves can be assigned to the Keros-Syros Group. In many ways, this phase from around the middle of the third millennium B.C. represents a high point in Early Bronze Age technology and art. Fine metalwork, beautifully carved stone vases, refined pottery shapes made of well-fired clay fabrics, and sleek marble figurines betray a sharp interest in visual form. Experiments with more naturalistic rendering than in the preceding phases result in images of ships, animals, and a few other items inspired by the natural world alongside the non-objective patterns and designs that had been popular for many years.

The Kastri Group

Objects in the Kastri Group represent a somewhat different culture from the items assigned to the Keros-Syros Group. Sometimes the Kastri Group is definitely later in time, but in most cases the assemblages come from different settlements—and even different islands—and surely some overlapping occurred between the end of the earlier Group and the first appearance of the people who used the Kastri Group artifacts. The Kastri Group has been found at sites on the Greek peninsula as well as in many of the Aegean islands.

Kastri itself is a settlement on Syros that is not very far from the Chalandriani cemetery, but its pottery is mostly later than the majority of the finds from the tombs. The town has a thick fortification wall with rounded towers. Metallurgy, especially, increases substantially during this period. An open mold for casting daggers and other objects and a broken crucible for melting the metal came from the fortified town at Kastri and show that at least some of the metal objects could have been made locally.

Technology also advanced during this period. For the first time in the Aegean, large amounts of tin were available to alloy with copper to make bronze. The increased use of tin may have a relation to the region of Troy on the northwestern Anatolian coast where the white metal also occurred during this period in larger quantities than before. Troy was very rich, and it must have been a center of trade. It was the period of the great gold treasures of jewelry and other objects found at Troy by Heinrich Schliemann. The objects included earrings, bracelets, rings, vessels, and other items. Similar pieces came from nearby Poliochni on the northern Aegean island of Lemnos.

The Phylakopi I Group

The town of Phylakopi on the large island of Melos was built on a hill near the coast where its residents had easy access to seafaring. The occupation phase from the closing years of the Early Bronze Age, called Phylakopi I, was an unfortified community composed of houses with several rooms set on narrow streets. Its material culture has been used to characterize the last Cycladic period of the Early Bronze Age.

Architecture

Houses in the Cyclades were mostly made of stone or mudbrick on foundations of fieldstones. The stone foundations were important to raise the fragile walls and keep their mudbrick from absorbing moisture from the ground, which might weaken them enough to cause the building to collapse. Roofs were sometimes flat and sometimes pitched to allow rain to flow off better.

Massive fortifications appeared by the time of the Kastri Group (Fig. 2.2). The people who built the wall at Kastri had a good knowledge of defensive architecture. The wall was high enough to make it difficult for an attacker to climb up, and the thickness would also have discouraged armed attack. High walls let defenders shoot arrows or throw spears or rocks from above the attackers, which is easier than from below, and the towers that were built at regular intervals would have allowed what is called grazing enfilade fire, which consists of hurling missiles along the side of the wall (the enemy soldiers trying to climb the wall are thus attacked from the side where shields do not reach). The people who lived at Kastri were clearly prepared to defend themselves. The houses sheltered by these walls were built in a very informal way, and their walls were often

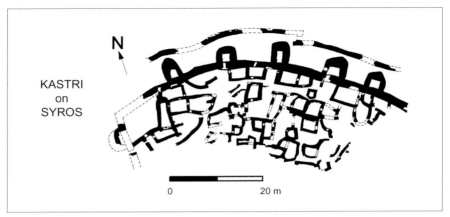

Figure 2.2. The settlement at Kastri, Syros. Kastri Group.

curved and their corners were rounded, aspects of construction that are not difficult if the walls are built of mudbrick or rubble and the roofs are flat. Enough space was left between the buildings so that draining water off a roof would not be a problem.

For most Early Cycladic settlements, the dead were placed in small underground chambers called cist graves. The burial spaces were small, and they consisted of simple underground box-like rooms. They were often lined with slabs or stones, and in most cases they were used for only one or two individuals. Just a few possessions accompanied the deceased.

In the large Kampos Group cemetery at Hagia Photia on Crete, the tombs were more complex than the simple cist graves (Fig. 2.3). They consisted of an underground chamber approached from the side, with a doorway leading in from a shaft excavated next to the room used for the burial. After the deceased and his or her offerings were placed inside the small room, the entrance was sealed with a vertically placed stone slab, and the entrance shaft was filled with heavy stones up to the surface. In several cases, a clay vase was smashed on top of the stones that filled the pit, perhaps as a last offering to the deceased.

Sculpture

Early Cycladic marble sculptures include some of the most attractive artifacts from the entire Early Bronze Age. Because they were already being made during the Stone Age and their use continued during the entire third millennium B.C., many examples survive into modern times. Most of the sculptures are female, but a few male figurines are present as well.

The earliest Bronze Age pieces, from the Grotta-Pelos Group, are always very simplified (Fig. 2.1b). They have smooth, attractive contours and an extension at the top that suggests a head. The figures are flattened, and they have two smooth, rounded shapes separated by a waist. These "fiddle-shaped" figurines are extremely typical of the phase, and their similarity to a small marble figure from Saliagos (Fig. 2.1a) suggests they have a long history in this region. Perhaps the images are intended as a sitting or squatting person, but one cannot be certain. Breasts on some of them indicate the image is female.

By the time of the Keros-Syros Group, several new classes have appeared, but for most figurines, anatomical details are minimized or omitted (although painted traces show that some of the features were added this way). A group called the Folded Arm Figurines (FAFs) forms the largest class (Fig. 2.4). Although it has several subvarieties, the group as a whole shares the main characteristics: a nude, frontal, female form with the head and body straight and the legs held together; toes pointed down so that the figure cannot stand; arms held tightly across the body and folded one above the other below the breasts; and a minimum of details. In the absence of any scrap of written records, we are left to wonder about the meaning. Is this figure goddess, mortal, or abstract concept? Why are the images found in both settlements and graves? The female nudity has suggested to many people that the figures have something to do with fertility, and the repetition of the stance suggests the group had a specific meaning, but we do not have enough information to make a positive conclusion about the ancient significance.

More specialized miniature sculptures also occur (Fig. 2.5). In addition to female figures with the arms folded across the front of the body (Fig. 2.5a), male figures of several types are known. One figure wears a bandolier across his shoulder (Fig. 2.5b). A particularly interesting pair from the island of

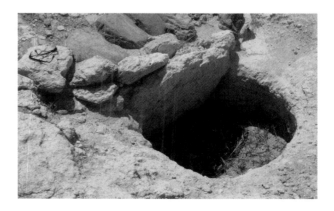

Figure 2.3. Grave from Hagia Photia, Crete. Kampos Group.

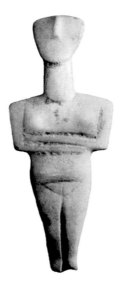

Figure 2.4. Folded Arm Figurine (FAF) from the Chalandriani cemetery on Syros. Keros-Syros Group. Ht. 13 cm (5.15 in).

Keros consists of two musicians (Fig. 2.5c, d). The individuals are both male, and their elliptical heads with the faces turned upward, along with the general treatment of the bodies and limbs, indicate a relation to the more numerous female figures. The standing musician plays a wind instrument with two soundboxes (perhaps similar to the Classical Greek aulos, which had a double reed like the modern oboe). His seated companion (whose arm is broken) strums a large harp, a stringed instrument better known from

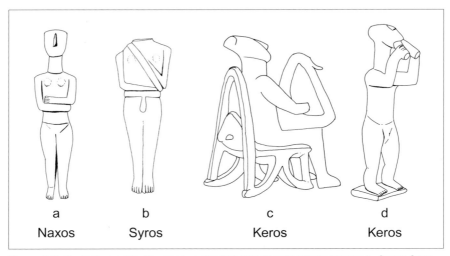

Figure 2.5. Cycladic marble figurines: a, Folded-Arm Figurine from Naxos; b, figure from Chalandriani, Syros wearing a bandolier; c, harp player from Keros; d, figure from Keros playing an aulos-like instrument. Keros-Syros Group. Not to scale.

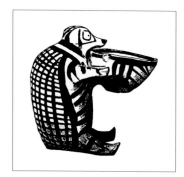

Figure 2.6. Clay vessel from Chalandriani, Syros, made in the form of a hedgehog holding a small cup or bowl. Keros-Syros Group. Ht. 10.8 cm (4.25 in).

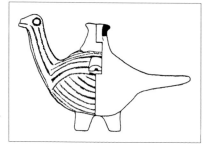

Figure 2.7. Bird-shaped bottle from Hagia Photia, a Cycladic site on Crete. Kampos Group. Scale 1:6.

examples found elsewhere in the ancient world, especially in Mesopotamia where the Royal Cemetery at Ur (whose graves are from about this same time) has yielded several examples.

Early Bronze Age harps were sophisticated instruments. They had large wooden soundboxes and systems for tightening the many strings individually to produce the desired notes. Aegean instruments could have played complex music. Because the pair of musicians from Keros has a great similarity in the sculptural style, the figures probably form a set, which may mean that different Cycladic musicians accompanied one another in ensembles or duets.

Other classes of sculpture also exist, but they are always of small size during this period. Playful pieces include a hedgehog, a burial offering from Chalandriani on Syros (Fig. 2.6) and the bird with a long neck modeled on a clay bottle found in a tomb at Hagia Photia (Fig. 2.7). Both pieces are clay containers. The hedgehog sits up nicely and holds his cup in his front paws. Because the animal is hollow and a hole leads from the cup into the larger cavity, pouring liquid into the cup would fill the vase, and it could be emptied by grasping the small creature's back and using the cup as a spout. The piece is from the Keros-Syros Group.

Pottery

Chronological changes in the Aegean Bronze Age are often measured by changes in the forms and ornaments used for pottery. Ceramic vases are common in the archaeological record because they were used in large

numbers by just about every settlement. After the clay is fired in a kiln, the material itself is very durable, and even if the vessels are broken, the pieces often survive in good condition.

The pottery of the Grotta-Pelos Group was all handmade (rather than made on a potter's wheel). Bowls, jars, and other simple shapes served utilitarian functions, while a few more specialized shapes like the bottle were developed for specific purposes. The bottle, an easily recognizable container whose use continued into the next period (Fig. 2.8a, b), must have held a liquid because its mouth is small and round to accommodate a tight-fitting stopper. Oil, perhaps perfumed, is the most likely possibility for the contents, which were shipped to many places including some on the north coast of Crete. The shape was always made with a narrow mouth and a slightly spreading lip, a rounded body with vertically pierced lugs on the shoulders, and decoration consisting of incised lines scratched into the clay before it was fired. The bottles were usually dark brown to black. This standardized appearance suggests the idea was to make the product easily recognizable to its potential customers.

Pottery continued to be an important commodity during the period of the Kampos Group. Clay vessels were now made in more varied shapes, some of them highly specialized. The bottle that had first appeared in the Grotta-Pelos Group continued to be used, and two examples are shown in Figure 2.8a, b. Their incised decoration is typical of the class. The small bird-like creature with a long neck and three legs (Fig. 2.7) was made as an adaptation of the bottle shape. Its head and neck are solid, and it basically remains a bottle in spite of the zoomorphic additions.

Many of the most popular shapes for inclusion in tombs were small containers with lids; they must have held valuable commodities used in small quantities. The small rounded boxes in Figure 2.8c and d are called pyxides (the singular is pyxis)—the forms are early versions of a class of container that would continue to be made and used throughout antiquity. The variation shown in Figure 2.8e has two bowls that sit on a conical base.

Large goblets called chalices (Fig. 2.9) consist of bowls or large cups on top of conical bases. This shape varies somewhat, and some versions look like a Neolithic chalice from Saliagos (Fig. 2.10) so there is no need to suggest any foreign inspiration for it, but this type of container is fairly common in the northeast Aegean as well, and some writers have suggested the immediate inspiration for the Bronze Age versions is most likely from western Anatolia.

No one knows for sure why the shape called the frying pan was made. The Kampos Group version (Fig. 2.8f) has a shallow bowl with straight sides and a flat base with a short handle. Because it never has any burn marks on it, it was certainly never used over a fire to fry anything. Many

Figure 2.8.
Pottery from
Hagia Photia,
Crete. Kampos
Group. Scale
1:6.

theories on the use of this enigmatic artifact have been suggested because
the decoration on the base would not be seen if its makers intended it as a
simple container. The form has been regarded as a lid, a mirror, a figurine,
and a bowl. Its similarity to conical bowls with tab handles (Fig. 2.8g)
suggests that in this early period it is probably simply a bowl, although by
the time of the next Group, its shape would have enough modifications to
suggest it must have had some symbolic overtones.

Several new shapes were introduced in the Keros-Syros Group. The new
pottery was distributed widely within the Aegean, which means that the
increased trade between regions was contributing substantially to Early
Bronze Age life. The Keros-Syros frying pans (Fig. 2.11) were much more
developed than their Kampos Group predecessors. The walls now flared

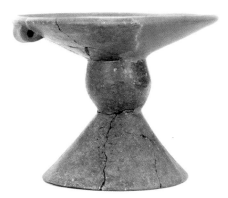

Figure 2.9. Cycladic chalice from Hagia Photia, Crete. Kampos Group. Ht. 21.3 cm (8.35 in).

slightly, the handle was made as a sleek tab or a pair of prongs that projected smoothly out from the vessel, and the flat surface was decorated by stamping circles and other simple designs with carved seals as well as by incising into the clay. Several of the pans had ships incised onto them, and occasionally an incised triangle with vertical slit was put on the lower part, suggesting a female pubic triangle, an early manifestation of the addition of details to suggest anthropomorphic character in what would otherwise be a non-objective pattern. As in some of the marble figurines, the artist made a minimal addition to create a form that was very near the boundary between pure design and what could be recognized as an image from the visible world.

The images of the ships are very interesting. Each one has a high prow and a lower stern, a short projection at the stern, and an emblem (like a fish swimming forward) at the prow. The many paddles or oars suggest that these are sea-going vessels. One cannot be too literal about counting the oars or paddles and assuming that the ships all had this large a crew, but the intent is clearly to suggest a substantial length for these sleek and swift crafts.

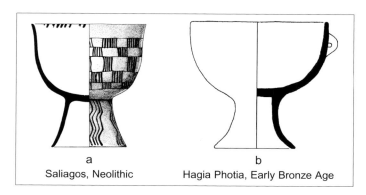

a
Saliagos, Neolithic

b
Hagia Photia, Early Bronze Age

Figure 2.10. Comparison between a Neolithic chalice and an Early Bronze Age chalice from the Kampos Group. Not to Scale.

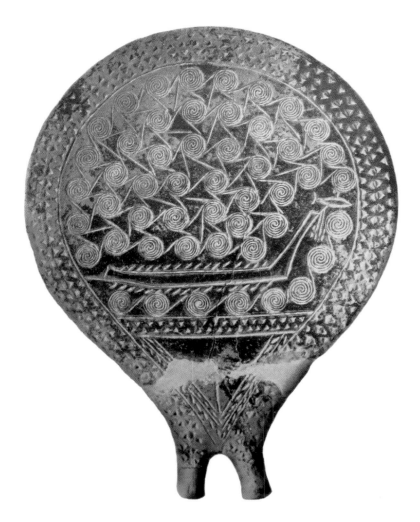

Figure 2.11. Frying pan engraved with the image of a ship, from a tomb at Chalandriani, Syros. Keros-Syros Group. Ht. 30 cm (11.75 in).

One of the most distinctive shapes was the sauceboat (Fig. 2.12). Although examples have been found both on the Greek peninsula and on Crete, the shape was most common in the Cyclades. The contours for this vessel were smooth and elegant, with a spout pulled out from an oval body set on a stable base. The suggestion has been made that the shape was first created by cutting a long-necked gourd and later copying the shape in clay to make a more permanent object, but metal is an alternative to the gourd as an inspiration because the rounded contours could have been easily produced with metalwork techniques.

A few examples of clay vases from the Syros cemetery come from one or more production centers where experiments with dark paint for decoration added a new dimension to the clay products. The hedgehog decorated in this manner is both sculpture and container (Fig. 2.6). The lines of dark paint enhance the shape of the little animal with the bowl between his forepaws; they add substantially to the object's interest.

The contrast between the Keros-Syros and the Kastri pottery is quite dramatic. The new shapes that form the Kastri Group are distinctive and easily recognizable, and an important point that signals new customs (and perhaps new people) is that the fresh shapes replace older vessels used for the same purposes. The new drinking vessels are especially different. A drinking cup with a tall form and two opposed handles is called a depas (a Greek word for a drinking vessel; the plural is depa). Although the depas itself (Fig. 2.13) has a design whose exact form would not outlast the Kastri Group, its main principle—two opposed handles for a drinking vessel—would continue to be used in Greece until the Classical period almost two thousand years later. The design's advantage is that it encourages the host to fill the cup with a beverage and then offer it to the guest who can take it by the other handle. One crucial characteristic about this particular cup is its rounded base so it cannot be put down until the whole cupful has been drunk. Other new and distinctive shapes include a one-handled vessel called a tankard (Fig. 2.14), some jugs with very tall spouts, and a few other shapes.

Like the metallurgy from this phase, these shapes have Anatolian parallels. The people who used the objects in the Kastri Group had a connection with Anatolia either because they traded with communities there or because they or their immediate ancestors came from that region. Whatever their origins, when the Kastri Group people settled in the Cyclades, they often made their pottery from local clay sources.

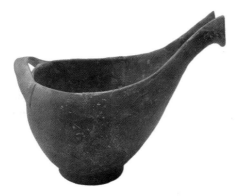

Figure 2.12. Clay sauceboat from Acrotiri, Thera. Keros-Syros Group. Not to scale.

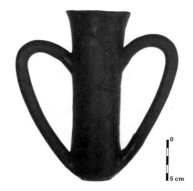

Figure 2.13. Depas from Hagia Eirene, Keos. Kastri Group.

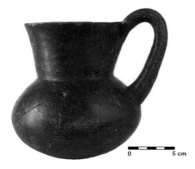

Figure 2.14. Tankard from Hagia
Eirene, Keos. Kastri Group.

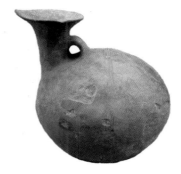

Figure 2.15. Duck vase from
Acrotiri, Thera. Phylakopi I Group.

The pottery of Phylakopi I has several vessels that differ from those of the Kastri Group. No real evidence suggests that the people who lived at Phylakopi in the first town were newcomers to the Aegean, and the new classes of pottery probably developed from earlier ones. Among the common vessels are bowls with inturned rims, jugs with elevated spouts, small boxes called pyxides, storage jars of several shapes, and a small closed container called a duck vase.

The duck vase (Fig. 2.15) has a rounded body and a constricted neck topped by a spout set off to the side. This class of vase is called an askos, and it has a long later history in the Aegean. In later periods, a vessel with a constricted neck that was designed so liquid could flow out very slowly probably held thick perfumed oils used as protection from the sun (like modern suntan lotions). The variety known as the duck vase only vaguely suggests the shape of a bird, and its makers may not have thought of the resemblance.

Other Arts

The introduction of new metallurgical practices into the Aegean by the people who used the pottery of the Kastri Group brought new arts to the region in the middle of the third millennium B.C. One of the most interesting innovations was the diadem (for a silver example found at Kastri itself, see Figure 2.16). Diadems—long, thin, flat bands of metal—were usually made of gold or silver. They were worn in some way by the people of several cultures in the Aegean and Western Asia, either across the forehead or in the hair or on clothing. Holes at the ends would have held them in place or helped attach them to a backing of some flexible material like leather or fabric.

The silver band from Kastri is broken, and only part of it survives. Although most diadems are plain, this one is unusual because it is decorated with figural ornament. It has a series of motifs added in the repoussé technique, including star-like emblems, a quadruped, and a bird-like figure with raised arms or wings. The diadem is unique, and the designs suggest that whoever wore it was a person of some importance.

Comments

The portable art of the Early Cycladic period consists largely of small objects that could be carried easily if a community moved. The architecture is not very monumental, the tombs are small, and except for the substantial fortification walls, only modest amounts of labor were invested in objects intended for visual communication or for permanent display. With this observation in mind, it is not surprising that many of the third millennium B.C. archaeological sites on the islands in the Aegean are small one-period or two-period settlements. Early Cycladic communities had little emotional attachment to a specific piece of land, and this transitory attitude must have influenced both their willingness to move from place to place and the scale of their architectural monuments and personal possessions.

Within the parameters of this small-scale art, however, Cyladic artists created some enduring images. The dynamic shapes and smooth contours of the Early Bronze Age figurines have inspired a long series of modern sculptors from Brancusi to Henry Moore. The playful image of a hedgehog in the improbable act of holding a little cup can delight modern eyes as it must have intrigued those who first saw it. Great art does not have to be large. Many of the Cycladic ideas about visual communication are universal enough for this early chapter in creative energy to have some relevance to our own times—we can appreciate the attractive shapes, the elegant contours, and the occasionally playful spirit even if we are not fully aware of the serious symbolism that lies behind many of the best pieces.

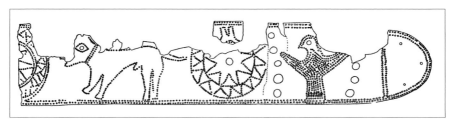

Figure 2.16. Silver diadem from Kastri, Syros. Kastri Group. Restored length of the bilaterally symmetrical diadem 47 cm (18.5 in).

Further Reading

Alram-Stern, E. 2004. *Die Frühbronzezeit in Griechenland mit Ausnahme von Kreta* (*Die Ägäische Frühzeit, 2 Serie: Forschungsbericht 1975–2002*, 2.1), Vienna.

Antonova, I., V. Tolstikov, and M. Treister. 1996. *The Gold of Troy: Searching for Homer's Fabled City,* London.

Barber, R.L.N. 1987. *The Cyclades in the Bronze Age*, London.

Bernabò Brea, L. 1964. *Poliochni: Città preistorica nell'Isola di Lemnos* I, Rome.

Bossert, E.-M. 1967. "Kastri auf Syros: Vorbericht über eine Untersuchung der prähistorischen Siedlung," *Αρχαιολογικόν Δελτίον* 22, pp. 53–76.

Branigan, K. 1974. *Aegean Metalwork of the Early and Middle Bronze Age*, Oxford.

Broodbank, C. 2000. *An Island Archaeology of the Early Cyclades*, Cambridge, UK.

Coleman, J.E. 1985. "'Frying Pans' of the Early Bronze Age Aegean," *American Journal of Archaeology* 89, pp. 191–219.

Davaras, C., and P.P. Betancourt. 2004. *The Hagia Photia Cemetery I. The Tomb Groups and Architecture*, Philadelphia.

Davis, J.L., and J.F. Cherry, eds. 1977. *Papers in Cycladic Prehistory,* Los Angeles.

Dickinson, O. 1994. *The Aegean Bronze Age,* Cambridge, UK.

Doumas, Ch. 1977. *Early Bronze Age Burial Habits in the Cyclades* (*Studies in Mediterranean Archaeology* 48), Göteborg.

———. 1979. *Cycladic Art: Ancient Sculpture and Ceramics from the N.P. Goulandris Collection*, Washington, D.C.

Fitton, J.L., ed. 1983. *Cycladica: Studies in Memory of N.P. Goulandris*, London.

Getz-Gentle, P. 1996. *Stone Vessels of the Cyclades in the Early Bronze Age*, University Park, Pennsylvania.

Getz-Preziosi, P. 1985. *Early Cycladic Sculpture: An Introduction*, Malibu.

Hadjianastasiou, O., and S. MacGillivray. 1988. "An Early Bronze Age Copper Smelting Site on the Aegean Island of Kythnos, Part Two: The Archaeological Evidence," in Jones, ed., 1988, pp. 31–34.

Hauptman, A., E. Pernicka, and G.A. Wagner, eds. 1989. *Old World Archaeometallurgy* (*Der Anschnitt, Beiheft* 7), Bochum.

Jones, J.E., ed. 1988. *Aspects of Ancient Mining and Metallurgy: Acta of a British School at Athens Centenary Conference at Bangor, 1986*, Gwynedd.

Karantzali, E. 1996. *Le Bronze Ancien dans les Cyclades et en Crète* (*BAR International Series* 631), Oxford.

MacGillivray, J.A., and R.L.N. Barber, eds., 1984. *The Prehistoric Cyclades: Contributions to a Workshop on Cycladic Chronology*, Edinburgh.

Manning, S.W. 1995. *The Absolute Chronology of the Aegean Early Bronze Age*, Sheffield.

Papathanassopoulos, G. 1981. *Νεολιθικά-Κυκλαδικά* (also published as *Neolithic and Cycladic Civilization*), Athens.

Podzuweit, C. 1979. *Trojanische Gefässformen der Frühbronzezeit in Anatolien, der Ägäis und angrenzenden Gebieten: Ein Beitrag zur vergleichenden Stratigraphie*, Mainz on the Rhine.

Rambach, J. 2000. *Kykladen,* 2 vols., Bonn.

Renfrew, A.C. 1969. "The Development and Chronology of the Early Cycladic Figurines," *American Journal of Archaeology* 73, pp. 1–32.

———. 1972. *The Emergence of Civilisation: The Cyclades and the Aegean in the Third Millennium B.C.*, London.

Rutter, J.B. 1979. *Ceramic Change in the Aegean Early Bronze Age*, Los Angeles.

Schachermeyr, F. 1976. *Die Ägäische Frühzeit. I. Die vormykenischen Perioden des griechischen Festlandes und der Kykladen*, Vienna.

Sotirakopoulou, P. 1986. "Early Cycladic Pottery from Akrotiri," *Annual of the British School at Athens* 81, pp. 297–312.

Stos-Gale, Z.A. 1989. "Cycladic Copper Metallurgy," in Hauptman, Pernicka, and Wagner, eds., 1989, pp. 279–292.

Tsountas, Ch. 1898, "Κυκλαδικά," *Αρχαιολογική Εφημερίς* 1898, pp. 137–212.

———. 1899. "Κυκλαδικά II," *Αρχαιολογική Εφημερίς* 1899, pp. 73–134.

Warren, P.M., and V. Hankey. 1989. *Aegean Bronze Age Chronology,* Bristol, UK.

Zapheiropoulou, Ph. 1984. "The Chronology of the Kampos Group," in MacGillivray and Barber, eds., 1984, pp. 31–40.

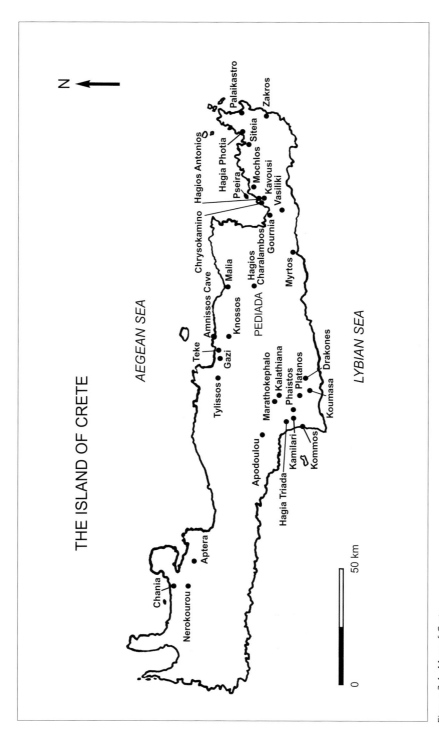

Figure 3.1. Map of Crete.

<div style="text-align: right; font-size: 3em;">3</div>

Early Minoan Crete: EM I to EM III/MM IA

Crete has the isolation and protection that only an island can offer, but it is large enough to support many towns and cities as well as smaller places (Fig. 3.1). With a distance of about 260 kilometers (ca. 160 miles) from east to west, it is the largest island in the Aegean. Countless fertile areas, including many low hills and grassy valleys, provide enough arable land for a substantial population. Although Crete is less than 325 km (ca. 200 miles) north of the Sahara Desert, its high hills and rugged landscape create several different climates: wetter in the west and dryer in the east where mountains block off the rain, and ranging from warm on the coasts to rather cool as one climbs higher into the mountains.

A few large regions, notably the Mesara plain in south-central Crete and the low hills in the north-central area, were so agriculturally important that they could produce more food than was needed locally. They provided an important foundation for trade with other places, and the residents of these parts of Crete pioneered in the large-scale processing of crops like grapes to make wine and olives to make perfume and oil, industries that would make the island wealthy in later times. It is not an accident that most of the later Bronze Age palaces developed near regions that had been important for agriculture over many centuries before the palatial rulers began to control and exploit them.

Crete was already inhabited in the Early Neolithic period. Except for Knossos, little is known of the other earliest sites, but by the end of the Neolithic, people had settled over the whole island. The Cretans were

farmers and herders who raised grains, vegetables, and fruit trees and kept sheep, goats, cattle, and pigs. Their villages were usually on low hills away from the marshes where mosquitoes were prevalent and near locations for agriculture and animal husbandry. Coastal sites suggest that sea travel was useful from the beginning.

Many of the characteristics of the Early Bronze Age were already present in Crete during the Neolithic. Pottery was all made by hand. The most common vases were utilitarian bowls and jars of red to black fabrics. Their surfaces were burnished by rubbing the clay with a smooth piece of stone or wood to compress the clay and make it more water-tight. Copper was known, but it was not common, and most tools were made of bone or stone. Obsidian was imported from the island of Melos. It was used to make chipped stone scrapers and blades for cutting soft materials like leather or fabrics. People occasionally camped in caves, especially if they were in the mountains taking care of their sheep, but most Cretans lived in houses of stone or mudbrick.

For modern study and analysis, the Cretan Early Bronze Age has been divided into chronological periods defined by changes in pottery styles (Fig. 1.2). The phases are called Early Minoan I, II, and III.

Early Minoan I

Early Minoan I (EM I) probably began at about the same time that the Cyclades were using the Grotta-Pelos Group of artifacts, but exact dates are not really known. A date somewhere just before 3000 B.C. for the beginning of the phase is likely. Some communities did not quit making or using their older pottery all at once, so we can probably assume that it took a few years for all locations to adopt the new styles that we use to define the Early Minoan time period.

Early Minoan IIA

The Cretan economy and its art and craftwork developed rapidly during the first stage of EM II as villages became larger and the expanding population had a greater need for containers and other objects. Sauceboats found at Knossos and elsewhere indicate that this period in Crete was at least partly contemporary with the objects in the Keros-Syros Group in the Cyclades (around and slightly after the middle of the third millennium B.C.).

Early Minoan IIB

The second stage of EM II began without any sharp break at the end of EM IIA. This situation contrasts sharply with that in the Cyclades where the end of the phase when the Keros-Syros Group was popular was either marked by the arrival of new people or by some other cultural crisis that led to destruction and abandonment at many sites. Kastri Group objects are found throughout the Cyclades, but very few of them reached Crete so the large island was now going its own way with less northern contact. The earliest piece of hippopotamus ivory known from Crete is from a context at Knossos dated to EM IIB, and this evidence for trade with the civilizations of the East Mediterranean is a good hint that the Cretans were starting to look in new directions and to more distant shores.

Early Minoan III and Middle Minoan IA

The line between EM III and MM IA is difficult to distinguish. It has traditionally been regarded as the point in time when red paint started to be used alongside white for decorations on pottery, but evidently many potters were either very conservative or had no access to the new color; they continued to use the white paint by itself for a long time, making it difficult for us to recognize the new phase.

Settlement Architecture

Most Early Bronze Age villages were on open hillsides, and the land surrounding them was used to grow food for a gradually expanding population. Houses were made of stone or mudbrick on stone foundations. Knossos and Phaistos, which would have important palaces during the Middle Bronze Age, were already substantial small cities by this period, but very little survives from the heart of their settlements (where the public buildings would have been) because of massive leveling operations at both sites at the beginning of the Middle Bronze Age.

The village of Myrtos gives us a good picture of a small settlement from the Early Minoan II period (Fig. 3.2). The site, on top of a hill in southeast Crete, has two architectural periods, an early one from EM IIA and a later one from EM IIB. Its evidence survives in good condition.

The later settlement at Myrtos consisted of about five or six houses clustered together on top of the hill. Foundations were of stone with walls of mudbrick supporting flat clay roofs. Each house had its own kitchen area along

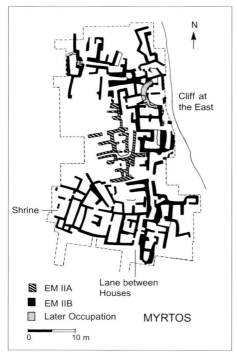

Figure 3.3. Female figurine holding a jug, from the shrine at Myrtos. EM IIB. Ht. 21.1 cm (8.3 in.).

EM IIA

EM IIB

Later Occupation

MYRTOS

Lane between Houses

Cliff at the East

Shrine

N

0 10 m

Figure 3.2. Plan of the EM II settlement at Myrtos on the southeast coast of Crete.

with space for storage and various domestic activities. A typical household had several rooms for its family members and their activities and storage needs. The town needed to store enough food to last until the next harvest, and much of it seems to have been put in clay containers of various sizes, including some large jars. The layout of the town was very informal, and each house had a different arrangement of interior rooms as well as some unroofed exterior spaces.

A small shrine served the religious needs of the settlement. The room had few surviving features to express its special character, but a clay model of a woman holding a jug must have been a focus for the beliefs (Fig. 3.3). The figure (called the "Goddess of Myrtos") had a broad body and a tall, elongated neck flowing smoothly into the head. Lines on the body probably signify clothing. The small jug held by the figure had a hole leading from it into the hollow interior so that any liquid poured into the little vessel would disappear into the human figure.

The symbolism of water and other liquids is an almost universal metaphor for abundance and nourishment, and the community living on top of this dry hilltop may have felt that water was a precious commodity even aside from

its symbolic meaning. One detail to notice from this context would be typical of Minoan Crete throughout its history: except for the small figurine, it is difficult to distinguish what in the room was ordinary and what was regarded as a religious item that was charged with special meaning.

Tomb Architecture

An important difference between Crete and the islands north of it involved the attention paid to tombs. Burial architecture in Early Minoan Crete varied somewhat from region to region, but the customs in regard to ceremonies associated with the dead were generally similar. Almost all tombs were communal, holding up to hundreds of individuals who were buried over the course of many centuries. Probably those buried in a tomb were related by family kinship or in other ways, and they wished to continue the association after death. After a sepulcher had been used for many generations, it might hold enough burials to make it too crowded for further use. Occasionally, some or all of the earlier bones would be pushed aside or removed to make room for more recent ones.

In addition to the Cycladic graves like those found at Hagia Photia (Fig. 2.3), several different types of tomb architecture are known from EM Crete:

1. Natural caves

2. Tholos tombs

3. House tombs

4. Cist graves

5. Rock shelters

Natural caves were used as tombs where they were available. They provided suitable burial architecture because they were large underground spaces that could be effectively closed off from the world of the living but could still be visited when the need arose. Modest architectural modifications like terraces or ramps improved them and made them more suitable for their intended purpose. Caves were especially popular as tombs in West Crete.

In the south-central part of the island, a circular chamber called a tholos tomb was preferred for burial. The word tholos (plural: tholoi) is the Greek word for any round building. The circular tholos tombs of the Mesara and neighboring regions were monumental constructions. They stood above ground, and their domed roofs would have created a strong visual impression. The class began in the Early Bronze Age (or possibly even earlier), and it continued until well into the Late Bronze Age. A MM IB example from Kamilari, with a diameter of about 11 meters (a little over 35 feet), is

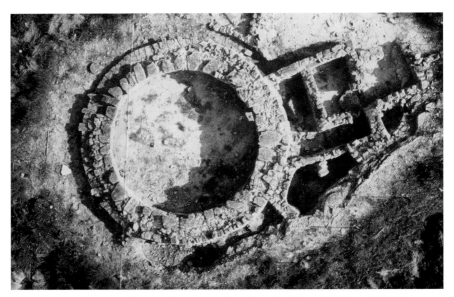

Figure 3.4. Aerial view of the tholos tomb at Kamilari. Used from MM I to LM IIIA:2. Internal diameter 7.65 m (ca. 25 ft 3 in).

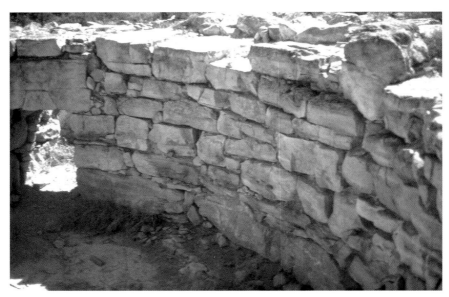

Figure 3.5. The surviving lower part of the Kamilari tholos tomb and its entrance, showing the massive lintel over the doorway.

a good example of the type (Figs. 3.4, 3.5). Like the other tombs in this tradition, it had a single entrance that led into its interior; a pair of massive stone blocks supported the doorway's heavy stone lintel. The walls were thick at the base, and the size of the chamber started to constrict from the floor upward (Fig. 3.5). The constriction was achieved by placing the stones so that each higher course extended into the interior a little more than the one immediately below it. For the dome, successive but slightly smaller rings of stones were added above one another. This method of creating a dome is called corbelling. The Minoan builders used mud and wet clay to bond their stones together to help hold up the walls during construction, but the finished domes were mostly supported by the weight and the pressures of the blocks themselves. Corbelled arches and domes are not as strong as vaults built with Roman arches, and modern architects have occasionally wondered whether some of the larger Minoan tombs needed wooden posts inside to help hold them up.

Rectilinear buildings of various sizes were used for burial away from the Mesara, especially in East Crete. The finest of these rectilinear tombs were large enough to be called house tombs. The earliest examples were built in EM IIA, but their origin is not completely clear; the concept of a monumental building used for burial that was built above the ground could have been imported from elsewhere in Crete, or it may have developed as an enlargement of the earlier East Cretan cist graves. Good examples come from Mochlos where a cemetery for an adjacent community was built on the western side of a tall hill (Fig. 3.6). Mochlos, now an island, was still connected to Crete during the Early Bronze Age; tectonic movements have caused a change in relative sea level in this part of Crete over the past four thousand years. The house tombs here consisted of stone buildings with one or more rooms. The example shown in Figure 3.6 is made of natural stone blocks gathered on Mochlos itself with mud used as a mortar between the stones. A paved court in front of the building could have been used for ceremonies. Richard Seager, who excavated the tomb in 1908, regarded the rooms as separate tombs (nos. IV, V, and VI), but no real evidence survives for how this complex would be apportioned in ancient times. The block of four rooms was used as late as the beginning of the Late Bronze Age, but the earliest objects found with the burials were from EM IIA.

Cist graves were small stone-lined chambers. Many of them were partly or completely built above ground, and they sometimes seem like miniature versions of the house tombs. They were constructed of small blocks or vertical slabs, and they were either rectangular or somewhat irregular. An example from Pseira, built of vertical slabs, is shown in Figure 3.7. It is not large enough for a body to be placed inside in an extended position but, like almost all Minoan tombs, it was used for successive burials over many

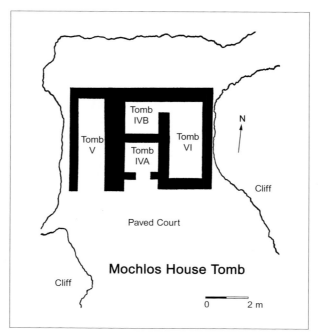

Figure 3.6. Plan of a house tomb (no. IV/V/VI) at Mochlos.
EM IIA to MM.

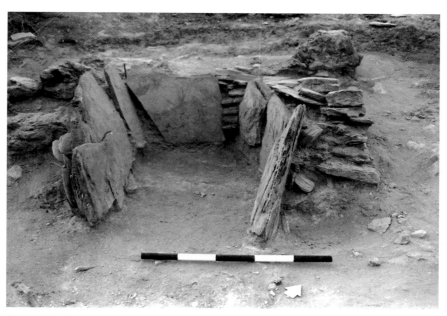

Figure 3.7. Cist grave (Tomb 3) from the Pseira cemetery. Used in the Early Bronze Age.

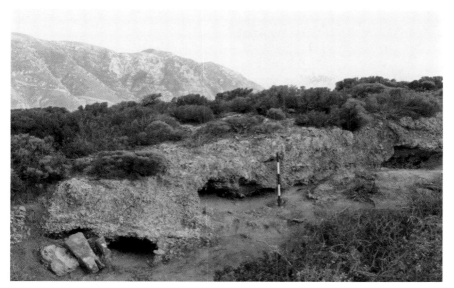

Figure 3.8. Rock shelters from the Pseira cemetery.

generations, and early interments were simply cleaned out the doorway to make room for new ones.

Small man-made caves called rock shelters were also used for the dead in some of the communities, especially in the small East Cretan towns. A group of three tombs from Pseira is shown in Figure 3.8. These small tombs did not hold as many people as the larger chambers—like the cist graves, they had to be cleaned out periodically to make room for new burials. Walls in front of the caves sealed their openings.

For all of these tombs, the Minoans used closed chambers for multiple burials over a long period of time. Benches, courtyards, deposits of skulls removed from the original tomb, and extra rooms filled with cult equipment demonstrate that Minoan cemeteries were the focus of considerable attention, and also that they were visited for later ceremonies after the time of burial. From the many cups and other objects, these ceremonies seem to have involved toasting, chanting, dancing, and other religious observances. Many later cult practices that the Minoans performed in shrines and in urban locations probably originated in these early ceremonies in honor of the dead.

Pottery

Pottery vessels were important to every household because they were readily available, and they were waterproof and insect-proof. They could

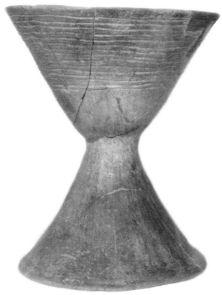

Figure 3.9. Minoan chalice from Tomb 134 at Hagia Photia. EM I. Ht. 22.5 cm (8.9 in).

be made in many sizes with shapes that were especially suitable for specific purposes. Clay pots were used in large numbers in every period.

Because clay vases were so common, and because they were made somewhat differently by new generations of potters, they are used to define the chronological periods. The opening phase of Early Minoan (EM I) is defined by the appearance of new ceramic containers. Two new wares are especially distinctive. One class is made of hard, well-fired gray to black fabrics that are dark completely through the wall of the vase (in cross section). The surfaces are nicely burnished, and they are thinner and harder than the Neolithic vases.

The most important vase made in this thin new fabric was the chalice (Figs. 3.9, 3.10a). It was an open container with a large bowl on top of a conical base, and it was probably a large drinking vessel that could be passed from person to person at ceremonies. Sometimes, as on the example in Figures 3.9 and 3.10a, the chalices were decorated with grooves. If they had patterns made by rubbing the surface of selected areas to make lines or designs with the burnishing tool, they are called Pyrgos Ware. They were gray to black because they were fired with no oxygen present, either in a pit or by some other system that was completely closed off from the air.

The other important EM I pottery is called Hagios Onouphrios Ware (Fig. 3.10b). It represents an important series of innovations. In contrast with the dark fabrics of Pyrgos Ware, these finished products are always pale in color. This result can only be achieved in a kiln chamber that admits

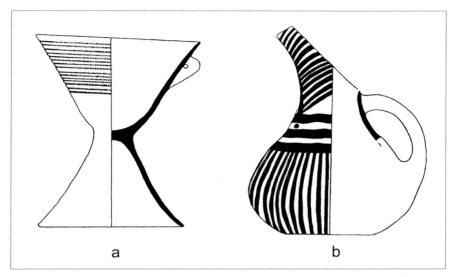

Figure 3.10. Minoan vases from Hagia Photia. EM I. Scale 1:4.

enough oxygen during the firing process to produce a clean, bright color. The vases are painted with designs in an iron-rich slip fired to an attractive red color that contrasts nicely with the pale clay of the vase itself (slip is a thick liquid made by mixing clay and water). Some of the finest Hagios Onouphrios Ware vases come from the south-central part of Crete, but they were exported widely throughout the island. Their decoration often uses long red lines that sweep around the vase.

The principles of design changed in EM IIA, and many products from this period used more planning and less informality than in earlier times. While EM I Hagios Onouphrios Ware used red paint and thick lines to create designs that flowed around the vase (Fig. 3.10b), and the dark gray to black pottery like Pyrgos Ware used incised or burnished lines that were put on freehand with little thought to composition (Fig. 3.9), the EM IIA designs were more controlled, with carefully, even meticulously applied thin brown to black lines painted on the vase (Fig. 3.11). The decoration of this period consisted only of lines, and no recognizable images have ever been noted. Often, as in Figure 3.11, the strokes were applied across one another and with the lines very close together.

In addition to their painted patterns, the EM IIA potters also experimented with incising lines into the clay before it was fired. The Fine Gray Ware vase illustrated in Figure 3.12, which was found in the north cemetery at Gournia, has carefully incised designs on its upper shoulders. It is a small clay pyxis that could have been used to hold any number of different items. Although this example has a tall cylindrical base that splays out

Figure 3.11. Jug from Koumasa (Koumasa Style). EM IIA. Scale 1:2.

at the bottom for better stability, pyxides without bases were popular as well. The incised lines are very carefully done. Rows of concentric semi-circles decorate the upper shoulder, and they are nicely spaced on the handle zone so that one of them is centered between the handles.

The careful execution that is visible in the decoration of the EM IIA pottery was partly influenced by the techniques used for decoration. Because neither the painted ornament nor the incising could be erased easily to correct any mistakes, an artist could not make up the design as it was applied. This situation led naturally to careful planning before beginning the work, and fine craftsmanship became a crucial part of what was expected by the consumers.

The overall pottery style changed in EM IIB. The potters began experimenting with more elaborate forms, and their production now included some highly exaggerated shapes. Jugs sometimes used very elevated upper parts (Fig. 3.13), and teapots were given long extensions at their spouts (Fig. 3.14). Several surface decorations were used, though most vases were

Figure 3.12. Pyxis from Gournia (Fine Gray Ware). EM IIA. Ht. 10.4 cm (4.1 in).

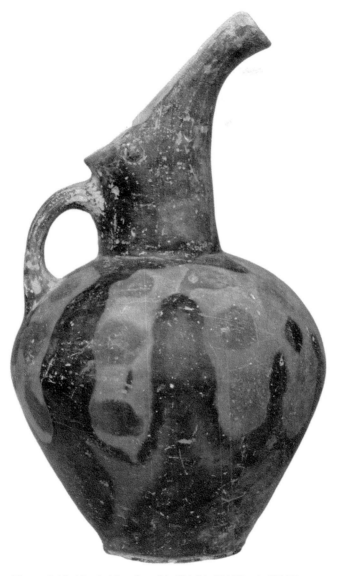

Figure 3.13. Mottled jug from Vasiliki (Vasiliki Ware). EM IIB.
Ht. 33.5 cm (13.25 in).

fairly plain. The finest containers were decorated with a mottled technique
called Vasiliki Ware after the site in eastern Crete where the pottery was
first found in quantity.

Vasiliki Ware was used for a number of differently shaped vessels
including cups, jugs, bridge-spouted jars, teapots, and small bowls. One of

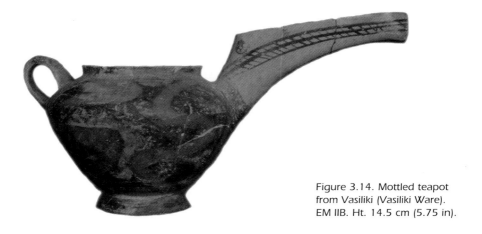

Figure 3.14. Mottled teapot from Vasiliki (Vasiliki Ware). EM IIB. Ht. 14.5 cm (5.75 in).

the popular shapes was a small goblet with a rounded bowl on a stemmed base (Fig. 3.15). It was a small version of the much larger chalices used in earlier times, and the suggestion has been made that drinking ceremonies that had once consisted of passing a large chalice of beverage among a group of people were now replaced by ceremonies in which everyone had his or her own small goblet for drinking. The suggestion is a good one, and it explains why the attractive, high-spouted jugs were now more popular; they were the display pieces for the ceremony, and they were needed to fill the large number of small goblets.

The ware was made with thick, sturdy walls. It was covered with a uniform coat of slip, and all the mottling was achieved with the firing process. If iron-rich clay is heated in the presence of oxygen during the firing, it will turn red from the formation of red iron oxides; an absence of oxygen will form black iron oxides. These simple chemical changes were exploited by the makers of Vasiliki Ware to produce mottled effects with red, pale to dark brown, black, and many colors in between. Some of the vases were accidentally mottled by contact with fuel during the firing, but the finest pieces were deliberately

Figure 3.15. Goblets from Vasiliki. EM IIB. Scale 1:3.

made with mottled patterns (Fig. 3.13). The exact effect has never been duplicated in modern times, but it was probably achieved by removing a vase from the kiln, dabbing on something flammable, and replacing it in the kiln so the selective burning would mottle the surface. That the vases do not have random patterns is demonstrated by even a casual examination of the best vases because the mottling forms patterns of dots where the flammable substance was placed on the vases.

The pottery of EM III laid the foundation for the dynamic expansion in art objects that would come in the Middle Bronze Age. Early Bronze Age Cretan potters had experimented in several ways. They decorated ceramics with burnished patterns, with lines incised into the clay, with dark linear ornamentation, and with mottled designs achieved in the firing process. The EM III system, which would emerge as the dominant ceramic decorative tradition for pottery for the next 300 to 400 years, was simple. The potters first covered each vessel with a solid coating of dark paint and then applied the designs in white on top of this undercoat (Fig. 3.16). The earliest examples of the new system, called White-on-Dark Ware, were conservative and fairly simple. The ornamentation became more complex by MM IA, and by the end of the phase, the potters were painting their vases with spirals, bands of curved lines, circle motifs, and many other designs (Fig. 3.17). The white designs contrasted nicely with the black background.

Sculpture

Small portable sculptures were made in a variety of materials, but they were not common during the Early Minoan period. In an age when most objects were only decorated with completely non-objective patterns, images of human beings and animals often had very special meanings. Most examples were used in graves and other contexts that suggest religious symbolism.

Only a few female figurines have been found from this long period. Figure 3.18 shows a marble figurine of the Koumasa Type found at Teke,

Figure 3.16. Straight-sided cup from Mochlos (East Cretan White-on-Dark Ware). EM III to MM IA. Ht. 6.5 cm (2.55 in).

Figure 3.17. Designs on East Cretan White-on-Dark Ware. EM III to MM IA.

and Figure 3.19 depicts a bone figurine from Hagios Charalambos. Both examples come from burials. Like so many of the contemporary Cycladic figures, the Cretan versions are completely nude. They show a frontal female figure with straight legs whose arms are folded under the breasts like the Folded-Arm Figurines from the islands to the north (Figs. 2.4, 2.5a). A sharp difference exists here, however, because the Cycladic figures of this type represent one of many different classes—the Cretans borrowed only a very small part of the rich Cycladic sculptural tradition. The repetition of the same gesture and stance over and over in the Cretan figures suggests a specific individual is intended, and the figure may be a goddess whose worship was borrowed from Crete's neighbors to the north. If so, a belief in a nude goddess did not last long in Crete because later figurines followed a tradition of clothed divinities (like the clay example from Myrtos, Fig. 3.3).

Animals were also depicted in miniature sculptures. A stone lid from the cemetery at Mochlos (Fig. 3.20) has its handle carved in the form of a dog. The lid must have been used to cover a pyxis. The dog was fashioned in the same manner as the rest of the vase, by an abrading technique that gradually wore away the stone.

When clay was used, the results could be more dynamic. The small sculptural group shown in Figures 3.21 and 3.22 comes from a tholos tomb

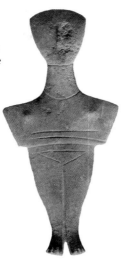

Figure 3.18. Marble Folded-Arm Figurine (Koumasa Type) from Teke. Ht. 13.7 cm (5.4 in).

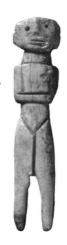

Figure 3.19. Female figurine made of bone, from Hagios Charalambos. EM II. Ht. 8.9 cm (3.55 in).

Figure 3.20. Stone lid for a small pyxis with a carved dog used as the handle, from Mochlos. EM III to MM IA. Diameter 11 cm (4.4 in).

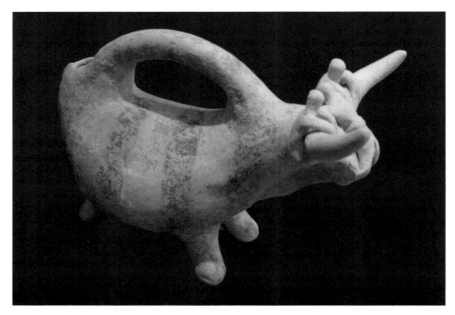

Figure 3.21. Bull-shaped rhyton with three figures performing acrobatics, found at Koumasa. EM II to MM I. Length 20.5 cm (8.1 in).

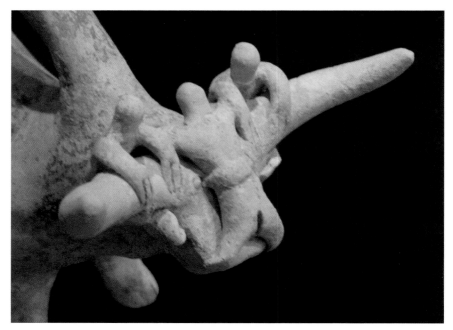

Figure 3.22. Detail of the bull from Koumasa.

at Koumasa. It is a hollow container in the shape of a bull, and the small spout at the animal's mouth indicates it was designed for liquids. Small human figures of indeterminate sex hang precariously from the bull's head and horns. The sculpture is an early version of a dangerous activity that would become extremely important in the Aegean by the Late Bronze Age (more than 50 Aegean artistic depictions of acrobatics involving humans and bulls survive). In later times, the activity, which surely symbolized human mastery over the natural world and probably involved religious ceremonies as well as sport, was especially popular in the palatial art of Knossos, the largest of the Minoan palaces, but in this early period it was being depicted in the south of the island well away from Knossos.

Other Arts

Portable art objects were popular in the Early Bronze Age. They included jewelry, small vases, sealstones, and other objects. In most cases, these items had a purpose aside from aesthetics. Except for jewelry (Figs. 3.23, 3.24), the Early Bronze Age Minoan society does not seem to have thought much about the concept of an object made just to be admired.

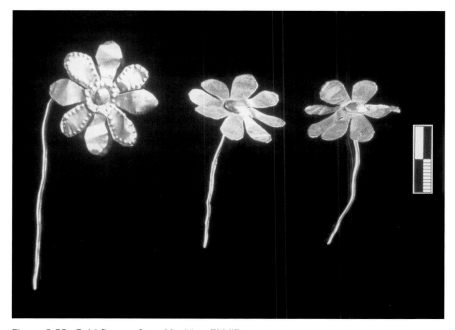

Figure 3.23. Gold flowers from Mochlos. EM IIB.

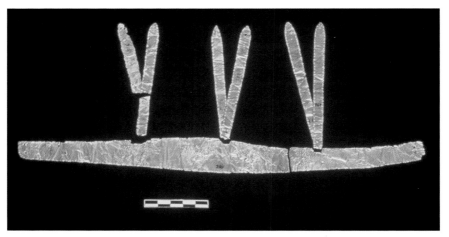

Figure 3.24. Gold diadem from Mochlos. EM IIB.

Gold was not native to Crete, but its bright and durable surface made it a valued material for jewelry. Many examples of gold ornaments come from Minoan tombs, and a large selection was found in the cemetery at Mochlos. Because most of the pieces from Mochlos were not found on the bodies themselves but were buried separately, exactly how they were worn is not always clear. Flowers like those in Figure 3.23 might have been placed in the hair. The strips and diadems (Fig. 3.24) could have been backed with leather or cloth, and they may have been attached to clothing or worn on the forehead or used as part of an elaborate coiffure. Beads were surely strung as necklaces, at least part of the time. Along with the golden jewelry, the residents of Mochlos and elsewhere wore pendants and beads of carnelian, banded agate, dark serpentinite, transparent rock crystal, and many other materials.

Stone vases were often made of exotic materials. The jug shown in Figure 3.25 is from a tomb at Hagios Antonios. The material for Early Minoan stone vessels was often carefully chosen for its patterns, and this example is made from travertine, the banded brown and white calcium carbonate that forms in caves as stalactites, stalagmites, and other formations. This material is rather common in some parts of Crete because of the extensive deposits of limestone and the many caves on the island. It often forms not only in open caverns but also in natural cracks in the limestone, and because it is a rather soft rock, it can be easily quarried for use.

Seals were used by many of the societies of the eastern Mediterranean. Their function was to act as a signature for an individual or as a badge for an official, and they were pressed into clumps of wax or clay placed on a knot, the edge of a lid, or some other device used to close documents,

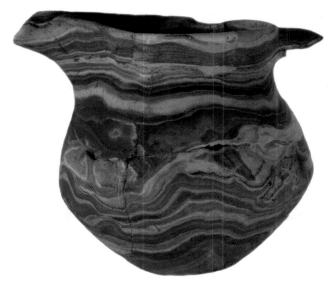

Figure 3.25. Small jug made of travertine, from Hagios Antonios. EM II to III. Ht. 9.6 cm (3.8 in).

boxes, jars, or baskets. Clay impressed with seals was even used over latches on the doors of storerooms. The closed door or container could not be opened without breaking the seal, which would prove that it had been examined. In Western Asia many of the examples were cylinders that were rolled across the surface of the wax or clay, but the Aegean seals were almost all stamps with a design carved into one or both of the seal's ends.

The earliest Minoan seals were very simple. Many of them had designs with just lines or drilled circles, but the artists soon adopted more complex motifs (Fig. 3.26). Seal production increased substantially toward the end of

Drakones Marathokephalo Kalathiana Hagios Charalambos

Figure 3.26. Designs on seals made of hippopotamus ivory. EM III to MM IA. Not to scale.

the Early Bronze Age, and some of the most interesting objects from the period are in this category. Both abstract and naturalistic elements were popular.

The seals shown in Figure 3.26 illustrate some of the motifs used between EM III and MM IA. All the seals in this group are made of hippopotamus ivory, a material that had to be imported from Egypt or the Syro-Palestinian coast. The curvilinear designs are early versions of the complex spiraling patterns that would develop considerably in the next period, especially in painted pottery.

One of the new developments that gradually entered Cretan artistic tastes during the Early Bronze Age was an appreciation of figural elements copied from the natural world. Seals were shaped in several forms (including animals), and they were also occasionally carved with images of various animals, including goats, deer, the pig, and lions like the one on Figure 3.26. Sometimes the animals from EM III to MM IA were not very accurate representations, but their appearance foreshadows the Cretan love of nature that would develop further in years to come. When the Middle Minoan palaces were built in MM IB and their rulers started sponsoring artistic developments, they encouraged a range of tastes in ornamentation including non-objective patterns, abstraction of natural elements, and the imitation of nature that had started here very quietly at the end of the Early Bronze Age.

Comments

During the period just before the building of the Middle Minoan palaces in MM IB, one can see an increase in Minoan economic activity, especially in the south where a new building phase began at Phaistos. A new interest in importing foreign goods from the East Mediterranean also appears in EM III to MM IA. Many of these Eastern imports are elite luxury goods. They include hippopotamus ivory (used for carving little figurines, seals, and other objects), scarab beads, carnelian agate beads, transparent pieces of quartz crystals, and other items. It is often difficult to know exactly how or from where these products reached Crete. Did an Egyptian trinket like a scarab beetle with a seal design come directly from Egypt, or did it go first to some town along the Syro-Palestinian coast and then to Cyprus or somewhere else before finding its way to Crete? Whose ships were involved? Trade was obviously increasing, but the important aspects of the foreign connections were the ideas that were arriving as well. The Minoans were developing a taste for elegant and artistic objects, and they were learning both how to acquire them and how to make attractive items themselves.

Another sign of the increasing technological expertise available at the end of the Early Bronze Age can be documented in a small smelting workshop at

Figure 3.27. Reconstruction of the use of bellows to pump air into the copper smelting furnaces at Chrysokamino.

Chrysokamino. The site is in a rural area in the eastern part of Crete well away from any known palace. The workshop imported copper ore from the north (from the island of Kythnos and from Lavrion on the Greek mainland), and it smelted it in Crete to produce copper for local and regional use. The site had been operating for some time before EM III–MM IA, but it now began using the bellows in the operation, which expanded the production. The bellows, a mechanical means of pumping air into the furnaces to make the fire hotter more quickly (Fig. 3.27), had surely been invented elsewhere, probably somewhere in the East Mediterranean. Its introduction must have meant an immediate increase in efficiency. Fragments of EM III to MM IA pottery provide a date for the operation.

Perhaps the disruptions north of Crete at the time that the Kastri Group appeared in the Cyclades helped encourage the Minoans to look eastward, but the continued arrival of northern ores from Kythnos and Lavrion at Chrysokamino shows that the situation was not this simple. Cretans were reaching out to the north as well as to the east in search of markets for their goods and raw materials for their expanding economic ventures, and the resulting development would be realized in the great palaces of the Middle Bronze Age.

Further Reading

Antonova, I., V. Tolstikov, and M. Treister. 1996. *The Gold of Troy: Searching for Homer's Fabled City*, London.

Betancourt, P.P. 1979. *Vasilike Ware: An Early Bronze Age Pottery Style in Crete* (*Studies in Mediterranean Archaeology* 56), Göteborg.

————. 1985. *The History of Minoan Pottery*, Princeton.

————. 2006. *The Chrysokamino Metallurgy Workshop and Its Territory*, Princeton.

Branigan, K. 1970. *The Tombs of Mesara*, London.

————. 1974. *Aegean Metalwork of the Early and Middle Bronze Age*, Oxford.

————. 1988. *Pre–Palatial: The Foundations of Palatial Crete: A Survey of Crete in the Early Bronze Age*, Amsterdam.

————. 1993. *Dancing with Death: Life and Death in Southern Crete c. 3000–2000 b.c.*, Amsterdam.

Davaras, C., and P.P. Betancourt. 2004. *The Hagia Photia Cemetery I: The Tomb Groups and Architecture*, Philadelphia.

Evans, A.J. 1921–1935. *The Palace of Minos at Knossos*, 4 vols., London.

Evans, J.D. 1971. "Neolithic Knossos: The Growth of a Settlement," *Proceedings of the Prehistoric Society* 37, pp. 5–117.

Fitton, J.L. 2002. *The Minoans*, London.

Hood, S. 1971. *The Minoans*, London, New York, and Washington, D.C.

————. 1978. *The Arts in Prehistoric Greece*, Harmondsworth.

Karantzali, E. 1996. *Le Bronze Ancien dans les Cyclades et en Crète* (*BAR International Series* 631), Oxford.

Koehl, R.B. 2006. *Aegean Bronze Age Rhyta*, Philadelphia.

Krzyszkowska, O. 2005. *Aegean Seals: An Introduction*, London.

Levi, D. 1961–1962. "La tomba a tholos di Kamilari presso Festòs," *Annuario della Scuola Italiana di Atene e delle Missioni Italiane in Oriente*, n.s. 39–40, pp. 7–148.

Manning, S.W. 1995. *The Absolute Chronology of the Aegean Early Bronze Age*, Sheffield.

Marinatos, N. 1993. *Minoan Religion: Ritual, Image and Symbol*, Columbia, SC.

Pendlebury, J.D.S. 1939. *The Archaeology of Crete*, London.

Renfrew, A.C. 1972. *The Emergence of Civilisation: The Cyclades and the Aegean in the Third Millennium b.c.*, London.

Sakellarakis, Y., and E. Sakellaraki. 1997. *Archanes: Minoan Crete in a New Light*, Athens.

Seager, R. 1912. *Excavations on the Island of Mochlos*, Boston.

Soles, J. 1992. *The Prepalatial Cemeteries at Mochlos and Gournia and the House Tombs of Bronze Age Crete*, Princeton.

Warren, P.M. 1965. "The First Minoan Stone Vases and Early Minoan Chronology," *Kretika Chronika* 19, pp. 7–43.

———. 1969. *Minoan Stone Vases*, Cambridge, UK.

———. 1972. *Myrtos: An Early Bronze Age Settlement in Crete*, London.

Warren, P.M., and V. Hankey. 1989. *Aegean Bronze Age Chronology*, Bristol, UK.

Xanthoudides, S. 1924. *The Vaulted Tombs of Mesará*, London.

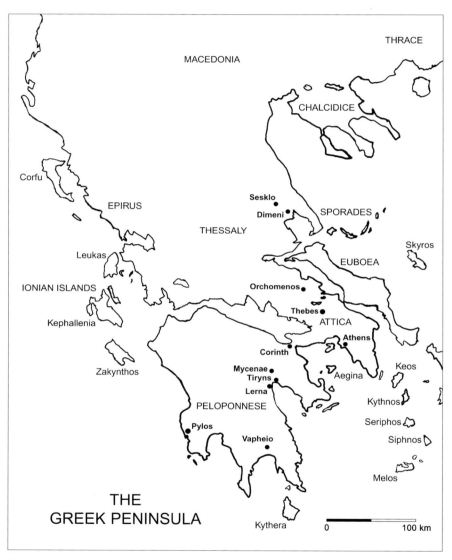

Figure 4.1. Map of Greece.

<div align="right">

4

</div>

The Greek Peninsula in the Early Bronze Age: EH I to EH III

People were already living in Greece during the Paleolithic period, and small groups of settlers probably arrived in the peninsula repeatedly during most periods of antiquity. Many of these people would have been quickly assimilated into the existing cultures while others would have brought new ways of doing things that fundamentally altered the status quo. By the end of the Neolithic period, the Greek peninsula already had hundreds of settlements, both large and small. Greece's domestic economy, like that of its neighbors, was based on growing grains and other crops and on raising livestock. Metals were already being used, and long-distance trade was present as well. The transition to what we call the Early Bronze Age was not marked by any especially sharp break aside from the gradual introduction of new pottery classes.

Unlike Crete and the other islands, the Greek peninsula had easy contact with the north (Fig. 4.1). The ease of land travel between Greece and the southeast parts of Europe meant that many ideas including those presented visually always had at least a little interaction with central and southeastern European towns and cities. For example, one of the most persistent artistic traits in this part of the world was an appreciation of non-objective patterns and designs. This taste was already present in the decoration on Neolithic pottery (Fig. 4.2), and it was never really abandoned in the ancient cultures in this part of the world in spite of strong influences from the figural traditions of Crete, Egypt, and Western Asia. This non-objective tradition would repeatedly emerge in Greece in later

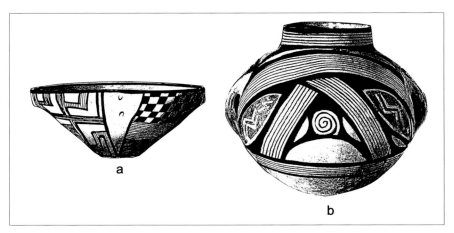

Figure 4.2. Pottery from the Dimeni Culture of Northern Greece: a, ht. 11 cm (4.3 in); b, ht. 25.5 cm (10 in).

times, and after the end of the Bronze Age it would dominate the artistic styles of Proto-Geometric and Geometric Greece.

The Early Bronze Age in mainland Greece has been divided into three stages, Early Helladic I, II, and III (Fig. 1.2). Lerna, a site in southern Greece with a clearly demarcated stratigraphy, has often been used to establish the relative chronology. The site does not have any habitation during EH I, but its later phases are clearly differentiated. Early Helladic II is especially well preserved.

Early Helladic I

The people of Greece at the beginning of the Early Bronze Age used different pottery from their Neolithic predecessors, but they raised many of the same types of crops and tended the same types of flocks and herds. Red polished vases were popular in southern Greece. The earliest houses were sometimes made of perishable materials, but stone and mudbrick soon became the norm for domestic buildings.

Early Helladic II

New foundations in Early Helladic II suggest that residents from outside the region arrived at some of the sites after the close of EH I (near the middle of the 3rd millennium B.C.). The Helladic cultures of EH II participated in the general expansion of technology and trade that occurred

throughout the Aegean at this time. Copper and other metals became much more common, and exchange between regions increased substantially. Large buildings called Corridor Houses that were constructed in several towns suggest civic cooperation for monumental public structures used by entire communities.

Early Helladic III

The disruptions that accompanied the arrival of the Kastri Group in the Cyclades occurred in mainland Greece as well. Some of the sites were destroyed, and new settlements with very different material cultures were laid over the ruins at some places. The towns from the end of the third millennium B.C. used the potter's wheel for the first time, built small houses with rectangular or apsidal ground plans, and did not construct any more Corridor Houses. Many people believe they were the group that would later be called Greeks because this is the last major cultural break before the use of Linear B tablets in the Late Bronze Age (translated as an early form of the Greek language).

Architecture

The well-preserved settlement of EH II Lerna (called Lerna III by the excavators) makes it a particularly good example of the middle phases of the Early Bronze Age in southern Greece. The presence of a large number of sauceboats indicates that the phase was contemporary with the Keros-Syros Group in the Cyclades and with EM IIA in Crete, but whether it persisted until the time of the Kastri Group is uncertain. During the early phases of EH II, Lerna III was a substantial town with rectangular houses and a well-designed fortification wall. It persisted for long enough to have a sequence of several building phases.

The largest and most monumental building of Lerna III was the House of the Tiles (Fig. 4.3), named for its roof covering. This class of building is called a Corridor House after the long hallways at the sides. Generally similar Corridor Houses have been found at several other EH II settlements in Greece, which shows that the architectural expertise that allowed the construction of large buildings was fairly well known during this period. A similar predecessor at Lerna, called Building BG, had been destroyed by fire either in an earthquake or as a result of some other calamity. Like the slightly later House of the Tiles, Building BG was a monumental Corridor House built of mudbrick and timber on stone foundations. During the early

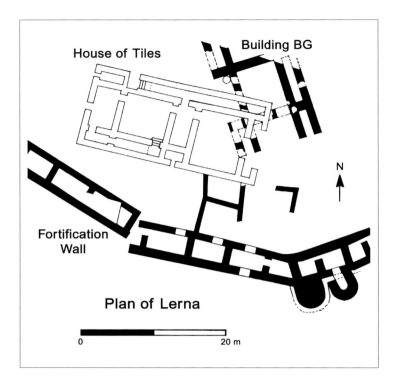

Figure 4.3.
Plan of
Lerna in
EH II.

House of Tiles

Building BG

N

Fortification
Wall

Plan of Lerna

0 20 m

phases of EH II, the town of Lerna and its large public building were sur-rounded by a massive fortification wall with towers at the corners where the construction changed direction.

After Building BG was destroyed, the House of the Tiles was built on a slightly different orientation. The new building was 25 meters long and 12 meters wide (ca. 83 x 40 feet). It had a series of four large rooms in a row with the corridors that give the class its name on the sides. Because the corridors on the two long sides almost certainly held wooden staircases leading to an upper story, one cannot really think of them as ordinary hall-ways. The building had wooden doors and doorjambs, a few rooms with plastered walls, and clay tiles over at least part of the roof.

The House of the Tiles is important as a demonstration of the skill in building practices during EH II. Making the square corners and straight walls required knowledge of some type of surveying, such as sighting along a board with pegs or nails at each end to create a long, straight line, because such precise construction cannot be achieved informally with a building of this size. The roof tiles were fired, which suggests a slightly pitched roof and some expert carpentry. The House of the Tiles was a high point in Early Helladic architecture, and the people who destroyed it and then settled on the site (the next phase is called Lerna IV) could not build

anything like it. They covered the ruins of the House of the Tiles with a mound of soil, placed a ring of stones around the mound, and did not build any later houses on the spot.

The people who built over the ruins of the EH II settlement at Lerna lived in small houses with one or two rooms. Some of their buildings were apsidal (horseshoe-shaped) with the entrance in the straight end. They built no monumental architecture on the scale of Building BG and the House of the Tiles. Because they had less foreign contact, fewer imported objects were present in the town.

The construction of fortification walls is a feature that had clearly developed into a necessary skill by the middle phases of the Early Bronze Age. The examples in Figure 4.4 come from different regions and time periods,

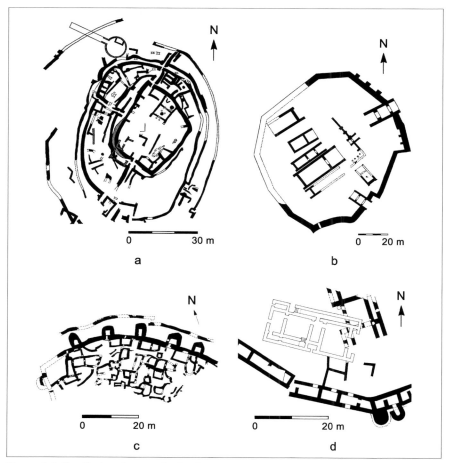

Figure 4.4. Fortified settlements in the Aegean: a, Dimeni, Late Neolithic; b, Troy, Early Bronze II; c, Kastri, Syros, Kastri Group; d, Lerna, EH II.

but they all share several common characteristics. The walls encircle the set-tlement they defend and follow the contours of the hill (some examples are not completely excavated so only sections of the walls have been mapped). Figure 4.4a, from Dimeni, is the earliest of the group. The walls can be assigned to the Late Neolithic period of northern Greece (called the Dimeni Culture after this site). The date is probably well before 3000 B.C. The vari-ous walls shown in this plan of Dimeni probably represent different phases of construction.

Neither this example nor the one shown in Figure 4.4b, which is from Troy IIC (mid-third millennium B.C.), add towers to the exterior face of the walls. Towers are a substantial improvement for defensive systems because they can act as high vantage points from which to observe the countryside and as bases for defenders shooting missiles along the sides of the walls. The town plans from Kastri (Fig. 4.4c) and Lerna (Fig. 4.4d) both show this improvement, although they are not far removed in time from the walls of Troy's Phase IIC. The walls from Lerna (Fig. 4.4d) also have compart-ments inside them that allowed some of the walls to be used as tiny rooms. The system, called a casemate wall, has some advantages over solid walls. First, it creates a thicker wall with less labor than a solid one of the same size would require. Thick walls are useful because the space on top of them can be used both to store missiles and weapons and as a route for defend-ing soldiers to travel along to lend assistance to wherever they are needed during an attack. Also, it provides spaces inside the walls that can either be filled with rubble to add strength or can be used for storage of food, weapons, or other supplies.

Pottery

The pottery of the Early Bronze Age in Greece was all handmade until the arrival of the potter's wheel at the end of the third millennium B.C. Wares were well made and carefully fired, and many local workshops sup-plied their regions with the necessary containers for storage, shipment, table service, and other needs. Although some of the pottery vessels from this period are not what many modern museum curators would regard as art objects, they often had attractive shapes that were enhanced by slips and occasional painted decorations. EH I vases in southern Greece were often unpainted or simply covered with a solid coat of slip.

New pottery styles arrived in southern Greece in Early Helladic II (Fig. 4.5). Pottery surfaces were now often given a slightly lustrous iron-rich slip (sometimes called "urfirnis"). New shapes like the sauceboat (Fig. 4.5a) were probably derived from relations with the people who used the

Keros-Syros Group in the Cyclades. The small bowl with a slightly inturned rim (Fig. 4.5b), a shape that was also typical of this period, was probably a vessel used for serving food. Painted bands were only used occasionally (as on the small jug in Figure 4.5c).

The sauceboat (Fig. 4.5a) was the premier vase for this phase. It was widely distributed on the Greek mainland, and it died out at the end of the EH II period. The form had a number of sub-varieties. Handles were either horizontal or vertical, and the spout could be taller or lower, but the shape was always sleek and elongated with the spout pulled out of the rim and raised above its top. Sometimes the tips of the spout were slightly flared for added interest.

The repertoire of vessel shapes changed in the next period. As the artifacts in the Kastri Group spread across the Cyclades and reached a number of sites on the mainland, particularly on the east coast of southern and central Greece, new types of pottery were introduced. Some of the most important changes in vessel shape were in the classes with vertical handles and open mouths, which are designs used for drinking. The new drinking cups included the two shapes shown in Figure 4.6, both of which have Anatolian parallels.

The depas from Orchomenos in Greece (Fig. 4.6b) is shown alongside an Anatolian example from Troy (Fig. 4.6a). The shape is well suited to feasts where the drinking of a beverage like wine is a necessary part of the social ritual. The cup can be filled by the host and handed to the guest who must immediately drink the entire amount before the vase can be set down because it has no base, so it can only lie down on its side. The one-handled tankard is too small to be a pouring vessel for cups like the depas, and it was probably used for drinking as well.

The pottery from the end of the millennium included a number of new forms including pieces made on the potter's wheel. The most interesting examples of the new vessels were fired solid gray with no paint of any

Figure 4.5. Clay vessels from Lerna. EH II. Scale 1:6.

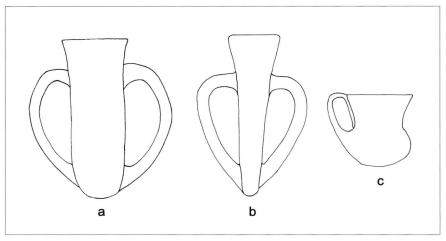

Figure 4.6. Kastri Group vases: a, depas from Troy; b, depas from Orchomenos; c, tankard from Orchomenos. Not to scale.

kind. They may be the ancestors of the Gray Minyan Ware of the Middle Bronze Age, a class that eventually developed into the fine ceramics of the Mycenaean Greek states during the Late Bronze Age.

Other Arts

The Early Helladic cultures of the Greek peninsula enjoyed a very different artistic tradition from the one that was present in the Aegean Islands. The emerging aesthetic attitudes on the mainland favored non-objective patterns rather than the depiction of the human figure, so (although small sculptures are not completely missing) no local Helladic equivalent exists for the long series of elegant marble figurines from the Cyclades.

This mainland taste is well illustrated by a series of sealings found at Lerna. A sealing is a lump of clay pressed over the latch of a door or the cover of a box or some other container and then completed by pressing a carved seal into its surface. Because the seal can have a unique emblem that represents one person, an image that stands for an office, or a design that signifies the ruler or whatever else is desired, seals had an extensive use in the periods before good mechanical locks were invented. When the clay of a sealing dries, the closed space cannot be opened without breaking apart the dried clay. Items sealed in this way are best secured when a guard is also posted nearby because the intact seal only shows that the contents have not been tampered with, and it does not physically prevent anyone from opening the item.

Among the artifacts found in the excavation of the House of the Tiles was a large deposit of clay sealings (Fig. 4.7). All of these small pieces of clay were broken and left nearby when the items that they sealed were either brought to the building, inventoried there, or sent out of it. The implication is that the people in charge of the House of the Tiles were using the building to receive something like taxes or trade goods, or they were safely keeping commodities that were later disbursed out to those who needed them. Whatever the exact situation was, the presence of the sealed containers shows that Lerna (and probably a number of its neighbors) had local governments that were interested in controlling access to items stored in a series of rather monumental buildings.

The Corridor Houses must have been used for communal activities. In terms of architectural symbolism, they will have dominated a town psychologically as well as physically. The conclusion that the House of the Tiles was an official building is important for the interpretation of the sealings because it means that the seals used there were official art, designed for the elite members of the Lerna community.

Some of the designs from the sealings found in the House of the Tiles can be seen in Figure 4.7. Because the original seals were probably carved out of wood, they do not survive. Sometimes several seals were pressed into the wet clay of a single sealing, suggesting that more than one individual was present when the transaction was accomplished.

The designs are interesting because of their variety. They are mostly composed of long, continuous lines that form designs ranging from fairly simple to quite intricate. Symmetrical compositions seem to be favored. Because of their curved outside contours, the motifs fit nicely onto their circular fields, which suggests they were planned as emblems for these particular round seals instead of being borrowed from some other art form on a differently shaped object.

Early Helladic elite art also included some vessels made of gold and other metals. Most examples were in shapes that were also made in clay,

Figure 4.7. Designs on sealings from the House of the Tiles at Lerna. EH II. Not to scale.

and one of the finest of them is the sauceboat shown in Figure 4.8. The vase came from southern Greece at some time before 1929. It was manufactured from a large sheet of gold.

The sauceboat design is especially common in clay, but it seems unsuited to this material because of the difficulty of making the long spout. Perhaps it was copied from originals made in other materials. Gourds with long necks could have been cut to make vessels with this shape, though no actual examples survive, and metal originals are another alternative.

For the example in Figure 4.8, the sleek shape was hammered out of a single sheet—the base was not attached separately but was seamlessly made out of the same piece used for the rest of the body (a technique also known from Western Asia including from as far away as the Royal Tombs of Ur in Mesopotamia). The ancient use for this attractive shape is not really known—it could be a pouring vessel, a drinking cup, or a container for something else. Whatever its purpose, the sauceboat was used in large numbers at Lerna and elsewhere.

Comments

During the third millennium B.C., the settlements of the Greek peninsula advanced from small villages to substantial towns. In EH II, they were already on the eve of more complex developments like state formation, and they had monumental public buildings, large-scale storage, and administration of commodities controlled with individualized seals. This development was interrupted by the phenomenon we call the Kastri Group. Opinion is divided on whether this episode in Aegean history represents an

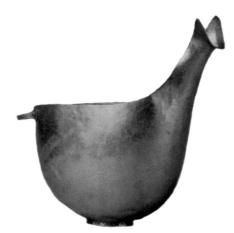

Figure 4.8. Gold sauceboat from southern Greece. EH II. Length including handle 15.5 cm (6.1in).

invasion by many small groups of newcomers or a simple expansion in trade with Anatolia that brought in new technologies and new ideas as well as new products. Whatever the exact explanation, the process took many decades. It resulted eventually in widespread changes in settlement patterns with abandonment of some sites and changes at others. The final years of the Early Bronze Age and the opening centuries of the Middle Bronze Age were a time of consolidation in mainland Greece when foreign contact declined somewhat (though it never ended), and the ideas that would emerge at the end of the Middle Helladic period had time to develop. By the end of the Bronze Age, this region whose history had begun in such a humble way would dominate the entire Aegean.

Further Reading

Alram-Stern, E. 2004. *Die Frühbronzezeit in Griechenland mit Ausnahme von Kreta (Die Ägäische Frühzeit, 2 Serie: Forschungsbericht 1975–2002, 2.1).*

Barber, E.J.W. 1991. *Prehistoric Textiles: The Development of Cloth in the Neolithic and Bronze Ages, with Special Reference to the Aegean*, Princeton.

Blegen, C.W. 1963. *Troy and the Trojans*, London.

Blegen, C.W., and J. Haley. 1928. "The Coming of the Greeks," *American Journal of Archaeology* 32, pp. 141–154.

Caskey, J.L. 1960. "The Early Helladic Period in the Aegean," *Hesperia* 29, pp. 285–303.

———. 1968. "Lerna in the Early Bronze Age," *American Journal of Archaeology* 72, pp. 313–316.

Cavanagh, W., and C. Mee. 1998. *A Private Place: Death in Prehistoric Greece*, Jonsered.

Dickinson, O. 1994. *The Aegean Bronze Age*, Cambridge, UK.

Krzyszkowska, O. 2005. *Aegean Seals: An Introduction*, London.

Manning, S.W. 1995. *The Absolute Chronology of the Aegean Early Bronze Age*, Sheffield.

Rutter, J.B. 1979. *Ceramic Change in the Aegean Early Bronze Age*, Los Angeles.

———. 1983. "Fine Gray-Burnished Pottery of the Early Helladic Period: The Ancestry of Gray Minyan," *Hesperia* 52, pp. 327–355.

———. 1995. *Lerna* III: *The Pottery of Lerna IV*, Princeton.

———. 2001. "Review of Aegean Prehistory II: The Prepalatial Bronze Age of the Southern and Central Greek Mainland," in T. Cullen, ed., *Aegean Prehistory: A Review*, Boston, pp. 95–147.

Schachermeyr, F. 1976. *Die ägäische Frühzeit*. I. *Die vormykenischen Perioden des griechischen Festlandes und der Kykladen*, Vienna.

Theocharis, D.R. 1971. *Prehistory of Eastern Macedonia and Thrace*, Athens.

Vermeule, E. 1964. *Greece in the Bronze Age*, Chicago.

Warren, P.M., and V. Hankey. 1989. *Aegean Bronze Age Chronology*, Bristol, UK.

Weinberg, S.S. 1969. "A Gold Sauceboat in the Israel Museum," *Antike Kunst* 12, pp. 3–8.

Weingarten, J. 1990. "Three Upheavals in Minoan Sealing Administration: Evidence for Radical Change," in T. Palaima, ed., *Aegean Seals, Sealings and Administration* (*Aegaeum* 5), Liège, 1990, pp. 105–120.

Wienke, M.H. 2000. *Lerna* IV: *The Architecture, Stratification and Pottery of Lerna III*, Princeton.

Zervos, C. 1962–1963. *Naissance de la civilization en Grèce*, 2 vols., Paris.

5

The Minoan Palatial Periods: MM IB to LM IB

During the long period of stability between Middle Minoan I and the first stage of the Late Bronze Age, the people of Crete developed a palatial civilization with written records, monumental stone buildings, and an organized bureaucracy. The people in charge of the palaces were patrons of the finest art, encouraging the development of monumental wall paintings, fine sealstones, and a long series of beautiful creations in many media. These developments took several centuries, and the finest pieces come from the end of this long period. The stability was periodically punctuated by destructions (either from earthquakes or from war or from both), but the society always managed to recover. Especially severe destructions during MM III destroyed the Middle Bronze Age palaces, but they were followed by the construction of new palaces in MM IIIB. The beginning of Late Minoan was interrupted by the eruption of the volcano of Thera, an event that occurred in the middle of LM I. The catastrophe was accompanied by earthquakes and perhaps by the sea waves called tsunamis that did not end the Minoan culture by any means but still marked a pause that can be documented in the archaeological record. Widespread destructions at the end of LM IB marked the end of the period.

Writers who study the Bronze Age have divided this long palatial period in two ways. Pottery changes allow a sequence of pottery periods called Middle Minoan I, II, and III (with subdivisions of A and B for each one) followed by Late Minoan I, also divided between A and B (Fig. 1.2). The eruption of Thera comes at the end of LM IA. Most scholars accept this

subdivision, but some of them also speak in architectural terms with the Protopalatial period lasting from MM IB to the end of MM IIIA and the Neopalatial period beginning in MM IIIB and ending in LM IB.

Architecture

Cretan palatial architecture provided rooms for the royal elite, the scribes, the craftsmen and craftswomen, the humble workers, and everyone else needed to manage a complex small state. Because the architects who built the palaces at Knossos, Phaistos, and Malia in MM IB began by leveling the sites and removing everything from the previous town to make way for the new construction, little survives of the immediately preceding buildings. Early levels have also not been excavated at the other palaces at Zakros or Chania, but the monumental architecture of the Middle Bronze Age could not have been invented all at once; predecessors must have existed somewhere even if we have little or no knowledge of them.

Although the palaces are all best known by their later phases, they were constructed in MM IB. They were all built around central courts. Materials included rubble, stones left pretty much as they were quarried, fine rectangular blocks cut to exact shapes (called ashlar masonry), wood, plaster, mudbrick, and even materials like cane, brush, and different types of clay that could be used in roofs. The building projects involved the mastery of many different skills because the stones needed to be quarried, transported, cut to size as needed for particular types of rooms, and finished with inner and outer surfaces. The buildings were made with great skill, and some of them were two or more stories high. Although only limited evidence survives for the appearance of windows and upper floors, representations in art like the Town Mosaic (Fig. 5.1) have provided good information on these details. Windows were sometimes divided by wooden grates, and timbers

Figure 5.1. The Town Mosaic, from Knossos, small faience plaques illustrating Minoan buildings with more than one story and with flat roofs, probably originally inlays on an object made of wood. MM II to LM I. Ht. of tallest building 5 cm (2 in).

were often allowed to extend beyond the walls in order to make the exteriors more attractive. Roofs were always flat.

The economic support on which the palaces depended is very easy to understand. Knossos, the largest of the monumental structures built around rectangular courts, is within one of the most fertile areas in Crete, a landscape of rolling hills that is famous in modern times for its grapes and other agricultural products. Phaistos, in the south, is near the large Mesara plain. Galatas, a somewhat smaller palace between Knossos and Phaistos whose territory was absorbed by some other political unit before the end of Middle Minoan, has the hills and the small plains of the Pediada region for its hinterland. Malia is on the coast far enough east of Knossos to have its own territory, and the same can be said for Gournia and Petras, which lie even farther east. Zakros, at the extreme eastern end of Crete, has less good land than the others, and it may have depended more on trade. Chania, in the west, had an abundance of good farmland. The usual situation, with a palace situated where it could take advantage of land for farming and herding, indicates that an agricultural economy was the principal means of support for the palatial system. During the Middle Bronze Age, all of these regions had their own styles in pottery, but a consolidation of traditions under Knossian influence by LM I has suggested to many people that by then the largest palace probably ruled all of Crete.

The ground plan for the palace of Knossos is shown in Figure 5.2. It occupies 20,000 square meters (about 5 acres). Though most of the surviving walls are those that stood when the building was burned down in LM IIIA:2 (the later part of LM IIIA), many of them had been built well before the destruction so the overall plan can give a general idea of many of the building's features for earlier periods as well. In most cases, only the lower parts of the rooms survive. The numbers on Figure 5.2 are explained below.

1. The West Court was a large open area paved with stone slabs. It was suitable for the gathering of large crowds of spectators, and slightly raised sidewalks across it were surely designed to lead processions, formal visitors, and even casual pedestrians to the palace's West Entrance.

2. The West Entrance, a room with a wide doorway whose lintel was supported by a column, provided a way into the building from the west.

3. The Procession Corridor was a long hallway whose walls were painted with a procession of life-sized human figures marching south. This corridor turned east at the corner of the building and led to the south side of the Monumental Doorway leading to upstairs rooms.

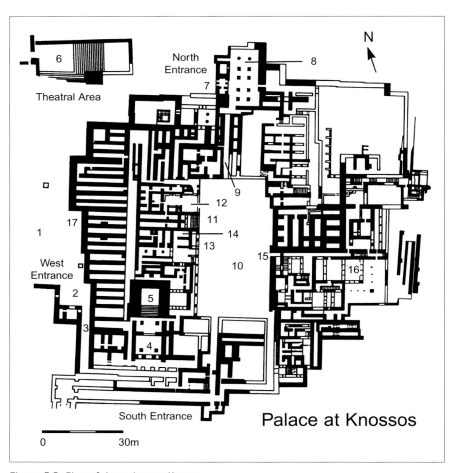

Figure 5.2. Plan of the palace at Knossos.

4. The Monumental Doorway must have been the most important way to enter the official reception rooms that were on the upper floor above the west side of the palace. These chambers do not survive (only the walls of the ground floor below them can be seen today). The Monumental Doorway is an important architectural feature because of its long later history. Its plan is shaped like an "H" with the cross-bar broken by an entrance, thus creating two covered porches, one inside and one outside the doorway.

5. A stairway led to the missing upper floor rooms.

6. The Theatral Area northwest of the palace was approached by a paved road (called the Royal Road) that ran along the western side of the West Court. The Theatral Area consisted of a paved

rectangular space with stone seats along two of its sides. It would have been a good place for ceremonies that did not require great masses of people as the audience.

7. At the north of the palace was an entrance that led into the Central Court (no. 10, below). Entering here allowed visitors to go up a ramp (no. 9, below) to the courtyard.

8. The Pillared Hall served as a support room and kitchen for a large rectangular hall on the upper story. The upstairs room whose floor was supported by the columns is thought to have been a dining room. Its large space would have permitted giant banquets where feasts could have been served to many guests.

9. The North Entrance Passage was a ramp leading up a slight incline to the higher elevation of the Central Court. An open portico on the west of this ramp, partly reconstructed in concrete, provides a good view of the typical Minoan columns (which were wooden) whose upper ends are larger in diameter than the bases (Fig. 5.3). The tree's trunk was placed upside down from how it grew. This position allowed extra floor space, gave a wider surface to support the lintel, and allowed the best wood at the base to resist absorption of moisture that might seep in from below (as the wood just above the roots is not always as good as higher on the tree).

10. The Central Court must have been the center of activity for every Minoan palace. Everyone would meet here: old and young, elites and commoners, merchants and customers, local people and visitors. The space would have provided room for crafts, daily chores, official meetings, and serious religious or governmental ceremonies.

Figure 5.3. The reconstruction of the North Entrance to the palace at Knossos.

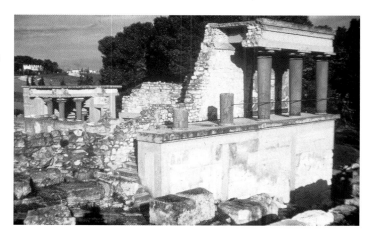

11. A stairway to the upper floor on the west side of the courtyard provided a way to reach the important rooms on the upper floor above the western side of the palace.

12. The Throne Room complex consisted of a suite of several chambers. The final form is what was standing in LM IIIA:2, but earlier architecture may have been generally similar, at least by the beginning of the Late Bronze Age. An anteroom with a base for a chair or throne on the north side could be entered from the courtyard. The next room had a gypsum throne against the north wall and a rectangular sunken area (called a lustral basin or an adyton) at the south. Griffins were painted on the walls in the final phase of the room. Inner rooms and tiny adjoining spaces were probably also used for whatever ceremonies took place in this complex. Whatever they were, the ceremonies must have been semi-private because the space was too small for more than a couple of dozen visitors.

13. The Tripartite Shrine Facade was a space whose foundations suggest a three-part division for the architecture facing the court. It was probably related to the religious and ceremonial functions of this part of the palace.

14. The Temple Repositories were rectangular boxes cut into the floor of a small room. They were found filled with an interesting deliberate deposit consisting of intact offerings of pottery plus broken and incomplete figurines and plaques, actual marine shells (many of them painted), and other objects, some of them made of faience. The faience female figurines that are often called Snake Goddesses were among these objects (see pp. 95–98). The underground pits were filled at the end of the Middle Bronze Age, and the room above them was built to hold two somewhat smaller rectangular boxes (found empty). The deposit is the result of a ceremony in which broken objects were gathered and carefully buried, but the evidence does not indicate whether the objects were broken in a catastrophe like an earthquake or deliberately smashed in the ceremony itself.

15. The Grand Staircase was a U-shaped stairway leading down from the level of the court to rooms built within a cutting at the east side of the hill. The land sloped down toward the east away from the Central Court at this point, and the builders cut into it even more in order to construct lavishly decorated rooms that were carefully insulated from the weather; they would have been cool in summer and warm in winter. These residential spaces, the finest ones in the whole palace, were surely built for the royal family.

16. The Hall of the Double Axes, named after incised mason's marks on some of the stone blocks used to construct the room, was part of a set of three rooms arranged with an east-west orientation. The eastern room had a solid north wall with the other three walls pierced by several doorways. An L-shaped colonnade and a terrace were at its east and south. The center room, to the west, shared a pierced wall (called a pier-and-door partition wall) with the eastern room, while its western side consisted of a pair of columns with a light well beyond them. A light well was a typical Minoan architectural feature consisting of a small rectangular room open to the sky and sometimes surrounded by more than a single story of rooms. Its purpose was to allow air and light to enter ground floor interior rooms, but in this case it also helped create ventilation for the entire complex. Air in the light well would have risen during hot weather, pulling in breezes from the cool, shady eastern side of the palace, and the doorways in the pierced walls could be opened or closed or partly closed depending on how much breeze was desired.

17. The West Magazines were ground floor storerooms at the west of the palace. During the Middle Bronze Age, they had rectangular boxes in the corridor floors as well as room for clay jars to hold the food and the other items needed for this large establishment. By the Late Bronze Age, very large jars called pithoi (singular: pithos) were used to hold oil and other products.

The palace at Phaistos was in south-central Crete (Fig. 5.4). Several of its details were very similar to those used at Knossos, and it was also built around a central courtyard. It covered 8,400 square meters (about two acres). Like Knossos, it had a Middle Bronze Age phase (the Protopalatial period) followed by a new construction that began to be used about MM IIIB (the Neopalatial period). The numbered spots in Figure 5.4 are described below.

1. The West Court was a paved area suitable for large groups of people. Two levels of paving were discovered there, a lower one associated with the Middle Minoan palace and a higher court for the newer palace constructed after the earlier one was destroyed by earthquake at the end of MM IIIA (visible at the right of Fig. 5.5). The Middle Minoan palace was larger than the later one, and the new paved court covered some of its rooms at the west.

2. The Grand Staircase led up from the West Court to provide an impressive way for visitors to approach important rooms on the

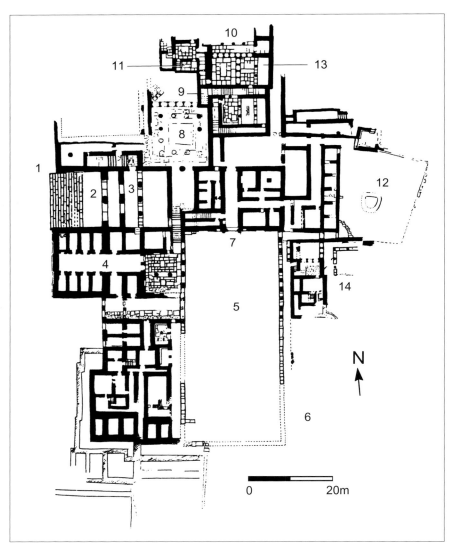

Figure 5.4. Plan of the palace at Phaistos.

upper story (Fig. 5.5). To its north, a second set of steps formed a right angle and created a Theatral Area where an audience could sit or stand and watch ceremonies or other activities in the West Court (not shown on the plan).

3. The Monumental Gateway was a sequence of small rooms with doorways defined by columns and pillars. The rooms east of here are not preserved at the upper floor level, and the walls on the plan are low, first floor walls from the space below the upper story.

4. Storage Magazines consisted of two rows of small storerooms on the ground floor with a hallway between them to provide easy access. The rooms above them are not preserved.

5. Although the Central Court originally had rooms all around it, they are now only preserved on two and a half sides.

6. The southeast corner of the palace has eroded down a slope.

7. The North Facade was at the north of the Central Court. It included the bases of pillars that flanked its central doorway.

8. The Interior Garden had a peristyle of columns around all four sides. It was on a high spot on the Phaistos hill above the level of the Central Court, the residential area to the north, and the area between them.

9. A staircase led down from the garden to luxurious rooms on the north side of the palace.

10. The Northern Residential Area consisted of rooms with pier-and-door partition walls leading to shady terraces at the north. During hot weather the sunshine in the Interior Garden would have caused the air inside it to rise, drawing a breeze up the staircase and creating a cool, well-ventilated series of rooms at the north side of the palace.

11. A lustral basin (adyton), a small sunken rectangular basin of unknown use (but probably for some type of ceremony), was associated with this residential area.

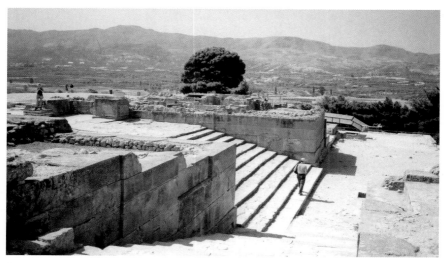

Figure 5.5. The entrance to the palace at Phaistos as seen from the top of the stepped area that forms the north side of the Theatral Area.

12. A furnace with traces of intense fire was in a small open court at the northeast. The purpose for the furnace is not known (its shape is not like metallurgical or pottery establishments known from other sites, and it may have been for lime production or for some other use).

13. A light well was an unroofed space used to admit ventilation and light into the building.

14. Residential quarters were at the east side of the Central Court.

The palace at Malia was on the northern coast east of Knossos. Its natural hinterland was the Pediada, a region of fertile, rolling hills south of the coast. The Middle Bronze Age phase was destroyed and then rebuilt about the same time as the palaces at Knossos and Phaistos. It occupied 7,500 square meters (about 1.85 acres). Like the palaces at Knossos and Phaistos, Malia was unwalled and surrounded by a large city (Fig. 5.6). The numbered places are defined below.

1. The South Entrance consisted of a vestibule leading directly into the southwest corner of the Central Court.

2. The Central Court, a paved rectangular open space oriented north and south, was the principal public area for the building.

3. Small rooms at the north of the west side of the Central Court may have been used for cult purposes.

4. Stairs on the west side of the Court led to an upper story where important rooms were located.

5. The Pillar Crypt had a ceiling supported by pillars built of stone blocks with several incised mason's marks.

6. The West Magazines were long ground floor rooms used as storage spaces.

7. Eight granaries were located at the southwest corner of the building.

8. A large room called the Pillared Hall had its ceiling supported by six pillars.

9. At the Central Court's northeast, a U-shaped staircase must have led to a large room above the Pillared Hall, which was probably a spacious dining area suitable for a large number of guests.

10. The North Entrance led directly into the northeast corner of the Central Court.

11. The East Magazines consisted of six long rooms opening on the east to a north-south corridor providing access to them.

12. Elegant rooms at the northwest of the palace built of squared stone blocks (ashlar masonry) and ventilated with pier-and-door partitions must have been the royal residential quarters.

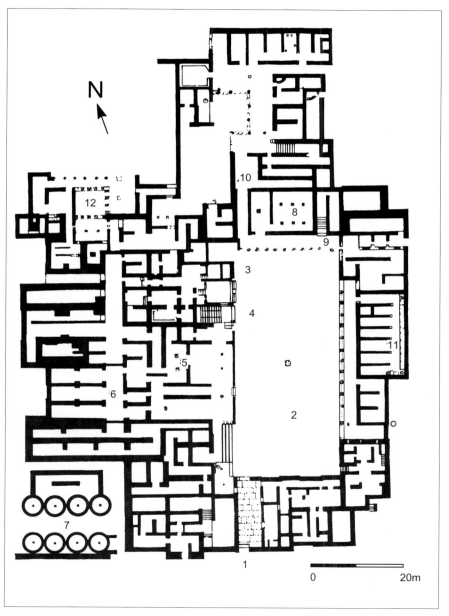

Figure 5.6. Plan of the palace at Malia.

The concept of using a central open space as a common area within an urban setting was one of the important contributions to world architecture that had an early development in Minoan Crete. Town squares and central courtyards were integral parts of Minoan building practices. By providing a place for the human interaction that was so important for urban cooperation, the courtyard allowed the palace to function like a miniature city.

Towns were around all the palaces, and smaller communities also existed. A good example of a Minoan town is Gournia (Fig. 5.7), located near the north coast east of Malia. The excavated area covers 25,000 square meters (about 6 acres). Its earliest residents moved there during the Neolithic period, and the settlement gradually increased in size. By LM IB, it had a substantial number of houses surrounding a modest palace that copied a few details from its grander neighbors. Paved streets between the blocks of buildings became staircases where the slope was steep. The numbered points in Figure 5.7 are discussed below.

1. The East Ascent, a roadway that used stone steps along part of its course, provided access from the east to the Public Square from Valley Road (no. 2, below).

2. Valley Road was a long paved street at the east side of the town.

3. The Public Square would have provided space for markets, festivals, or other public gatherings.

4. A small set of steps that formed an angle might be regarded as a small Theatral Area, and it also led from the Public Square into the palace.

5. The palace at Gournia (Fig. 5.8) used squared stone masonry. Only the lower parts of the ground floor rooms survive, and the important spaces must have been upstairs.

6. Storage rooms included an almost square chamber found with tall jars (pithoi) around the walls. Long, thin magazines were immediately to its west.

7. West Ridge Road led around the town at the west.

8. The Shrine was added to the town in LM III. It was a small room with a bench across the east wall where clay figurines of goddesses with upraised hands and tall cylindrical stands with religious symbols on them were used in the ceremonies (see Ch. 9, pp. 191–193).

9. The North Trench was a dump for pottery from EM III to MM IA (placed here after a destruction in the town).

10. East Ridge Road conducted traffic between the blocks of houses at the center of the town.

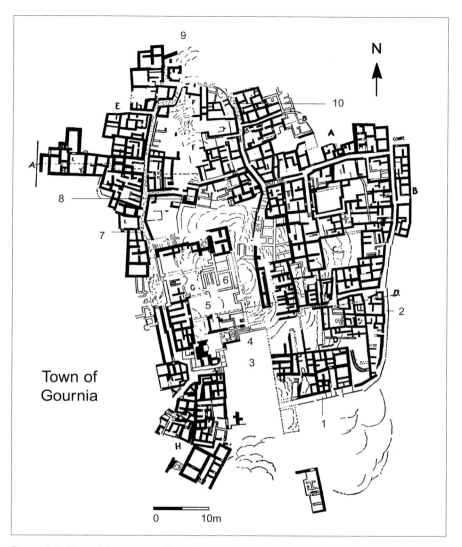

Figure 5.7. Plan of the town at Gournia.

Minoan houses were all different from one another. Each one was constructed to suit the needs and desires of those who would live in it, and building practices were adjusted to any topographic challenges provided by the choice of site. Although houses were sometimes built in the countryside, most people preferred to live in towns or villages and walk out to their fields to work. Foundations were always of stone, walls were of stone or mudbrick, and roofs were flat. Most houses had several rooms, and upper stories were common.

Building AM at Pseira, also called the House of the Three Buttresses, is a good example of a modest Minoan house in a medium-sized town (Fig. 5.9). Pseira, a seaport built on an offshore island near Crete's northern coast, had an abundance of good stone, so it was the preferred local building material. Houses were often constructed on more than one terrace because of the steep slopes on the peninsula near the harbor.

The House of the Three Buttresses had only four rooms on the ground floor. The entrance at the east, easily recognized by its well-worn threshold block, led into Room AM 4/5 from the street where a small paved court (AM 1) with a bench would have provided a shady spot to sit during the afternoons. Rooms AM 4/5 and AM 7 were on the terrace where the street was located, while the other two rooms were lower down the slope of the hill so one could walk out of the ground floor of AM 4/5 into the room or porch above Room AM 6. The building site caused some construction problems for the builders because it sloped down steeply in two different directions, toward the south and toward the west. At the south, an earlier house named AD North already existed, and its northern wall with its three buttresses provided enough support to hold up the fill needed to make a level floor in Room AM 4/5. For the western slope, the builders used an extra wall (between AM 4 and 5) to support the deep fill of soil. These different construction methods solved the problem successfully and resulted in a solidly built structure.

Minoan Crete also had some more specialized architecture. Figure 5.10a is a small shrine building located inside a sacred cave near Amnissos, a seaport

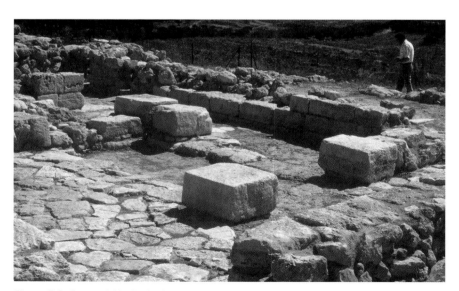

Figure 5.8. Squared blocks (called ashlar) in the small palace of Gournia. LM I.

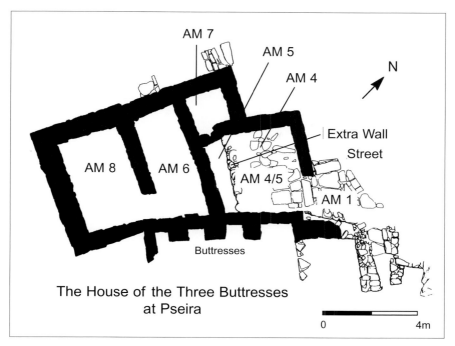

Figure 5.9. Plan of the House of the Three Buttresses (Building AM) at Pseira. LM IB.

on the coast northeast of Knossos. The structure is built around a pair of stalagmites. The cave has often been identified with a cavern dedicated to a Minoan goddess named Eileithyia who was mentioned by Homer in the *Odyssey,* though little solid evidence survives to prove this association. An open space that could have held a crowd of worshippers is in front of the building (southeast of the drawing in Fig. 5.10a), but the structure itself is too small for a large group because even the largest room is only about two meters across (between six and seven feet). The little shrine, about 3 by 4 meters in size on the exterior (ca. 10 x 13 ft), illustrates a principle called the bent-axis approach. Unlike the religious architectural traditions of Classical Greece, Rome, and many modern religions where visitors proceed directly from the exterior of a religious building through a centrally located doorway to an altar or some other focal point that is directly before the worshipper, Minoans did not approach their important locations directly. For this little building, the side of the cave at the east forced whoever wished to enter the shrine to walk along its east side and make a sharp degree turn to the left, then make another left turn and, walking around the two stalagmites in the interior, end up in the most private space by this winding, spiral route. We have no idea what took place here, but the structure was certainly too small for anything except a small private ceremony involving no more than two or three people.

Figure 5.10. The bent-axis approach in Minoan ceremonial buildings: a, building inside the Amnissos cave; b, MM II shrine at Malia.

The same approach was used for other special buildings like the small Middle Minoan shrine from Malia illustrated in Figure 5.10b. A roadway at the south forced the visitor to make a right angle turn to the left to enter an anteroom (no. 1 in Fig. 5.10b), and from here additional turns had to be made to reach the more private chambers (nos. 2 and 3). Among the special objects in this shrine were a bench, offering stands, and objects decorated with religious symbols. The bent-axis approach was used regularly in Minoan buildings, even the palaces (note its use in the route that goes from the West Entrance at Knossos to the main staircase leading up to the important rooms upstairs above the western side of the palace, Fig. 5.2, nos. 2–5).

Pottery

The system used for the decoration of EM III to MM IA pottery—a solid coat of dark slip all over the pot with the decoration added over the slip in white—was the foundation for the finest styles of the Middle Bronze Age. Beginning with fairly simple designs at the start of the period, the potters gradually increased both the complexity of their motifs and the sophistication of their compositions. By MM IIB, about the 18th century B.C., vases were expertly made on the potter's wheel and then finished with elegant effects of whirling designs and balanced but opposed elements. This pottery is called Kamares Ware (Fig. 5.11).

Many of the vessels have designs that were inspired by the floral kingdom, but they were simplified and made more abstract than their inspirations in nature. Leaves, flowers, buds, curved vines, and other floral elements were first reduced to lines or to flat areas of color. Contour, especially curved contour, was emphasized. The flat elements were then arranged into designs that emphasized curved lines, and often the individual motifs were joined together so that they flowed across and around the body of the vase until they were blocked by another design that balanced the first one. The effect created by such a design that leads the viewer's eye around the volume of a three-dimensional vase is called torsion. It has a psychological relation to the rotary motion of a vessel as it turns on the potter's wheel as if the act of making the pot can have an echo in its decoration.

The example of Kamares Ware illustrated in Figure 5.12 comes from Knossos, although it might have been imported into the northern palace from a workshop in the Mesara. The vase has two horizontal handles and a small spout at the rim. It demonstrates many of the characteristics of Kamares Ware, as its decoration, much of it inspired by leaves and tendrils, spreads across the surface to create an overall design of considerable complexity.

The finest pieces of Kamares Ware were made in the palaces at Knossos, Phaistos, and Malia. Other workshops provided products that were not always so artistic; in fact, the Middle Minoan pottery of Crete was far from uniform across the island. In addition to Kamares Ware, Cretans used vases with simple white or white and red decoration over the dark background, and sometimes the same dark slip used for the overall coating on Kamares Ware was used for the decoration itself.

After the destructions that ended MM IIB, potters began exploring some new ideas. Many of the vases from this period were decorated more simply than in MM II. Especially in Central Crete, the elaborate and painstaking motifs of the previous period were abandoned in favor of simpler designs, especially large white spirals. Why did the elaborate style of

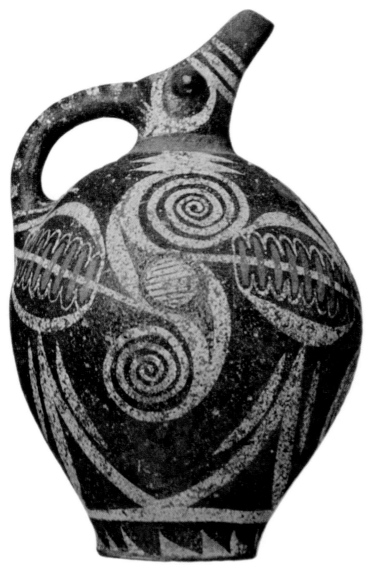

Figure 5.11. Kamares Ware jug from Phaistos. MM IIB. Ht. 27 cm (10.65 in).

Kamares Ware end? As always with rapid and fundamental stylistic changes, the causes are elusive, but it is not only the decoration that changed—many MM III vases were poorly fired with paint that flaked off easily, and the shapes were thick-walled and less carefully fashioned than in MM IIB. Were the most talented artists lured away by the rapidly emerging art of wall painting being used for the recently built new palaces?

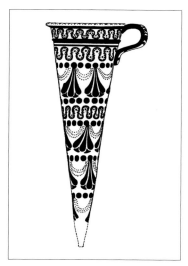

Figure 5.16. Conical rhyton from Palaikastro (Floral Style of the Special Palatial Tradition). LM IB. Ht. 34.2 cm (13.5 in).

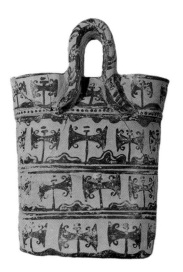

Figure 5.17. Basket-shaped rhyton from Pseira (Alternating Style of the Special Palatial Tradition). LM IB. Ht. 19.8 cm (7.8 in).

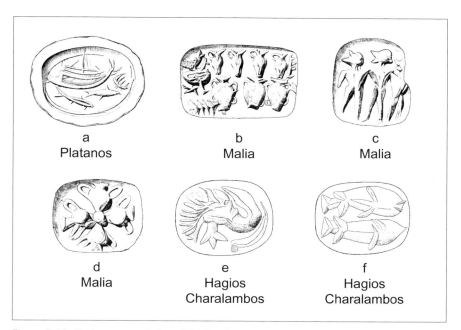

a
Platanos

b
Malia

c
Malia

d
Malia

e
Hagios Charalambos

f
Hagios Charalambos

Figure 5.18. Designs on seals from Middle Minoan Crete.

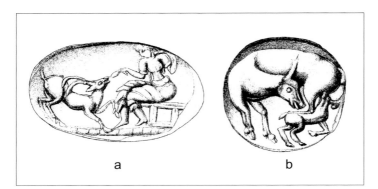

Figure 5.19. Designs on sealings from Chania. LM IB.

a b

grapes. If we may believe the artistic representations like the one on this small seal, the ships that carried these goods were now broader to carry more cargo, and they used sails.

Other seals from early in the Middle Minoan period reveal additional expanding interests. A seal from Malia (Fig. 5.18b) illustrates either a pottery workshop or a storeroom filled with jugs and jars. Rows of vessels lined up for transport or storage were common enough to inspire seal-cutters like those who made this seal and the one shown in Figure 5.18d. Human figures (Fig. 5.18c), animals (Fig. 5.18e, f), and other designs were also added to an increasingly long list of subjects suitable for representation on seals.

By LM IB, the production of sealstones had become a major art form. The seal cutting industry was attracting some of the finest artists of the time. The workshops were able to use hard stones in the quartz family including a long list of semiprecious gem materials: carnelian, banded agate, transparent rock crystal, amethyst, and others. Emery powder and a drill that could be moved as it ground into the stone facilitated the making of complex scenes.

The two images in Figure 5.19 are clay sealings impressed with complicated scenes. They both come from the palace site at Kastelli in the modern city of Chania in western Crete. The seated female figure who feeds a wild Cretan goat is probably a deity because of the platform on which she sits: perhaps she is a goddess of nature who nurtures wild animals. The tender scene of the cow looking toward her suckling calf shows that the seal cutters were capable of expressing emotions and that they dared to attempt complex poses that fit well within a tiny circular field.

The Master Impression (Fig. 5.20) also survives only as an imprint in clay from Kastelli, Chania. Its size and shape indicate it was probably made by a gold seal ring. The regal pose of the man brandishing a staff on top of a city is a good symbol of power, though whether he is ruler or god is not clearly revealed. He stands over his territory with staff extended, dominating a scene that includes the sea and its shore as well as a town of substantial size.

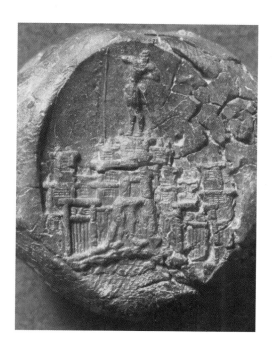

Figure 5.20a. Photograph of the Master Impression from Chania. LM IB to II. Ht. 2.67 cm (1.1 in).

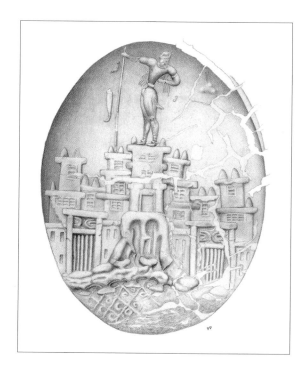

Figure 5.20b. Drawing of the Master Impression from Chania.

Wall Paintings

Minoans were always interested in color. The dark red of hematite was used to paint walls as early as the Early Minoan period. The small villages of Vasiliki and Myrtos, for example, used red paint extensively. The pigment was probably mined locally on the island because hematite, a naturally occurring iron oxide, is found all over the world including on Crete.

More elaborate wall decorations survive from the end of the Middle Bronze Age and the beginning of the Late Bronze Age. Their style is uniquely Minoan, but several of the motifs betray influences from the eastern Mediterranean, especially Egypt. One of the earliest surviving paintings is a panel from Knossos called the Blue Monkeys Fresco (Color Pl. 1A; the scene was nicknamed the Blue Boy before its monkeys were correctly identified). The painting is very fragmentary, but its main subject is clear. Several monkeys are painted in blue and are shown in a landscape setting consisting of blue and yellow irregular sections of rock. Crocus plants, some of them in manmade containers, grow between the rocks. The blue color of the animals is a convention borrowed from Egypt. The background for the scene is the traditional dark red of earlier painted walls, over which the details of crocuses and other plants are painted in white, as on Middle Minoan pottery (Fig. 5.13). The date of the painting has been sometimes regarded as MM IIIA, though it may be a little later. Interestingly, the scene combines landscape elements that hang from the top as well as rising up from the base. The effect is highly decorative, and the scene is somewhat artificial and well removed from the real world.

Although the idea of using paintings to enhance large wall spaces was most likely borrowed from Egypt or somewhere else, part of the painting technique was invented in the Aegean. Egyptian murals, for example, were painted in water-soluble paint on stone or on dry plaster made from mud or from gypsum. The Minoans burned limestone to make quicklime, and they then added water to the quicklime to produce lime plaster, a very durable material that was especially useful in a rainy climate like Crete. By painting on the plaster before it was dry, they produced what is called true fresco (*buon fresco* in Italian). In true fresco, a chemical change occurs as the plaster dries, and the paint is trapped within it so it does not just rest on the surface where it can easily wash away. Although the artists sometimes added paint after the wall was dry, many of the paintings were of true fresco. As a result, they are extremely durable, and they sometimes survive even if they came off the walls and broke into small pieces.

The House of the Frescoes was a well-constructed building near the palace at Knossos. One of its rooms was decorated with an elaborate landscape (Color Pl. 1B). Continuing the tradition that began with the Saffron

Gatherer, the scene showed birds and monkeys within a rocky landscape filled with plants of several types including ivy, crocus, iris, rose, papyrus, lily, and myrtle. The scene was crowded with images, but the artists replaced the red background with white so the plants would appear more successfully. The birds, like the monkeys, were painted in blue. Irregular bands of rocks were depicted as sections of patterned colors, and a blue stream added another detail to establish the riverine setting.

This type of river scene with lush plant and animal life has been called a Nilotic Landscape after the Nile River in Egypt. Such scenes were used in Egyptian tombs as settings for paintings of hunting and fishing that allowed important Egyptian figures to demonstrate their skill in these elite activities, but the Aegean version used the landscape by itself and made the composition more irregular and informal, eliminating the precisely drawn patterns used for the plants in Egypt.

Other types of scenes were also popular. Human figures, some of them life-sized, were shown in a variety of activities. They were especially numerous at Knossos where they decorated many rooms in the Neopalatial palace.

One of the best known of the large-scale figures is called the Lily Prince (Color Pl. 2). The figure, shown in a walking stance, survives only as non-joining fragments. Color Plate 2 shows some of the largest pieces restored as a single figure facing to the left. This image is a three-dimensional plaster relief with a flat background and slightly raised figure. Paint is added over the relief to emphasize the form. As restored, the figure wears an elaborate floral headdress, holds his right arm against his chest, and strides forward leading something (perhaps a bull intended for sacrifice or for "bull leaping" games).

This restoration has been very controversial. The figure wears the abbreviated male costume seen on many other male figures, and the upper torso is male rather than female. Most Aegean paintings use the Egyptian color conventions to distinguish the sexes with reddish brown for men and white for women, but this figure's skin in not as dark as the red background for the scene, so the color conventions do not quite fit here. On the basis of the musculature, some writers have suggested that the fragments should be divided between three different figures with the upper torso facing right and the others facing left. Disputes over the direction the figure faces are seemingly solved by the observation that no black paint is present at the base of the neck on the left where the hair would be for a figure facing right (see M. Shaw in the references at the end of this chapter). With the hair at the right, the figure must be moving left in spite of the full-front upper torso. This does not solve the problem completely, and difficulties still remain. The arm at the viewer's right may have been raised too high to lead a bull, and it is still possible that the headdress goes with another image because the best parallels for such a crown are used with sphinxes

and women. This controversy is a great example of the scholarly dialogue that is so prevalent in the field of Aegean art and archaeology.

Sculpture

Minoan sculptures were created in various sizes, but most surviving examples are fairly small. In general, the style moved from simplified and abstract at the beginning of Middle Minoan to a height of naturalism in LM IB. Sculpture at large scale was made mainly in plaster relief or in perishable materials like wood so the development can be traced most completely from the miniature pieces.

Small clay figurines are known from tombs and especially from peak sanctuaries, which were religious focal points on mountains where worshippers gathered for special ceremonies. The figure of a bull with athletes suspended from its horns from Koumasa (Fig. 3.21) shows the style of sculpture for both human figures and animals at the end of the Prepalatial period.

The Middle Minoan and Late Minoan I style can be seen in several small sculptures including many pieces made of bronze. Figurines made in the lost wax process come from settlements as well as sanctuaries. Human worshippers are especially common in this class, and the example in Figure 5.21, from Tylissos, is typical.

A more dynamic figure is shown in Figure 5.22. The elaborately costumed woman, fashioned from clay, comes from the peak sanctuary at Petsophas near Palaikastro in eastern Crete. A long garment includes a high peak behind the neck, an open bodice, and a thick belt. A fancy hairstyle (or

Figure 5.21. Bronze figure from Tylissos. LM IB. Ht. 24.9 cm; ht. excluding the tenon and base 20 cm (7.875 in).

possibly a hat or headdress) provides an elegant note suggesting the woman is dressed for a special ceremony. Her arms, which are not preserved, were probably raised in a gesture that might mean adoration or prayer. A male figure from the same remote cult site is illustrated in Figure 5.23. The peak sanctuaries were ceremonial centers on mountain tops where the worshippers left a large number of offerings in the hope of receiving help from the gods. This figure, armed with a dagger, has a gesture that may signify prayer or worship.

Toward the end of the Middle Bronze Age, the palatial patrons began encouraging more naturalistic art. A group of figurines found in the Temple Repositories at Knossos provides a glimpse of these new ideas. Among the objects found in this group of symbolic items were faience plaques depicting a cow and a goat with their young, various plants and flowers, inlays from unknown wooden objects, painted seashells, various objects of stone, and pieces of five or six small sculptures of elaborately dressed women. The objects were buried in two rectangular underground pits (the so-called Temple Repositories [Fig. 5.2, no. 14]) along with a large number of intact pieces of pottery.

Two of the female figurines found in this context are shown in Figures 5.24 and 5.25 (the others are too fragmentary to be restored). Both women have floor-length costumes with aprons, elaborate belts, and open bodices that expose the breasts. They hold snakes in their outstretched arms. In

Figure 5.22. Female figurine from the peak sanctuary at Petsophas. MM I to II. Ht. ca. 17.5 cm (6.9 in).

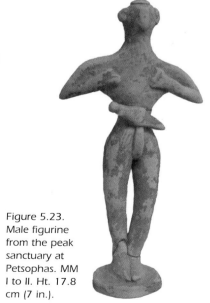

Figure 5.23. Male figurine from the peak sanctuary at Petsophas. MM I to II. Ht. 17.8 cm (7 in.).

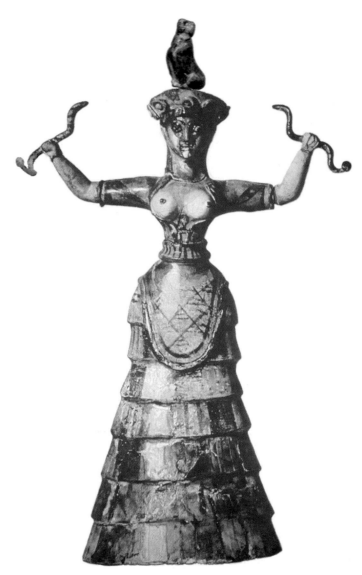

Figure 5.24. Female figurine holding snakes from the Temple Repositories at Knossos. MM III to LM IA. Ht. 29.5 cm (11.6 in).

contrast with the style of earlier times, the women have many more details, and they have specific attributes. The larger figure wears a tall hat and has snakes coiled around her arms. Her slightly smaller companion is restored with a smaller headdress (it does not join because the head is a modern restoration). She holds two snakes in her hands, and a seated cat is restored on her head. Her dress has flounces on it. The flounces, strips of cloth added to what was apparently an outer garment suspended at the waist, seem to show some knowledge of eastern costumes: goddesses and other important figures wore flounces on their clothing in Syria, Babylonia, and elsewhere, and such foreign styles were familiar to the Minoans because they are occasionally illustrated on objects imported into Crete (like the Babylonian cylinder seal shown in Fig. 5.26). This clothing is an early example of a costume that would soon become a major fashion for women in both Crete and other parts of the Aegean.

The elaborate costumes of the figurines demonstrate their elite status in Minoan culture, and they have often been regarded as priestesses or goddesses. In truth, we do not know who the figures were because their details, while surely easily understood by the Minoans, are not clear to those without more knowledge of the society. They were part of an elaborate assemblage of symbolic objects, and it is possible that they were broken deliberately before being placed in the rectangular pits.

The faience used for these Minoan sculptures is another sign of eastern influence. The material, sometimes called Egyptian blue or Egyptian paste, is a man-made substance manufactured from sand, fluxes, water, and copper carbonates. The copper minerals and some of the chemistry in the fluxes leave a deposit on the surface as the water evaporates and the faience dries. Firing the material in a kiln fuses the sand in the body and vitrifies the deposit on the surface to make a shiny coating colored blue by the copper minerals. The Minoan figurines are made of small parts carefully fitted together. They have painted lines on the surface that were applied before the faience dried to make permanent details in black. The technique, which was common in Egypt, must have been imported into Crete.

The sculpture style of LM IB can be studied in large-scale reliefs like the Lily Prince (Color Pl. 2) as well as in miniature pieces. The Harvesters Vase (Fig. 5.27), a carved stone vessel, comes from Hagia Triada, a small settlement just south of the palace at Phaistos. The vase is an ostrich-egg-shaped rhyton carved from two pieces of serpentinite, a dense and easily carved metamorphic rock that can be polished to an attractive sheen. Only the top half of the vase survives. The pierced container depicts a procession of men participating in some unknown festival (not necessarily a harvest in spite of the modern name). One man shakes a

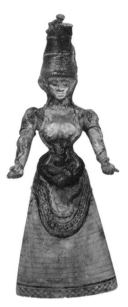

Figure 5.25. Female figurine wearing a high headdress, with snakes coiled around her arms, from the Temple Repositories at Knossos. MM III to LM IA. Ht. 34.2 cm (13.4 in).

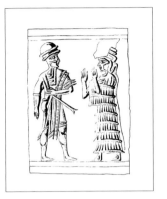

Figure 5.26. Babylonian cylinder seal found at Platanos in Crete. MM I–II. Ht. 2.4 cm (1 in).

sistrum, an Egyptian percussion instrument, and some of his followers have open mouths to show they are singing or chanting. One remarkable aspect is the great detail of the anatomy. Even though it is carved at a very small size, the musculature is carefully depicted. The lifelike rendering of LM IB will not be attempted again for many centuries.

An Egyptian painting of a group of Aegeans presenting gifts at the Theban court (Fig. 5.28) is a good comparison for the Harvesters Vase because both scenes were created early in the Late Bronze Age, and they both show processions of Aegeans. The two works illustrate the very different styles of Egypt and Crete. The Egyptian painting comes from the tomb of Rekh-mi-re, a high official during the 18th Dynasty. While the Aegean artist uses overlapping to create a sense of three-dimensional space, the Egyptian scene is very flattened, and even the men are two-dimensional. Each marching man is separate from those on his right and left. The Harvesters Vase is filled with anecdotal details while the Theban painting eliminates all but the essentials and shows the figures against an empty white background. Because of these differences, the viewers receive very different messages. The Harvesters Vase encourages whoever sees it to linger on tiny details of musculature and hair styles and imagine or remember an actual procession with the thousands of details that surround people in the real world. The Egyptian scene is much more selective, and it provides only the most important parts of the story: the identity of the men and the nature of the rich gifts they present to honor the Pharaoh.

A rhyton in the shape of a bull's head (Fig. 5.29) was also made in LM IB. It has a primary opening behind the horns and a second one, for pouring, at the mouth. The horns and eyes and a white stone line around the muzzle are added in other materials (the gold over the wooden horns is not certain, but it is a good guess for a palatial carving from Knossos). The back has a flat stone slab to close the hollow interior.

Objects like this rhyton must have been used in ceremonies. The two openings, both of which are rather small, would have been intended for a liquid like wine. Perhaps passing the liquid through the container gave it a blessing, or maybe the small secondary hole in the animal's muzzle was kept closed until the right moment in the ritual when it would be uncovered to release whatever liquid was inside.

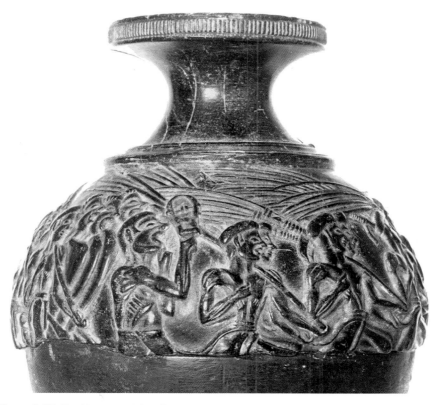

Figure 5.27. The Harvesters Vase from Hagia Triada, the upper half of a rhyton carved in relief with a procession of male figures. LM IB. Diameter 11.5 cm (4.5 in).

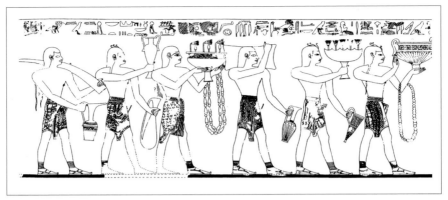

Figure 5.28. Procession of Aegeans bringing gifts to the Egyptian court, a wall painting from the tomb of Rekh-mi-re at Thebes. Reign of Tuthmosis III.

Other Arts

The Minoans made art objects in many materials and for many purposes. Small faience plaques like the many small representations of houses in the Town Mosaic (Fig. 5.1) were probably used as an inlay in some wooden object like a chest or a fancy wooden table.

Fine metal vessels do not often survive, but those that do show the same sense of good design found in other objects. The goblet with two handles illustrated in Figure 5.30, which was made of silver, was found at Gournia. Instead of having a simple circular mouth, the rim was pressed inward at four places to create an undulating shape, and the two handles were positioned between lip and shoulder so that their angle extended the shape of the lower body.

Jewelry could be as creative as other artistic objects. A Middle Minoan gold pendant illustrating a pair of bees or wasps (Fig. 5.31) was buried as an offering to the dead in a tomb at Malia. Its manufacture incorporated a series of difficult metalworking techniques including gold granulation.

Carving vessels from stone continued to be popular. A selection of vases can be seen in Figure 5.32. The group includes a simple cup with a vertical handle (a), a small lamp (b), and a vase with flower petals carved on its exterior so that the whole bowl seems like a blossom (c). All of them are containers that would have been used in ordinary houses at the beginning of the Late Bronze Age. As in earlier times, the interiors are made by drilling followed by abrasion to smooth out the irregularities if the vase was intended to be open. The abrasion, like smoothing wood with sandpaper, would be done with a piece of sandstone or with sand and a wooden block. Emery, a rock containing corundum and magnetite, might be crushed and used instead of

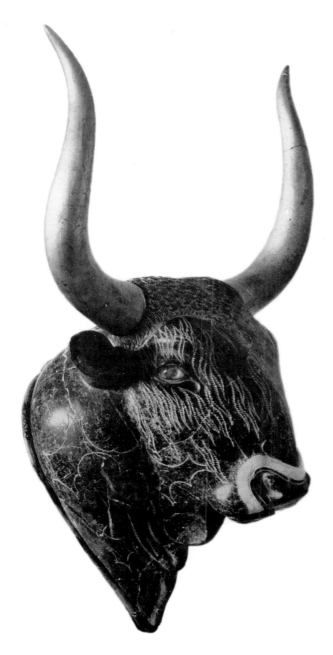

Figure 5.29. Stone rhyton in the form of a bull's head, from Knossos. LM IB. Ht. without the restored horns 20.6 cm (8.2 in).

Figure 5.30. Silver kantharos from Gournia. MM II. Ht. 8.1 cm (3.25 in).

sand to make the work go faster because emery is second only to diamond in hardness, but the process is still extremely slow. Stone vases were very popular in Middle Minoan and Late Minoan I Crete, and perhaps they were valued partly because of the time invested in their manufacture.

The stone vases used at the palaces could be far more splendid than the simple vases in Figure 5.32, as one can see from the sculpture of the bull's head used as a rhyton (Fig. 5.29). One of the finest of these elite products is the rhyton shown in Figure 5.33. Made from a single large quartz crystal (which was broken into hundreds of pieces when it was buried), the vase comes from the LM IB destruction deposit at the palace of Zakros. Quartz

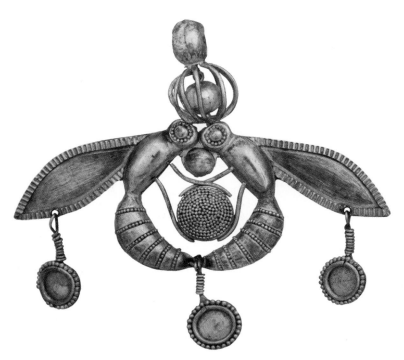

Figure 5.31. Gold pendant from a tomb at Malia. MM IIB. Width 4.7 cm (1.9 in).

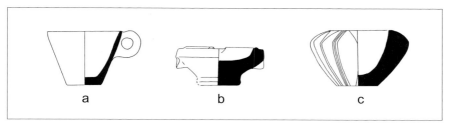

Figure 5.32. Serpentinite vases: a, cup from Palaikastro; b, small lamp from Pseira; c, blossom bowl from Pseira. MM II to LM I. Scale 1:6.

crystals of this size do not occur in Greece so the raw material was imported from the Alps, Anatolia, or some other distant location. The crystal rhyton has a tall oval shape with a handle made of beads. Its elegant design would have made it an object for display as well as for use in rituals.

Fabrics were also important. They had been a part of Minoan culture since the third millennium B.C., and as people began to desire more attractive possessions, woven goods became more elaborate. The earliest loom weights in Crete coincided with the introduction to the island of sheep that had been successfully bred to yield fine wool, an event that occurred near the end of the Neolithic period. Figurines and paintings show that Minoan fabrics had reached a high artistic status by the Middle Bronze Age.

Cloth with patterns made on the loom (as opposed to stitched, embroidered, or painted fabrics) can often be recognized in secondary representations like paintings because woven designs often include repeat-patterns and because they cover the entire space with the design (as opposed to isolated elements that are separated from one another, which are common in embroidery). Bands of design are easy to achieve on a loom, so they are common as well.

Minoan fabric designs are illustrated in Figure 5.34. These patterns come from the clothing shown on Pseiran wall paintings. Their repetition of simple geometric shapes and the complete coverage of the entire space are indications that the paintings may copy woven fabrics where every thread helps form the design. All of these designs would be easy to make on a Minoan loom.

Aegean looms, like the Classical Greek ones that continued the same tradition, differed from Egyptian looms in their basic design. While Egyptian looms were horizontal, Aegean ones stood upright. The vertical threads (called the warp) were attached to a horizontal beam at the top of the loom, and they were held in place by stone or clay weights. Weaving on a warp-weighted loom began at the top by interleaving the horizontal threads (called the weft). The cloth was rolled up at the top as it was finished so the weavers could always work at a comfortable height. For

Figure 5.33. Transparent quartz rhyton from the palace at Zakros. LM IB. Ht. 16.5 cm (6.5 in).

Figure 5.34. Textile patterns from wall paintings found at Pseira. LM I.

repeated designs, a weaver tied selected warp threads to a horizontal piece of wood so they could be pulled out and away from the others all at once to make a space (called the shed) through which the weft thread would pass. Several horizontal sticks of this type could be prepared for speedy alternation to create the desired pattern over and over.

Wool, the main material available for weaving in Crete, took dyes much more easily than linen. Minoan colors included reds, yellows, and browns, all taken from plants. Blues and a fine purple came from the gastropod called the murex. Minoans loved intricate designs, and they used colored threads to make elaborate patterns, especially for the garments worn by elite ladies on special occasions.

An example of some of the intricate patterns on clothing can be seen in Figure 5.35, a wall painting from Pseira showing a woman in a patterned costume. The long dress may have more than simple woven designs because it has rosettes that seem to gather in parts of the cloth, which suggest it could include applique, cut-outs, or embroidery, making it an elaborate item, indeed.

Further Reading

Barber, E.J.W. 1991. *Prehistoric Textiles: The Development of Cloth in the Neolithic and Bronze Ages, with Special Reference to the Aegean*, Princeton.

Betancourt, P.P. 1985. *The History of Minoan Pottery*, Princeton.

Bouzek, J. 1985. *The Aegean, Anatolia and Europe: Cultural Interrelations in the Second Millennium B.C.*, Prague.

Branigan, K. 1970. *The Tombs of Mesara*, London.

———. 1974. *Aegean Metalwork of the Early and Middle Bronze Age*, Oxford.

Figure 5.35. Elaborate costume worn by a Minoan woman or goddess (restoration of a wall painting from Pseira by Maria Shaw; rendering by Giuliana Bianco). LM I.

————. 1988. *Pre-Palatial: The Foundations of Palatial Crete: A Survey of Crete in the Early Bronze Age*, Amsterdam.

————. 1993. *Dancing with Death: Life and Death in Southern Crete c. 3000–2000 B.C.*, Amsterdam.

Cadogan, G. 1976. *The Palaces of Minoan Crete*, London.

Davaras, C. 1989. *Guide to Cretan Antiquities*, 2nd ed., Athens.

Dickinson, O. 1994, *The Aegean Bronze Age*, Cambridge, UK.

Evely, R.D.G. 1993–2000. *Minoan Crafts: Tools and Techniques* (*Studies in Mediterranean Archaeology* 92), 2 vols., Göteborg and Jonsered.

Faure, P. 1964. *Fonctions des cavernes crétoises*, Paris.

Fitton, J.L. 2002. *The Minoans*, London.

German, S.C. 2005. *Performance, Power and the Art of the Aegean Bronze Age* (*BAR International Series* 1347), Oxford.

Gesell, G.C. 1985. *Town, Palace and House Cult in Minoan Crete* (*Studies in Mediterranean Archaeology* 67), Gothenburg.

Graham, J.W. 1969. *The Palaces of Crete*, Princeton.

Groenewegen-Frankfort, H.A. 1951. *Arrest and Movement*, London.

Hägg, R., ed. 1997. *The Function of the "Minoan Villa,"* Stockholm.

Hägg, R., and N. Marinatos, eds. 1984. *The Minoan Thalassocracy: Myth and Reality*, Stockholm.

————. 1987. *The Function of the Minoan Palaces*, Stockholm.

Hirsch, E. 1977. *Painted Decoration on the Floors of Bronze Age Structures in Crete and the Greek Mainland* (*Studies in Mediterranean Archaeology* 53), Göteborg.

Hood, S. 1971. *The Minoans*, London, New York, and Washington, D.C.

————. 1978. *The Arts in Prehistoric Greece*, Harmondsworth.

Immerwahr, S.A. 1990. *Aegean Painting in the Bronze Age*, University Park, PA, and London.

Kantor, H.J. 1947. *The Aegean and the Orient in the Second Millennium B.C.*, Bloomington, IN.

Koehl, R.B. 2006. *Aegean Bronze Age Rhyta*, Philadelphia.

Krzyszkowska, O. 2005. *Aegean Seals: An Introduction*, London.

MacGillivray, J.A. 1998. *Knossos: Pottery Groups of the Old Palace Period*, London.

Marinatos, N. 1993. *Minoan Religion: Ritual, Image and Symbol*, Columbia, SC.

Marinatos, S., and M. Hirmer. 1960. *Crete and Mycenae*, London.

Mastokakis, M., and M. van Effenterre. 1991. *Les Minoens: L'âge d'or de la Crète*, Paris.

Müller, W. 1997. *Kretische Tongefässe mit Meeresdekor*, Berlin.

Otto, B. 1997. *König Minos und sein Volk: Das Leben im alten Kreta*, Düsseldorf.

Palmer, L.R. 1962. *Mycenaeans and Minoans*, New York.

Pendlebury, J.D.S. 1939. *The Archaeology of Crete*, London.

Poursat, J.-C. 1966. "Un Sanctuaire du Minoen Moyen II à Mallia," *Bulletin de Correspondance Hellénique* 90, pp. 514–551.

Sakellarakis, Y., and E. Sakellaraki. 1997. *Archanes: Minoan Crete in a New Light*, Athens.

Shaw, J.W. 1973. *Minoan Architecture: Materials and Techniques* (*Annuario della Scuola Archeologica di Atene e delle Missioni Italiane in Oriente,* n.s. 33), Rome.

Shaw, M. 1997. "Aegean Sponsors and Artists: Reflections of their Roles in the Patterns of Distribution of Themes and Representational Conventions in the Murals," in *TEXNH: Craftsmen, Craftswomen and Craftsmanship in the Aegean Bronze Age*, R. Laffineur and P.P. Betancourt, eds., Liège.

———. 2004. "The 'Priest-King' Fresco from Knossos: Man, Woman, Priest, King, or Someone Else?" in *XAPIΣ: Essays in Honor of Sara A. Immerwahr*, A.P. Chapin, ed., Princeton.

van Effenterre, H. 1980. *Le Palais de Mallia et la cité minoenne*, Rome.

Walberg, G. 1976. *Kamares: A Study of the Character of Palatial Middle Minoan Pottery*, Uppsala.

———. 1978. *The Kamares Style: Overall Effects*, Uppsala.

———. 1983. *Provincial Middle Minoan Pottery*, Mainz on the Rhine.

Warren, P.M., and V. Hankey. 1989. *Aegean Bronze Age Chronology*, Bristol, UK.

6

The Aegean Islands:
MC to LC IA

The population of the Cycladic Islands gradually increased during the Middle Bronze Age. Substantial towns like Phylakopi on Melos, Acrotiri on Thera, and Hagia Eirene on Keos were busy stopping points for the ships that passed regularly between islands and carried a wide variety of goods. Metals continued to be important commodities, and the mines on the islands of Kythnos and Seriphos joined the mainland region of Lavrion in providing copper, lead, and silver for Aegean as well as a few eastern consumers.

As the population of the whole Aegean area grew in size, new towns were founded, urbanization increased in the older settlements, and governments had to respond by becoming more complex. In Western Asia, larger political units were already being established in order to manage trade and the precarious food supplies resulting from greater numbers of people to feed. The same thing was also occurring in Crete where palatial bureaucracies were managing many parts of the landscape. The situation in the Cyclades was somewhat different because most islands were too small to have much of an agricultural base on their own, and their populations were not large enough for a successful defense against large numbers of intruders. These topographic challenges lie at least partly behind the fact that the islands began to be dominated economically by other regions during the Middle Bronze Age, a situation that would continue into later times. By the end of the Middle Cycladic period, Cretans had moved north to exert their economic and cultural influences over a large part of the Aegean Sea.

This gradual increase in Minoan influence was the most important development during the Cycladic Middle Bronze Age. By the beginning of Late Cycladic I, the islands that were closest to Crete were using Minoan loom weights for their looms, Minoan cooking pots in their kitchens, and Minoan technology for their pottery, stone vases, and other crafts. They were writing in the Linear A script and using Cretan seals. Whether or not this social change was accompanied by some measure of Minoan political rule is hotly disputed. Some scholars prefer to see the Cyclades as an independent series of islands with only economic and social influence from Crete, and others suggest that such profound Minoanization must mean both colonists and foreign political domination. A middle ground with political domination at Kythera, Thera, and some of the other islands but with only economic influence in more distant places has also been suggested.

The best evidence for the situation in LC I has been excavated at Acrotiri on the island of Thera (also still known by its earlier Italian name, Santorini). The town was buried by an eruption of the Theran volcano at the end of Late Minoan IA (Late Cycladic IA), which would be about 1525 B.C. by the traditional chronology and about a century earlier by the high chronology (see Fig. 1.2). The fall of pumice covered the houses up to their upper stories and preserved stone and mudbrick buildings so well that sometimes their monumental paintings were still on the walls. Pottery, stone vases, household implements, and many other objects were buried just as they were left when the residents quickly fled from their homes, never to return. Because the pumice was porous enough for water to seep through it, organic objects rotted away so wood, cloth, baskets, and other perishable materials did not survive. The archaeological excavations have only recovered evidence for these items if they were burned and preserved as charcoal or if they left a cavity in the pumice that could be filled with plaster to provide a cast of the lost original.

The town on the south coast of the island was excavated by a French expedition in the late 19th century and by a Greek project directed by Spyridon Marinatos and then by Christos Doumas beginning in 1967. Acrotiri's town plan consisted of irregular blocks of buildings separated by narrow streets (Fig. 6.1). Small open squares provided spaces for people to meet one another and to conduct their daily activities. Evidence for some of these tasks, like the preparation of flour by grinding grain, was well preserved (Fig. 6.2). The houses were made of both stone and mudbrick with the regular addition of wooden beams within the walls to produce a grid that would help hold the building together, a trait that may have helped stabilize walls during the earthquakes that are common in this part of the world. The technique of putting timbers within the walls to strengthen them was also used in Crete as well as at Ugarit and a few other places in Western Asia.

Figure 6.1. Triangle square at Acrotiri, Thera, with the West House at the left and Block Delta at the right. LC IA.

Figure 6.2. The Mill House at Acrotiri, Thera. LC IA.

Pottery

The Cyclades developed some highly distinctive ceramic products during the Middle to Late Bronze Age. Middle Cycladic vases were sometimes decorated with linear ornament in dark, dull paint (called Matte Painted Ware) and sometimes painted with white designs on an overall coat of dark slip. By Late Cycladic I, however, the island potters had borrowed many ideas from Crete. The choice of raw materials, the techniques of manufacture, the shapes of vases, and many of the individual ornaments were all often inspired by Minoan products. The paint used for Middle Cycladic vases had mostly been made of manganese oxide, a material that produced a solid black color that was flat and lusterless. When the islanders began imitating Minoan styles, they also adopted the Cretan iron oxide slips along with the firing technology that vitrified them enough to make them slightly lustrous. This new technology transformed the Cycladic system more thoroughly than would have happened if the workshops had just copied Cretan shapes and designs. The depth of the Minoan influence must mean that some movement of potters was involved because the technology was too complex to be copied by someone who just examined a finished object.

Within this newly transformed tradition, however, the Cycladic potters did not just make copies; on the contrary, sometimes the local pieces were more spontaneous and more colorful than the products that inspired them, making them visually exciting in their own right. One of the more interesting Cycladic products was a clay jug made in the southern part of the region (Fig. 6.3). The vessel, called a nippled ewer, has a high, almost vertical spout and a pear-shaped body. Small painted dots that look like eyes are added at the sides of the spout. Although the high, beak-like upper part might suggest a bird, the resemblance to a human figure is enhanced by the addition of nipples at the front of the vase and a necklace around the neck. The nipples are shaped from clay, painted dark, and surrounded by dots to make them stand out boldly. The example illustrated in Figure 6.3 comes from Acrotiri on Thera, but similar ewers have been found on Melos and elsewhere. Because the pale-colored clay used for the class is typical of both Thera and Melos, it is hard to know exactly where such vases were manufactured.

Nippled ewers sit at the boundary between representational and non-representational art. The potter adds enough details to suggest a bird or a feminine form, but the vase remains mostly an inanimate container. The idea is not so far removed from the fiddle-shaped figurines of the Early Bronze

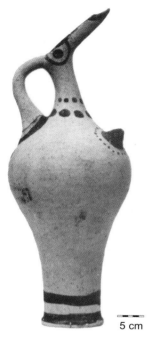

5 cm

Figure 6.3. Ceremonial vase
(nippled ewer) from Room Delta
4 at Acrotiri, Thera. LC IA.

Figure 6.4. Amphora from
Phylakopi, Melos. LC IA. Ht. 27 cm
(ca. 10.6 in).

Age (Fig. 2.1b) where the viewer is also required to envision a female fig-
ure from subtle hints, but here the subject is not a piece of sculpture but a
utilitarian pouring vessel that has been transformed by a few details into an
object of special character. Most scholars who have studied the period sus-
pect the vases were used for cult practices, and the feminine characteristics
remind us that nude female figurines from the Early Cycladic period sure-
ly had ceremonial uses as well.

The vase shown in Figure 6.4 comes from Phylakopi on Melos. It is dec-
orated with reeds, which were popular in Minoan pottery. The Cycladic
brushwork, however, is applied so quickly that it has a fresh and lively feel-
ing that is very different from the more carefully controlled Minoan exam-
ples. A round-bodied jug with a small spout (Fig. 6.5) is from Thera. Here,
the ornament consists of large running spirals that cover more of the vase
than was usual in Crete. A jug (Fig. 6.6) is decorated with wheat. A flying
swallow is displayed on the jug shown in Figure 6.7. The bird flies freely
on the side of the vase, giving it a carefree spirit.

Figure 6.5. Jug from Room Delta 3 at Acrotiri, Thera. LC IA.

5 cm

Figure 6.6. Jug from Acrotiri, Thera. LC IA. Ht. 20.7 cm (8.15 in).

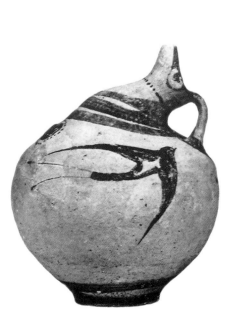

Figure 6.7. Jug from Acrotiri, Thera. LC IA. Ht. 18.4 cm (7.25 in).

Architecture and Wall Painting

At the beginning of the Late Cycladic period, when a local tradition of wall painting became so popular in the islands that the region could support many different workshops, it is not really possible to separate wall decoration from its architectural setting. The painters did not think of murals as an art on panels that could be moved from place to place or used in several different contexts. Instead, they planned rooms as complete spaces that included both the decoration of the walls and the architecture that defined them. By working in this way, the artists could plan details like lighting, relative placement of different compositions, access, sequential views that the visitor would see when entering and moving through the building, and other aspects of the interior to create an integrated set of visual messages for either one chamber or for a series of adjacent rooms. This type of sophisticated artistic planning was also probably typical of Crete during this period, but the poor preservation of the architecture and the fragmentary condition of the surviving wall paintings means that this aspect of Aegean art can only be studied in detail from Acrotiri, the town on Thera that was buried by the volcano.

As on Crete, the painters at Acrotiri used lime plaster, and they often applied the paint while the plaster was still wet. This technique produced true frescoes in which the paint combined chemically with the wall to create a permanent surface. Impressions from strings pressed into the wet plaster were used as guides for long horizontal lines, another technique borrowed from Crete. Unlike the usual practice in Crete, however, the Cycladic painters preferred white as their background, and they used several organic dyes as well as the more permanent natural mineral colors so they had a larger range of paints from which to choose and a more colorful and varied final product.

Wall paintings seem to have had more than one role within the community. In some buildings, only a single room was painted. The exact function of these special chambers is not completely clear, though a ritual use of some type has often been suggested. In other cases, like the large mansion called Xeste 3, a building could have an extensive program of wall decoration combined with special architectural details leaving little doubt that it must have been used by larger numbers of people than would be in a single family and that it must have played an important role within Acrotiri's ceremonial activities.

A house in Block Delta is an example of a building with only one painted space. A small and otherwise unpretentious room opening from a courtyard provides one of the most enchanting landscapes from the entire Bronze Age (Color Pl. 3). The painting, on three walls, is called the Spring Fresco. It

depicts a flock of swallows flying among clumps of lilies that sprout from irregular knobs of rock. The rocks are shown as a series of areas of contrasting colors, a detail borrowed from sources in Crete such as the paintings in the House of the Frescoes (Color Pl. 1B). The informality of the swaying lilies in this Cycladic landscape also echoes the treatment of the growing plants in the same Cretan wall painting. The Theran room manages to capture the sense of a breeze rippling through the sparse vegetation by its repeated use of gently curving lines and by the fact that the individual elements are not symmetrical

The mood continues with the beautifully rendered swallows. The flying birds are carefully observed from nature, but they are painted with great economy of line (Color Pl. 3B). By reducing them to just a few strokes, this master artist manages to capture the essence of their movement without laboring over details of individual feathers. Some of the birds seem poised in the air. What is most remarkable about them is their three-dimensional form. One swallow is seen from below in three-quarter view with the back wing in perspective and shown smaller as it angles away from the viewer, a detail of accurate observation that is (so far as we know) the first three-quarter view of a bird in flight in the history of art.

Ironically, the subject of the Spring Fresco is not springtime, so the name given by the excavator is wrong. The birds are poised with their beaks together, but they are not kissing in mid-air (birds do not kiss). The scene happens in the autumn when dutiful adult swallows continue to feed their offspring even after the young birds are mature enough to fly, and the parents even feed them in mid-air, so the scene shows a parent feeding its almost grown youngster "on the fly."

Very different types of subjects are shown in Color Plate 4A, a reconstruction of an interior space with two different paintings. The architectural setting for the paintings of Boxing Boys and Antelopes illustrates how a room could be organized to accommodate more than one scene. Thin horizontal lines and a band of ivy leaves at the top of the walls and undulating red backgrounds visually tie the two paintings to each other as well as to the room itself. Relating the two paintings to one another is very important in this situation because they are rendered in very different ways.

The Antelopes have a linear style; they are painted in outline form with slightly curved strokes whose widths vary along their lengths. The species shown here is not completely certain: the figures may be antelopes, gazelles, goats, or an imaginary creature with characteristics taken from more than one animal. Open mouths suggest the two beasts are talking to one another, which is an interesting touch that serves to show close interaction between the two creatures.

The Boxing Boys are very different. Their large heads and slightly plump bodies indicate youthfulness. The boys also have small locks of dark hair

(Color Pl. 4B), a characteristic used for many other young Theran figures. Evidently Theran children went through stages when their heads were partly shaved and only selected locks were allowed to grow, so if a figure in a painting has a full head of hair, he or she is assumed to be an adult. The two boys compete in a boxing match where the participants wear only one glove, leaving the other hand free to grab the opponent. Jewelry suggests they are in the elite class so this contest could be a friendly match for exercise or (more likely) an initiation scene in which successful competitions allow young boys to advance to the next stage in their maturity. One supposes a "rite of passage" observed by wild creatures symbolizing the world of nature would make a more serious subject for a painting than a simple genre scene showing a favorite pastime.

The West House (Fig. 6.1) is a residential building with an important upstairs space decorated with fine wall paintings. The building's entrance at the southeast corner (Fig. 6.8) faces onto Triangle Square, across the street from Block Delta. As with many houses at Acrotiri, the West House has a window next to its doorway so a staircase just inside the entrance would have plenty of light. The visitor has a choice upon entering: either to go into the public rooms downstairs to the left or to climb the stairs to the more private spaces on the upper floor.

The volcanic ash was deep enough to preserve many of the upstairs spaces in the town. In addition to the two floors shown in Figure 6.8, at least part of the West House had a higher story as well. As is to be expected, the upper floor followed much of the arrangement of the downstairs spaces but with some rooms modified slightly. Room 3, for example, occupied a large part of the upper story above the block just to the left of the entrance vestibule.

Room 5, upstairs at the northwest of the building, has a series of windows that flood this end of the floor with light. The cycle of wall paintings in the room is designed expressly for this particular architectural space, and all of the room is planned as a unified whole (Color Pl. 5A). Paintings that imitate slabs of stone are just above the floor. Their repetitive pattern of colored lines establishes a visual base for the more dynamic scenes higher in the room. Above the stone imitations are the rows of windows separated by scenes of nude youths holding fish that decorate the structural supports for the beams of the roof. Because the youths face one another and have similar colors, related poses, and the same scale, they help to unify the overall space.

Above the windows is a long painting called the Miniature Fresco that goes all the way around the room at the top of the wall (only one part of it is shown reconstructed in Color Plate 5A). The Miniature Fresco occupies all four walls with a continuous scene. The west wall is poorly preserved, but its adjacent north wall, with a number of individual events painted at a small scale, survives in much better condition. The small individual scenes

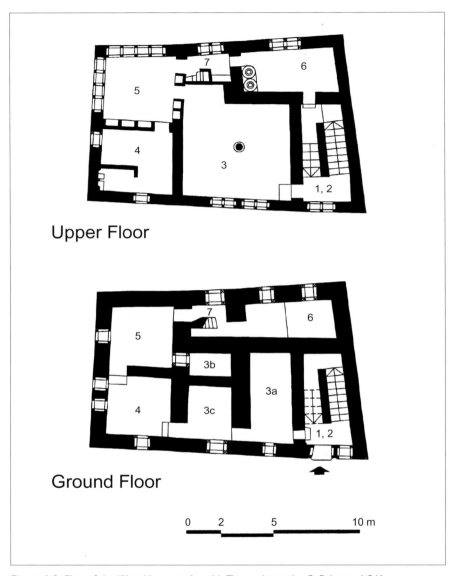

Upper Floor

Ground Floor

0 2 5 10 m

Figure 6.8. Plan of the West House at Acrotiri, Thera, drawn by C. Palyvou. LC IA.

are shown next to one another with no boundaries between them. Some of the scenes are peaceful, like the two women who have filled their vases with water from a well or spring and carry them home on their heads (Fig. 6.9). Nearby are herds of goats being driven to the watering place to drink and also armed warriors who march in the other direction and approach a town (Fig. 6.10). The latter hold tall rectangular shields, carry spears, and wear

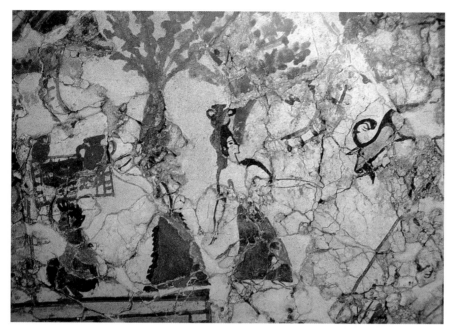

Figure 6.9. Detail of the Miniature Fresco from the West House at Acrotiri, Thera, showing a well or spring and nearby women who carry amphoras balanced on their heads. LC IA.

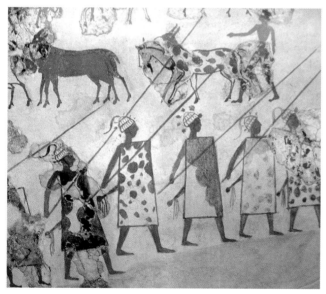

Figure 6.10. Detail of the Miniature Fresco from the West House at Acrotiri, Thera, showing armed men and a herd of goats. LC IA.

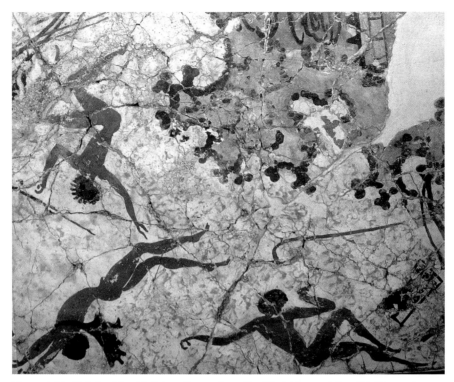

Figure 6.11. Detail of the Miniature Fresco from the West House at Acrotiri, Thera, showing drowning men. LC IA.

helmets and swords. Below them is a naval scene (Fig. 6.11). Men in contorted poses float in the water: the angular positions might indicate death.

These small vignettes are painted above or below or next to one another without any break between them, a disregard for spatial integrity that seems very naive to modern eyes accustomed to a more orderly series of events. Are the herds of goats going to get water contemporary with the advance of the armed men, or are we seeing a sequence of events that happen at different times in the story? Who are these people, and how do they relate to one another? We are looking at the early stages of visual narrative when the way to depict stories has not yet been codified. The artists do not have any rational, sequential arrangement to let the viewers understand what came first and what came later. The scenes are not specific enough to identify who is friend or foe or anything about the relative chronology, but they do hint at some type of exciting narrative, with a journey that involves travel to foreign places.

The next wall, on the east, has a long river scene. The waterway is shown from above as a long blue line flanked by rocks and plants depicted from the side (Color Pl. 5B). Among the plants are many palm trees, which indicate

a tropical climate, and the ground away from the stream is painted in yellow to imply a desert. The inclusion of papyrus plants suggests Egypt, and the addition of a wild cat shows that this place is a far-off and exotic land, certainly not Thera.

The landscape changes again on the south wall, and the frieze shows several ships that have set out across the sea (Color Pl. 6). They sail toward the right within a sea where dolphins frolic. The painting provides a good view of Theran ships. Although they differ in details, the main points of the vessels are generally similar. At the stern, a small cabin holds the captain. His helmsman steers the vessel with a long steering oar called a sweep. The passengers sit in the comfort of a shady cabin while the crew members lean over the side to put their paddles in the water. The artist has painted the passengers with their helmets hanging near them to show that the men are warriors. The ships have painted motifs on their sides to allow them to be recognized from a distance, and they are obviously large sea-going vessels. Each one is fitted with a rectangular sail held by horizontal beams at the top and bottom in a system of rigging familiar from Egyptian river boats. One of the ships is decorated with festoons of flowers (Color Pl. 6B), showing that this scene depicts a festival or some other happy occasion.

At the end of the painting is the arrival town. Its multi-storied buildings with flat roofs may be a portrait of Acrotiri (Fig. 6.12). It is walled, but its city gate is open to welcome the arriving fleet. Townspeople line up on the coast while others stand on the roofs to get a better view.

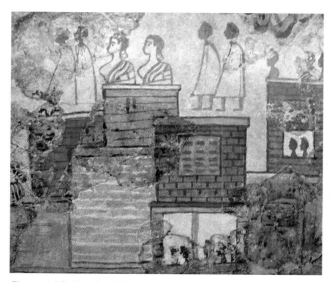

Figure 6.12. Detail of the arrival town from the Miniature Fresco from the West House at Acrotiri, Thera. LC IA.

The Miniature Fresco is a remarkable document. It shows us a view of the Theran concept of the world with both familiar and distant, even exotic landscapes. The human figures are small participants in this world, and they travel within it to places that are sometimes peaceful and sometimes hostile. The lack of specific characters we can recognize and the absence of universal clues to identify places and individuals probably has to do with the nature of the audience. The scenes are certainly specific enough to suggest that this is a narrative, and those familiar with the story could probably have identified individual ships with known captains and familiar crewmembers. The audience is not composed of strangers or future generations who do not know the story or the gods who need to be reminded who is worshipping them. The painting is in an upstairs room in a small building where local audiences may enjoy being reminded about what happened but do not need overt explanations or identifications about a story they already know. Pictorial cycles like this one can best succeed if they are supported by some type of oral or written narratives, like epic poetry or even simple story-telling so that people can keep the memory of the narrative fresh in their minds.

What is missing in the Miniature Fresco is the image of the king or great leader. Unlike a substantial amount of the official art we know from the great civilizations of Egypt and Western Asia, the great leader does not play much of a role in Aegean art. Whoever commissioned the Miniature Fresco and the other paintings in the West House did not expect to be portrayed as a great and powerful figure receiving adulation or homage or gifts. The subject of the painting is the varied landscapes of different places and the actions of groups of people within them, not the exploits of a single hero. The largest figures on the walls are young boys holding fish, not the master of the house. Modesty of this type may suggest some self-assurance in a society with few challenges to the leader's position, which in a Bronze Age society probably means a religious and kin-based society where young people advance through various stages in their life that are pre-set through tradition rather than determined by opinions based on who can persuade or threaten the most neighbors.

The plaster-covered stone offering table shown in Figure 6.13 was found in the same house with the Miniature Fresco. It had been set on a window sill before the site was abandoned. The decoration, a series of dolphins, is an attractive scene of marine life whose style and technique are borrowed from wall painting.

Xeste 3, a building at the south of the excavated area, is much larger than the West House. Its complicated plan can be divided into two different parts (Fig. 6.14). The western section has many small rooms, and it seems to be a private service area in contrast with the larger and more specialized public rooms in the eastern half of the building. The entrance for the western part of the building is at the southwest (no. 11).

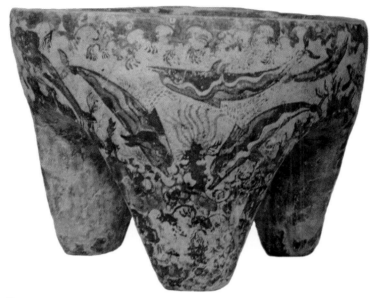

Figure 6.13. Stone offering table covered with plaster and painted with a marine scene, from the West House at Acrotiri, Thera. LC IA.

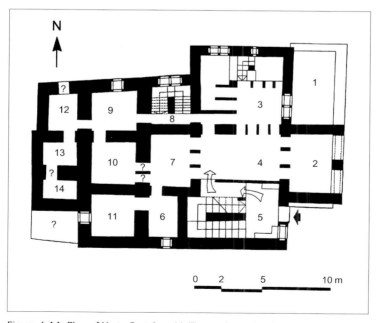

Figure 6.14. Plan of Xeste 3 at Acrotiri, Thera, drawn by C. Palyvou. LC IA.

The eastern part of this large building had only 5 rooms, but they were much larger than the compartments at the west. The eastern block had its own entrance at the southeast (no. 5). At the north was Room 3, a space with a lustral basin (sometimes called an adyton) and pier-and-door partition walls. The lustral basin was a sunken rectangular space similar to architectural features found in Crete. The pier-and-door partitions, which are walls broken by many doorways, also originated in Crete. The exact use of these features is difficult to know, but their use in Xeste 3 in rooms with elaborate wall paintings suggests that they were probably used in ceremonies. The multiple doorways would have allowed selected parts of the room to be open or closed at different times, and the function of an underground compartment also suggests some private part of a ritual that the entire audience was not allowed to witness. Another stairway is in Room 8, leading up to more private parts of the building.

The eastern part of Xeste 3 was decorated with wall paintings of men and women engaged in various activities. The crocus was a persistent theme in this cycle of paintings, and it was used both on the lower and on the upper floor. In the paintings on the upper floor, girls pick the plant's flowers (Color Pl. 7A), and one young girl empties her basket of blossoms at the foot of a large throne where a regal goddess sits with her griffin behind her (Fig. 6.15 and Color Pl. 7B). Showing a god or goddess as a seated figure with a mythological creature in attendance is a common convention in many Mediterranean and Western Asian societies, so the identification of the woman as a goddess is certain. A blue monkey also attends this Aegean deity, and the animal reaches up to hand the enthroned woman the stigmas from some crocus flowers. The goddess wears a necklace of dragonflies and ducks, and a crocus is painted on her cheek. Behind her grow more clumps of crocuses, and nearby is an adjacent wall painted as a thicket of reeds. This divine figure is clearly involved with plants and animals, so she must preside over the lush world of nature.

Modern understanding of the meaning behind the Theran frescoes is hindered by the fact that we only comprehend a few of the many conventions used by this society. Hairstyles tell us that the figure in Color Plate 7A is a young girl even though we do not know her exact age. Although we can understand the concept of requesting help or blessings from a supernatural force visualized as an enthroned woman, we may have some doubts about exactly what is being requested. Are the young girls participating in a rite of passage from youth to adult status as has been suggested for the Boxing Boys, or is this a ceremony in preparation for marriage? Does the cycle of scenes portray a joyous festival at the time that the crocus crop is picked? Crocus is the source of saffron, a substance used for flavoring, as a dye for cloth, and especially as a medicine for a wide variety of ailments. Is this goddess a deity

Figure 6.15. Reconstructed drawing of the enthroned goddess from Xeste 3 at Acrotiri, Thera, drawn by R. Porter. LC IA.

of healing, or is she a more general goddess who rules over all of nature, or is she both? The persistent appearance of the crocus flower is an important element in the painting's symbolism, and an appeal for medical healing seems much more likely than a more simple request in such an important communal building, but even without knowing all the details, we can still appreciate that the beauty of the scenes and their subtle symbolism are a celebration of the joy and bountifulness of the natural world.

Sculpture

Some remarkable clay sculptures from the site of Hagia Eirene on the island of Keos demonstrate that large-scale modeling, while rare, was already present in the Aegean at the beginning of the Late Bronze Age. A small amount of evidence from Crete (such as a wig of stone for a lost figure from Knossos and the occasional finds of life-size clay feet that must have been attached to perishable images) suggest that wood was probably the material of choice for most of the large Bronze Age sculptures from the Aegean region, which makes the female figures from Keos even more remarkable.

The sculptures all represent women. They are modeled out of terracotta, and sometimes the clay is shaped around some other objects (such as a stick to provide a base for an arm). Most of the figures come from a building used as a shrine or temple, so they must have had some role in the local cult. Although the earliest examples of the sculptures are from LC I, a few fragments from LC III indicate that the practice of making sculptures lasted for a long time at this site. Using technical details as a guide, the statues have been divided into nine different groups, and some of the classes contain several different examples (see the book by Miriam Caskey in the list of references below). A total number for the sculptures is not possible because of the fragmentary state of many of them, and it is not possible to be sure if fragments of different parts of the body always belong together, but the series was obviously a substantial one.

The figure shown in Figure 6.16 preserves almost all of its details. It is a little over a meter high (more than 40 inches). The woman wears a long garment over her lower body with a heavy belt-like girdle at the waist and another heavy roll around her neck (perhaps the roll around the neck is a garland of flowers strung on a cord). She has large breasts, probably intended to be bare (like Cretan parallels), and she holds her hands near her waist. Perhaps she is depicted in the act of dancing, but one cannot be sure of the intent for the pose. The figure is hollow, which is a necessary detail for any large clay object that needs to be fired in a kiln (the clay will

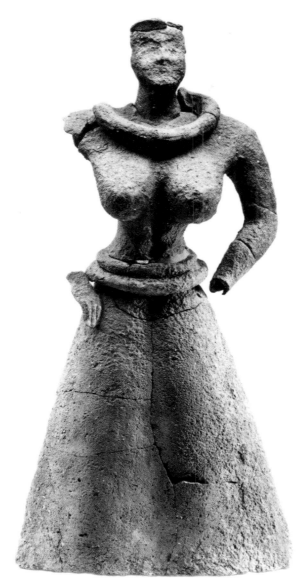

Figure 6.16. Clay sculpture from Hagia Eirene, Keos. LC I (?). Original ht. (including the missing upper part of the head) ca. 1.05 m (ca. 41 in).

break during firing if it is too thick in any one spot). The artists must have added details in paint, but unfortunately they do not survive so we can only appreciate the figure as the bare clay form.

Either the residents of Keos had a particularly long list of goddesses, the practice was to depict one deity over and over, or the large clay figures are worshippers. Whatever role the clay sculptures played in the cult ceremonies is lost to us, and we can only appreciate them as an example of the rather powerful style of imagery that existed here at the beginning of the Late Bronze Age.

Other Arts

The small tripod offering table found on a window sill in a room in the West House (Fig. 6.13) was carved of stone, covered with plaster, and then painted with images of dolphins swimming and leaping out of the sea near a rocky shoreline. Perhaps it was set on the window with an offering just before the residents departed. The object was painted with some of the marine motifs that would become popular on LM IB pottery in the next period after the eruption of Thera. The shoreline for the sea had a knobby and irregular edge, and the dolphins had their tails painted sideways (like fish), both of which were conventions that would be used by the slightly later vase painters. In fact, Theran styles were within the mainstream of the later development of Aegean art. Acrotiri was a large and rich town with an important position within the Aegean trading network. Its residents were able to commission and enjoy art objects that reflected the latest artistic traditions.

One of the new categories provided by the blanket of volcanic ash that covered the island of Thera consists of evidence for objects made of perishable materials. These objects do not survive intact, but their cavities within the ash can be carefully filled with plaster before the ash is removed in order to make casts of the original articles. Although the shapes of baskets, leather goods, and a few other items have been recovered in this way, the most common items that are best understood from casts are objects made of wood. The windows and doors whose shapes have been recovered in this way have provided considerable information on the timber construction and carpentry used in Acrotiri's buildings. Thanks to this technique and the careful excavation of the town, we can appreciate the architectural layout of rooms like those reconstructed on paper in Color Plates 4A and 5A.

One of the most remarkable objects whose shape is preserved by its cast is the small table shown in Figure 6.17. Its three intricately carved legs

The Greek Peninsula: MH to LH IIA

The Middle Helladic period had a long, smooth development. As it did in the Early Bronze Age, the population continued to support itself through agriculture and animal husbandry. Stability gradually returned after the disruptions that had occurred in the second half of the third millennium B.C., and small towns prospered. Trade never died out completely, and both pottery and other commodities were distributed widely. Burial was mostly in small cist graves cut into the soil or soft bedrock.

Although some minority views suggest that the Greeks arrived at the end of the Middle Helladic period or that they were already in Greece during the Neolithic era, most scholars believe that the people who would later be called Greeks arrived toward the end of the third millennium B.C. A single large invasion at the end of the Early Bronze Age is highly unlikely, and probably small groups of related people who spoke an Indo-European language migrated south over a fairly long period of time. They probably arrived peacefully in some places and with a more hostile reaction elsewhere. The original homeland of the Indo-Europeans has to be in the north because their language had names for northern items like the wolf and the oak tree but had no words for ships or anything else related to the sea. The new people settled among those already living in the Aegean without completely replacing the earlier population, so words that were non-Greek, like names ending in -ssos (Parnassos, Knossos, Tylissos) or in -nthos (Corinthos, Tirynthos) survived even into later times. If this theory is accepted, then the Middle Helladic people were already speaking an early version of Greek, and we might expect some

of the characteristics of Middle Helladic society to develop into the later Greek traditions.

Pottery

Among the Middle Helladic clay vases with styles that would continue for many centuries, the stemmed goblet with two opposed handles has a special place (Fig. 7.1). The clay is fired to a gray color, and the class is called Gray Minyan Ware. Many Middle Helladic potters liked angular shapes, and the one in Figure 7.1 is made on the potter's wheel so that its component parts are carefully separated. Sharp angles set off rim, bowl, stem, and base. The vase has no decoration, and the shape was considered complete with no added paint of any kind. The opposed handles—allowing the host to hand the cup to his guest—would be standard fare for wine vessels into the Classical Greek period and beyond. At the very end of the Middle Bronze Age, the base of this type of goblet is much flatter than before (Fig. 7.2).

During both MH and LH I, local ceramic style favored designs composed of lines and patterns that were completely non-objective (Fig. 7.3). Vases were often decorated with horizontal bands. The painting was carefully related to the shape of the vase (a type of ornament called architectonic design). Ceramic ornamentation in this period can be divided into two classes, architectonic design and unity design. The differences between them can be seen in the two vases in Figure 7.4a and b. The mainland amphora has an architectonic design because each structural part of the vessel is treated differently. The rim has a band painted on it, distinguishing it visually from the unpainted neck, and the upper shoulder is set off from both neck and lower body by a band of decoration. The band extends from the base of the neck to the bottom of the handles, so its placement is determined by the vase's physical structure. The formal character

Figure 7.1. Clay goblet, unpainted (Gray Minyan Ware), from Eleusis. MH. Scale 1:8.

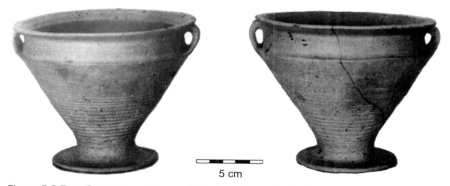

Figure 7.2 Two Gray Minyan Ware goblets from Grave Circle B at Mycenae. Late MH.

of the ornamentation is emphasized by the vertical lines midway between the handles and by its symmetry. Even on this simple vase (with cursory Mycenaean motifs and irregular lines caused by poor eye-to-hand coordination), the vase painter has used a pre-planned, architectonic composition determined by the vase and the placement of its handles. By contrast, in the unity design of the Minoan stirrup jar (Fig. 7.4b), the complex ornamentation spreads across the entire vase and ignores the individual parts of the structure as if the shape has nothing to do with the motif used on it. In many vases from the Middle Bronze Age and the beginning of the Late Bronze Age, compositions for Aegean pottery were created at one extreme or the other of these two concepts, with many architectonic designs made on the mainland and with both unity designs and architectonic designs

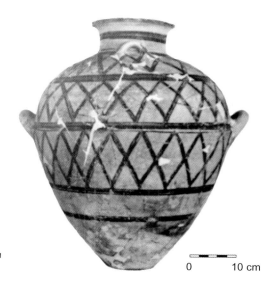

Figure 7.3. Jar from Mycenae, from Grave Circle B. Late MH to LH I.

used in Crete. The motifs on the mainland were often much simpler than in Crete. After LM IB, the traditions became blurred, and vase painters often combined aspects of both extremes. The later example from the Mycenaean period in Crete (Fig. 7.4c) uses complex Minoan motifs applied in a rational, architectonic composition.

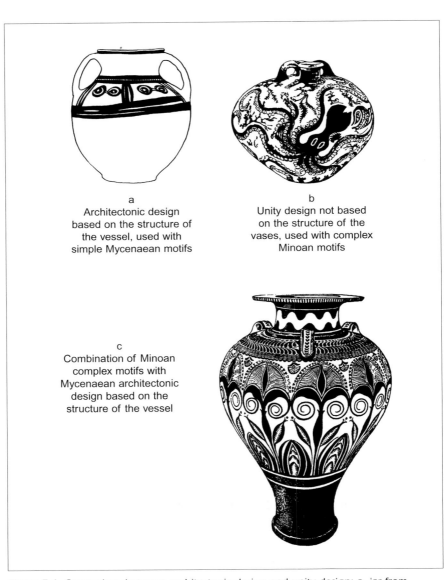

a
Architectonic design
based on the structure of
the vessel, used with
simple Mycenaean motifs

b
Unity design not based
on the structure of the
vases, used with complex
Minoan motifs

c
Combination of Minoan
complex motifs with
Mycenaean architectonic
design based on the
structure of the vessel

Figure 7.4. Comparison between architectonic design and unity design: a, jar from Mycenae, LH I; b, stirrup jar from Gournia, LM IB; c, pithoid jar from the Royal Tomb at Isopata, Knossos, LM II. Not to scale.

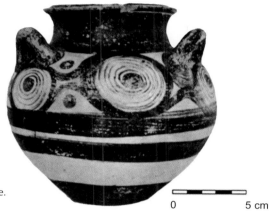

Figure 7.5. Small jar from Mycenae.
LH I.

0 5 cm

At the end of the Middle Helladic period, Mycenaean potters began accept-
ing more and more influences from Crete. The use of iron-rich slips for dec-
oration and the firing system that produced their lustrous surfaces became
increasingly fashionable for pottery on the Greek mainland as well as in the
Cyclades. Along with the technology, Mycenaean potters began using some
of the Minoan designs. The jar shown in Figure 7.5 is decorated with spirals
on the upper shoulder; it uses both the Cretan pottery technology and an imi-
tation of a Minoan spiral band except that the dots placed between the spirals
betray the fact that this piece was made by Mycenaean potters.

Architecture

Many Middle Helladic houses were relatively small structures with no
more than two or three rooms. They were much smaller than the domestic
buildings used in Crete during this same period. At Eutresis (Fig. 7.6), the
houses were free-standing. The example illustrated here had a rectangular
megaron plan with a front room and a larger back room approached via an
axial entry. A hearth for cooking and an oven for baking bread were in the
back room because this private area was used for food preparation (the
fires will also have kept the house warm on winter nights). The front door
opened onto a small courtyard, and the family must have performed many
of the household's daily tasks in the open air.

At the transition between the end of the Middle Helladic and the begin-
ning of the Late Helladic periods, the rulers of Mycenae began accumulat-
ing great wealth. The source of the riches is not known, but perhaps trade
was responsible for at least part of the picture because many foreign objects
appear in the archaeological record from there at the beginning of the Late

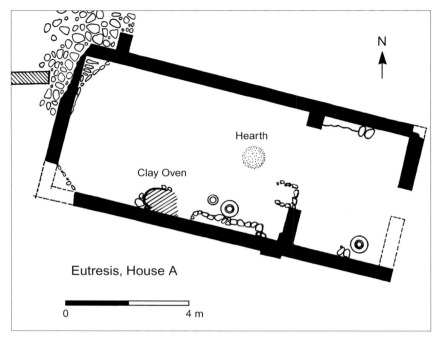

Figure 7.6. Plan of House A at Eutresis. MH.

Bronze Age. Among these items are amber from the Black Sea region and objects from Crete and the East Mediterranean, so serious changes were happening within the society.

The rulers of the city began to express their new status in several ways. Although few architectural remains from this period survive from Mycenae, the massive fortification walls of the city show that it was already a wealthy metropolis. The main buildings would have been located at the top of the Mycenaean hill well above the rest of the town.

Most Middle Helladic burials were in small underground tombs called cist graves (an example from Mycenae is shown in Figure 7.7). They were usually too small to allow the body to be placed in an extended position, and so the knees of the deceased had to be bent. As in previous centuries, the graves were often lined with stones at the sides and covered with slabs to close them and create small underground compartments. Only a few objects (especially pottery) were placed inside these small graves.

Perhaps because the Mycenaean rulers wished to continue to enjoy their wealth in a life after death, they began placing richer objects inside the graves at the end of the Middle Bronze Age. Tombs were now larger, and those of the leading families were set off from the graves of lesser citizens. The elite graves were placed within circular areas outlined by stones. Two

of these grave circles were constructed at Mycenae. Grave Circle B was the earlier of the two, and its earliest graves were ordinary MH cist graves (Fig. 7.7); the later cemetery, Grave Circle A, overlapped in time with the end of the earlier circle and lasted well into Late Helladic I. Both circles were originally outside the city, but the fortification walls were later extended to include Grave Circle A. Opinion is divided on whether or not these circles were covered with tumuli (mounds of soil). Tumulus burials were common in many places north of Greece, and examples have been found at Marathon and a few other places in Greece as well, but they were not really common.

The burials in Grave Circle B (Fig. 7.8) show a gradual progression from small cists to larger entombments to fully developed shaft graves, which suggests that the later custom developed gradually. The circular cemetery was located just west of the city gate between two later grave monuments (the Tomb of Clytemnestra and Chamber Tomb 1). Twenty-four graves were within the circle (they are identified by letters in the Greek alphabet).

Grave Circle A, brought inside the city about 300 years after it was built, can be seen just south of the city gate, which is decorated with heraldic lions (see Ch. 8). It is east of the West Cyclopean Wall (Fig. 7.9). Its seven graves, designated with Roman numbers, are mostly larger than those of Grave Circle B. The earliest ones are partly contemporary with the latest graves in Grave Circle B (although this cemetery did not end as soon as the earlier one did). The objects in Grave Circle A include some of the finest objects from the beginning of the Late Helladic Period.

In its final form, each shaft grave was an underground room. A rectangular shaft large enough for several people was excavated into the ground. When an elite member of the ruling class died, one can imagine an elaborate funeral procession that displayed the deceased and all the valuable

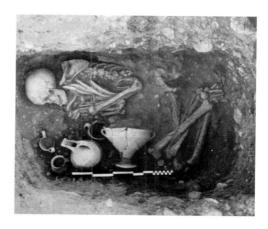

Figure 7.7. Cist grave *Eta* from Grave Circle B at Mycenae. Late MH to LH I. The scale in the photograph is 1 m long.

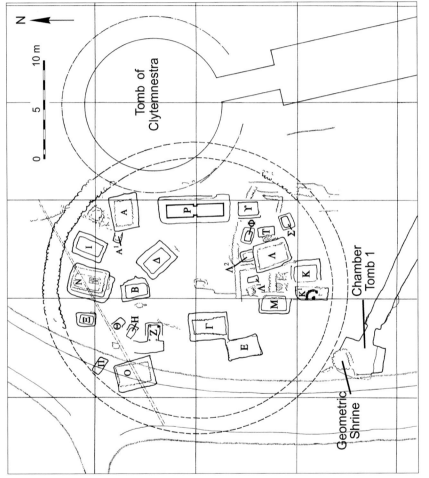

Figure 7.8. Plan of Grave Circle B at Mycenae, drawn by D. Theochares.

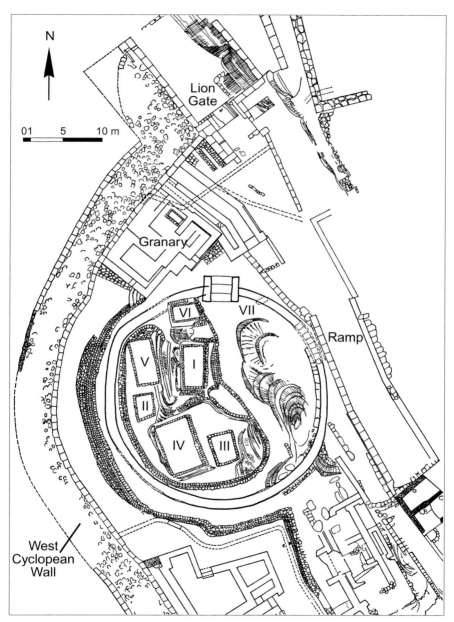

Figure 7.9. Plan of Grave Circle A at Mycenae, drawn by Garvey, after I.M. Shear, *Kingship in the Mycenaean World*, fig. 1.

objects that would be placed in the tomb. The body was laid in an extended position at the bottom of the shaft along with the rich grave goods, and the mourners then consumed a funeral meal. The chamber was roofed with beams and covered with soil (remains of the funeral meal in the soil fill provide evidence for the feast held at the cemetery). After the shaft was filled in, a stela (a stone slab set up as a grave marker) was placed on the surface to locate the tomb for the future when a close relative might die.

In the 13th century B.C., 300 years after the Shaft Grave period, the citadel of Mycenae was expanded to bring some of the ancestral tombs inside the city walls. A new city gate decorated with lions and a new section of defensive wall were added to the old fortifications (Fig. 7.9). As a part of this new remodeling, the ground level above Grave Circle A was filled in to raise it to the level of a ramp and roadway inside the gate. The stelae were erected at the new higher level, and a more monumental circular wall around the Grave Circle was constructed at the same time. The new wall, built as a double circle of vertical stones with additional slabs across the top, was fitted with an entrance facing the roadway so visitors could enter the circular cemetery to see the final resting place of the city's early kings.

Sculpture

The stelae set up above the shaft graves provide examples of local preferences in LH I sculpture. Figure 7.10 is a rectangular stone slab carved on its front side in low relief. The upper part is decorated with spirals, and the main panel is carved with a scene of a chariot and its driver approaching a man on the ground who holds a weapon or some other object. This sculpture is most likely a battle scene, though the charioteer could also be either racing or hunting. Illustrations of heroic skills occur very often in the art of this period. The men buried in the Shaft Graves regarded themselves as warriors, and they were interested in art objects that praised them for their courage and daring and advertised their masculine skills at every opportunity.

The style of this stele is extremely cursory. The landscape is omitted, and the figures are only outlines with no details whatsoever. Two possibilities exist. Either the local Mycenaean sculptors were uninterested in more than general outlines, or (what is more likely) the stelae from the Shaft Graves were carved as backgrounds for plaster reliefs added over the stone, and the plaster has disappeared through time. In either case, the artists would have finished the stelae by painting the details on the plaster and stone.

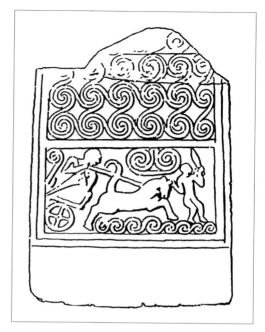

Figure 7.10. Stone stele from Grave Circle A at Mycenae. LH I. Ht. 1.34 m (51.48 in).

Metalwork

Many of the objects in the Shaft Graves at Mycenae were made of metals, and an especially large number were gold. The faces of several men were covered with golden masks, and the one shown in Figure 7.11 has a mustache and a beard that give the image some individual characteristics suggesting a relation to the person who died. One child who must have been a member of an important family was buried with golden plates that covered the whole body. Large diadems and other ornaments made of sheet gold may have been attached to leather or cloth, and a long series of disks ornamented with dragon flies, octopuses, and other designs must have sparkled on the surface of elegant pieces of fabric, either costumes or shrouds to cover the deceased. Cups and other vessels of the precious metal were added to the graves as well. The styles used for some of these pieces (the gold dragonflies and octopuses, for example) look Minoan, which suggests that some of the objects were either imported or made by Minoan artists working at Mycenae.

The lion's head rhyton in Figure 7.12 is made of sheet gold. Like all rhyta, it has an opening at the top for filling and a small hole below (at the mouth)

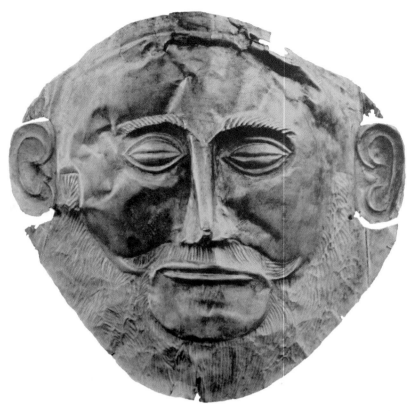

Figure 7.11. Gold mask (the so-called "Mask of Agamemnon") from Grave Circle A at Mycenae. LH I. Ht. 26 cm (10.25 in).

for pouring out its liquid. It is made in the repoussé technique, which consists of hammering and pressing the gold from the back to form the desired shape.

The goblet shown in Figure 7.13 has a mixture of Minoan and local Helladic influences; perhaps a craftsman originally trained in the Cretan style then made objects for the Mycenaean warriors. The basic shape of the vessel is copied from a Minoan shape called a chalice (see Fig. 3.9, for example). The idea of a pair of handles, however, is a local trait, and the appendages have been added in a rather awkward way and then finished with small doves at the top. The goblet is called the Cup of Nestor because a similar vessel is described by Homer in the *Iliad*. Homer, of course, was not describing this particular cup (it was already buried in the Shaft Graves, possibly for centuries, when the *Iliad* was composed), but evidently a generally similar one was in circulation whenever this particular passage in the epic was composed.

vessel that was separate from its decorated exterior. The scenes show the capture of wild bulls. One animal rampages through the countryside and gores a man who is turned upside down by the force of the beast, which also tramples another unlucky fellow. On the other cup, a quieter animal is captured more easily. The artist has added many details, and the musculatures of both men and animals are faithfully recorded. The tree on the second cup provides a believable landscape setting, and even the rocks have carefully worked details.

Performance

Performance is a form of art. Rituals, processions, and other human actions can be visual communication that completes the message of the costumes, objects, and architectural setting used along with these actions. The objects buried in the Shaft Graves were expressions of ostentatious wealth, military preparedness, and political power. Many of the items were of costly materials, especially precious metals. Art objects of the finest craftsmanship available included both locally made and foreign pieces. The great treasure placed in a Shaft Grave was partly a statement by the surviving members of the community. The evidence for a procession that carried these objects to the dead person's final resting place and then for a burial ceremony and a great feast in front of the grave implies an audience that would surely have been impressed by the elite objects. The performance at the time of burial conveyed a message that Mycenae owned so much treasure that the rulers could discard vast amounts of it to honor an important member of their community.

Other Arts

The artistic repertoire from the Shaft Graves includes objects of several materials. A bowl in the shape of a duck carved from a large quartz crystal is shown in Figure 7.17. The piece comes from Grave Circle B at Mycenae. Quartz is a hard material, and the duck's head and body would have been made by long hours of simple abrasion to wear the quartz away and then polish it. The result is an attractive and unusual bowl with a quite naturalistic rendering of the duck's head.

One of the most interesting objects from the Shaft Graves is the rhyton shown in Figure 7.18. It is made from an entire ostrich egg cut to form a vessel for liquid. It has a small hole at the base and another one at the top, with the upper opening fitted with a faience mouthpiece to complete the vessel.

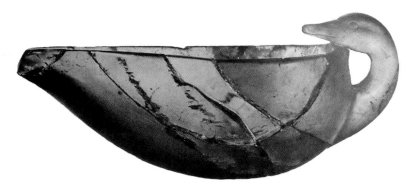

Figure 7.17. Quartz crystal bowl in the form of a duck from Grave Circle B at Mycenae. LH I. Length 13.2 cm (5.25 in).

Several other rhyta made of ostrich eggs are known from the Aegean. The faience used for the mouthpiece suggests that this example was probably made in Crete because many other faience pieces come from the south Aegean island. Like all rhyta, the ostrich egg vase would not hold liquid because of the hole in its base, and it must have been used as a filter or funnel or as a sacred vessel for ceremonies.

Comments

Between Middle Helladic and Late Helladic I, the communities of southern Greece developed from poor and locally focused towns to powerful and wealthy communities with many overseas relations. Did these changes happen entirely as a local development, or did new residents from somewhere else have a role in the new attitudes? The evidence for newcomers is fairly slight, but the possibility cannot be entirely discounted even though the local development in Grave Circle B suggests a gradual change from Middle Helladic cist graves with few objects to Late Helladic shaft graves with very rich offerings.

Scholars have debated several possibilities on the source of the new Mycenaean wealth. Were the Mycenaeans paid mercenaries who hired themselves out as soldiers in Egypt or elsewhere? Were they pirates who captured a great amount of treasure? Did they grow rich as merchants by acting as middlemen in trade between the Aegean and the East Mediterranean on the one hand and northern Europe and Italy on the other? Was the situation so complicated that several factors were involved? The evidence is not definitive, and hints point in different directions. The origin of the gold is a problem because the metal is very scarce in the Aegean during this period, and

its sources could be either in the north or the east. The Baltic amber points to the north, while contacts at the south (especially with Crete) indicate a close relationship with the southern Aegean, which had ties with the East. The many fine objects with both Minoan and local influences indicate that at least some of the material was probably made at Mycenae itself. For the rest, we cannot know for sure, but trade is probably the most likely possibility. Greece had access to many products needed in Crete and elsewhere, especially copper, silver, hides, wool, timber, and slaves. Most of these products were raw materials, and none of them would leave much of a trace in the archaeological record. They were, however, very much desired, and we know that by the next period, the Mycenaeans were active merchants. Perhaps their trade had already begun by this period.

One of the most important changes during this period was an economic transformation that affected the society as a whole. In the early Middle Helladic period, the residents of southern Greece were mostly farmers and herdsmen, and wealth would have been expressed in land and its crops and animals. Large tracts of farmland for agriculture and hills for herds can be owned, transferred to new ownership, or inherited, but they cannot be moved. Ownership of land and the agriculture and animal husbandry it supports must be by local residents. The change in Late Helladic represents a great influx of more portable wealth consisting of gold, silver, bronze, and small art objects made of various costly materials. The difference is that this new wealth can either be stored or moved; it can be hoarded, sent at great distance as gift or payment, or captured by foreigners and taken back home. It is not affected by bad weather that destroys crops or by disease that kills animals, and it is not consumed as food.

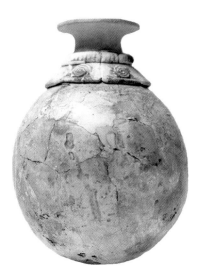

Figure 7.18. Rhyton made from the shell of an ostrich egg, from Grave Circle A at Mycenae. LH I. Ht. 15.0 cm (5.9 in).

One of the results of the permanence and portability of the new form of wealth must have been an increased emphasis on protecting it. Many aspects of the Late Helladic society demonstrate the new role of warfare in the culture. The inventory from the Shaft Graves includes a great many weapons, including spear heads, arrowheads, and daggers, categories that were not as common in Middle Helladic graves. Themes of warfare and hunting in the figural art praise skills needed in battle. The hours of manpower spent on fortification walls must have been related to a fear that someone might attack. All of these details are related to the new character of what was considered valuable: portable wealth must be protected.

Further Reading

Bouzek, J. 1985. *The Aegean, Anatolia and Europe: Cultural Interrelations in the Second Millennium B.C.*, Prague.

Cavanagh, W., and C. Mee. 1998. *A Private Place: Death in Prehistoric Greece*, Jonsered.

Cline, E. H., and D. Harris-Cline, eds. 1998. *The Aegean and the Orient in the Second Millennium B.C.* (*Proceedings of the 50th Anniversary Symposium, Cincinnati, 18–20 April 1997*), Liège.

French, E. 2002. *Mycenae. Agamemnon's Capital: The Site and Its Setting*, Charleston, SC.

Harding, A.F. 1984. *The Mycenaeans and Europe*, London.

Hooker, J.T. 1976. *Mycenaean Greece*, London.

Koehl, R.B. 2006. *Aegean Bronze Age Rhyta*, Philadelphia.

Marinatos, S., and M. Hirmer. 1960. *Crete and Mycenae*, London

———. 1973. *Kreta, Thera und das mykenische Hellas*, Munich.

Mee, C., and W. Cavanagh. 1985. "Mycenaean Tombs as Evidence for Social and Political Organization," *Oxford Journal of Archaeology* 3, pp. 45–61.

Mountjoy, P.A. 1986. *Mycenaean Decorated Pottery: A Guide to Identification* (*Studies in Mediterranean Archaeology* 73), Göteborg.

———. 1993. *Mycenaean Pottery: An Introduction*, Oxford.

———. 1999. *Regional Mycenaean Decorated Pottery*, Rahden, Germany.

Mylonas, G.E. 1951. "The Figured Mycenaean Stelai," *American Journal of Archaeology* 55, pp. 134–147.

———. 1966. *Mycenae and the Mycenaean Age*, Princeton.

Papadimitriou, N. 2001. *Built Chamber Tombs of Middle and Late Bronze Date in Mainland Greece and the Islands* (*BAR International Series* 925), Oxford.

Shear, I.M. 2004. *Kingship in the Mycenaean World and Its Reflections in the Oral Tradition*, Philadelphia.

Taylour, Lord William. 1964. *The Mycenaeans*, London.

Vermeule, E. 1964. *Greece in the Bronze Age*, Chicago.

———. 1975. *The Art of the Shaft Graves of Mycenae*, Cincinnati.

Wace, A.J.B. 1949. *Mycenae: An Archaeological History and Guide*, Princeton.

Warren, P.M., and V. Hankey. 1989. *Aegean Bronze Age Chronology*, Bristol, UK.

8

Mycenaean Greece:
LH IIB to LH III

Many scholars believe that the destructions in Crete and several Aegean islands at the end of LM IB/LC IB resulted from the conquest of the Aegean by Mycenaean Greeks. The Linear B tablets found in Crete in LM III show that people who spoke Greek were in charge of the Minoan palaces by then, and the change from the Minoan language of the Linear A documents to the early Greek language of Linear B may have happened at the time of the LM IB destructions. Certainly, the artistic changes visible throughout the Aegean after LM IB indicate that a historical transformation of some type occurred and that mainland ideas were much more influential than before.

By the end of LH IIIB, circa 1200 B.C., Mycenaean trade reached all the way from Sardinia to the western parts of Asia. Whether this far-flung economic pattern was guided by various kings or by one great ruler at Mycenae or by private or semi-private merchants is not really understood, but its successful results are clearly visible. Palace bureaucracies controlled farming, stock raising, and manufacturing on an unprecedented scale, and the workers produced surpluses for overseas trade that brought increasing wealth to the rulers. The Linear B tablets, almost all of them economic documents that tabulated large quantities of palatial products, provide information on metalworking, perfume making, weaving, and other activities. They also give some information on the government itself. The typical Mycenaean state was ruled by a king called a *Wanax* who shared his power with an officer called the *Lawagetas* as well as with other

members of an elite class of nobles. Together, they ruled a successful economy that became increasingly affluent, and they enjoyed traditional noble pastimes like hunting and feasting. They were great patrons of the arts, and they built splendid palaces.

This age was remembered in Classical Greek mythology as a time of great heroic deeds when all the major kings of Greece gathered together under the leadership of Mycenae to fight the Trojan War. Agamemnon, the king of Mycenae, was the undisputed leader of the expedition, and the other kings, though they were rulers in their own right, accepted his leadership. The epic tales recounted by Homer and other poets represented an oral tradition handed down to future generations in literary form rather than as factual history, and it is not always easy to distinguish the kernels of truth from the exciting literature.

Beginning toward the end of LH IIIB (near 1200 B.C.), disruptions began to affect the Mycenaean economy. The immediate causes of the difficulties are not well understood, and earthquakes, wars, or crop failures may have contributed to the economic collapse, but the main problems were probably built into the system itself. Greece was a small region, and its fertile land was limited. Although the successful Mycenaean economic system led to a stable food supply, better living conditions, and a gradually growing population, the amount of available land could not support an increasing number of people forever. As a result of the increasingly efficient agricultural management, the population was healthier and lived longer. Eventually, so many communities depended on the system that food supplies had to be critical enough for any disruption to spread quickly throughout a Mycenaean state. If a local food supply was destroyed by any cause, an angry and armed population had the choice of facing starvation or trying to take food from someone else. The result was widespread warfare. The economic collapse did not happen all at once, and many regions made serious efforts at recovery, but by the 11th century B.C., the trade was pretty well disrupted, the palaces were gone, and many people had left the Aegean to try their luck in Cyprus or somewhere else in the East Mediterranean.

Pottery

New artistic fashions spread throughout the Aegean in the period known as LH IIB on the Greek peninsula (LM II on Crete and LC II in the Cyclades), and they can be seen especially clearly in the stylistic changes that took place in pottery. Traditional shapes for drinking and other purposes became more elegant and more suitable for impressive display.

Many of the vases survived in good condition because they were buried in tombs, and they give us a new chapter in artistic design.

A two-handled goblet with the bowl supported on a graceful stem is the main drinking vessel during LH IIB. The shape is shown in Figure 8.1. It is called an Ephyraean goblet (a name borrowed from Homer), and it represents the sleek Late Bronze Age descendant of the more angular goblets used in the Middle Helladic period (Fig. 7.1). The bowl now flows smoothly out of the foot, and the separation into different parts is not as clearly emphasized as in earlier vases. A single decorative element (in this case the bud of a flower of some kind) is painted on each side of the vase, and the rest of the goblet is left empty.

The principles of this new art combine Cretan and mainland ideas. The two vases in Figure 8.2 illustrate the point. The jar from LH II (Fig. 8.2b) has a piriform shape (meaning it is shaped like a pear). It is decorated with a palm tree, a motif borrowed from Minoan Crete. A comparison between the Mycenaean vase and its Minoan predecessor from just a few years before (Fig. 8.2a) is very instructive for the differences between the two styles. The Minoan vase is a rhyton from Pseira. Its decorative palms are of the same type as the ones on the piriform jar from Mycenae, but the rendering is subtly different. On the slightly earlier Pseiran piece, the palms are painted with a few more details, with irregular edges for the trunks (where the old leaves have fallen off) and jagged edges at the bottoms of the leaves. The palms are at different angles, as if they blow in the wind. Small ivy plants sprout from the irregular ground so the viewer is encouraged to imagine a scene adapted from a natural landscape. On the Mycenaean version, the irregular ground is now a flat line, the trunk is smoother, and other details are eliminated. The decoration is restricted to the upper shoulder.

Figure 8.1. Ephyraean goblet from Mycenae. Ht. 16 cm (6.3 in).

0 8 cm

Figure 8.2. Comparison between Minoan and Mycenaean palm motifs showing the subtle stylistic differences between them: a, LM IB; b, LH II. Not to scale.

| a | b |
| Pseira, Crete | Mycenae |

The youngest palm leaves sprout not from the stem, as in nature, but from the bud at the top, and they are rendered as curved lines reaching almost to the ground, which is a complete misunderstanding of the fact that they are supposed to be young leaves. The result of these changes is that references to a living landscape are more distant; the artist has copied another painting, not nature.

In the next 300 years, the decorative style used for ceramics gradually becomes more and more abstract throughout the Aegean. The direction of the development can be traced in the sequence of vases decorated with octopuses shown in Figure 8.3. The LM IB Minoan example from Gournia, from about 1450 B.C., shows the body of the animal at an angle

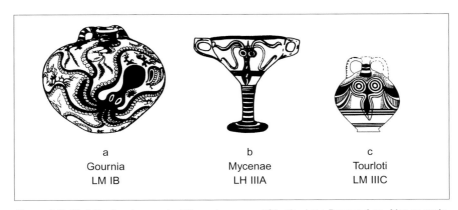

a	b	c
Gournia	Mycenae	Tourloti
LM IB	LH IIIA	LM IIIC

Figure 8.3. Stylistic development of the octopus motif in the Late Bronze Age. Not to scale.

so the composition is balanced but not symmetrical. The eight tentacles are informally arranged around the creature, and some of them overlap one another. The suckers, carefully painted at the sides of the tentacles, help give the animal added interest. Two hundred years later, the kylix from Mycenae has bilateral symmetry with the two sides of the vase painted as mirror images of one another. The creature has lost its suckers, and it has only four tentacles. Did the artist ever actually look at an octopus while he was drawing it, or did he only copy other paintings or rely on his memory? However it was conceived, the result has lost touch with the actual appearance of the sea animal—not crowding the small space with tentacles has become more important than copying what the animal looks like. In the next stage, from LM IIIC (the 12th century B.C.), thin lines are added between head and tentacles to further reduce the lifelike aspects. In this small stirrup jar found at Tourloti in East Crete, two-dimensional design has triumphed over visual references to the natural world.

The old Middle Helladic taste for pure design never completely died out in Greece in spite of the popularity of Minoan ideas about the use of elements borrowed from the real world. Gradually during LM III, these older ideas reasserted themselves more strongly. By LH IIIB, pure design had become a very important part of ceramic ornamentation, and many vase painters used geometric designs that were never intended to suggest real objects.

Traditional designs like the band of spirals fit into this taste very well. The example in Figure 8.4 is a LH IIIB bowl or krater used for mixing water and wine. It comes from a tomb at Enkomi in Cyprus, and it is a good example of the Mycenaean export of fine ceramics. A deep bowl (Fig. 8.5) illustrates similar principles on a vase from Mycenae itself. The decoration

Figure 8.4. Mycenaean deep bowl from Enkomi, Cyprus. LH IIIB. Ht. 23.4 cm (9.25 in).

0 10 cm

Figure 8.5. Deep bowl from Mycenae. LH IIIB.

is bilaterally symmetrical with a rectangular pattern of wavy lines midway between the handles and pairs of other designs flanking it on both sides. The form of the vase with its pair of handles and the non-objective decoration on the upper shoulder fit together in a rational design whose visual message is restrained and formal.

Mycenaean pottery was varied enough to permit the co-existence of several different styles. One of them depicted animals and human figures engaged in different activities in a cursory style that emerged toward the end of the Bronze Age. The subjects were usually so simplified that they look like caricatures. Large vessels like the kraters used to hold the wine drunk at banquets provided a conveniently large space for the paintings of charioteers and other subjects. These kraters were especially popular among Mycenaeans who had emigrated from Greece to Cyprus, and many examples have been found in Cypriote tombs.

The amphoroid krater in Figure 8.6, discovered in a tomb at Enkomi in Cyprus, is one of the most elaborate of these figural vases. Two figures in a chariot are shown in a landscape suggested by very stylized trees. Nearby

Figure 8.6. Amphoroid krater from Enkomi, Cyprus, decorated with scenes of a chariot, a human figure, stylized trees, and a man holding a pair of scales. Ht. 37.5 cm (14.75 in).

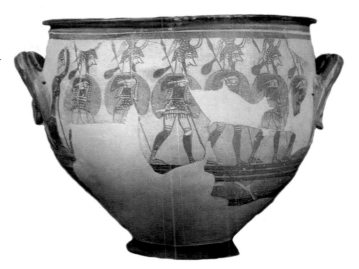

is a man who holds a pair of scales. Could this scene be related to the Egyptian tomb paintings where the heart of the deceased is weighed against a feather? If so, then the vase might have a subject that was related to funerary rituals, and it could have been planned especially for placement in a tomb.

One of the most interesting examples of this figural style was a krater called the Warrior Vase (Fig. 8.7). Found at Mycenae, it was decorated with a line of armed soldiers marching toward the right carrying their supplies in small bags tied to their spears. They were given horned helmets and small shields, a change in military gear from the larger shields favored at the beginning of the Late Bronze Age (compare Fig. 6.10). At the left, a woman stood to bid farewell with her hand to her head, a gesture of grief at their departure.

Architecture

Late Helladic architects were especially successful in building palaces, citadels, and tombs. Their public architecture often took monumental form with construction on a large scale. The most important buildings were decorated with wall paintings and filled with art objects to suit needs that were symbolic as well as functional.

Both of the goals can be seen in the citadel at Mycenae. The fortification walls from the beginning of the Late Bronze Age were so massive that later tradition said the stones were set up by the giant mythological race

called the Cyclopes. The blocks were roughly hewn, and the walls could be 6 meters thick (almost 20 ft). These Cyclopean walls must have been built during a hostile and dangerous time when neighbors could not be trusted and security began with a strong and well-armed defense. In addition to the defensive aspects, however, the walls were also impressive and even intimidating.

About the middle of the 13th century B.C., during LH IIIB, the size of the central citadel at Mycenae was expanded to extend the wall circuit around Grave Circle A (Fig. 7.9). The remodeled walls allowed room for new houses, and they also added a new detail to help the defensive situation at the entrance to the city. With walls several stories high, the weakest place would have been this wooden gate. In the new situation at Mycenae, the gate's defense was improved by adding a new wall that jutted out 14 meters (over 45 ft) from beside the city's main gate (Fig. 8.8). Massive walls now protected the space in front of the entrance on three sides so defenders could hurl missiles on attackers in this confined space from both left and right as well as from above.

The situation also accommodated a new symbol for the city over the rebuilt gate. Two heraldic lions (their heads are missing) facing a Minoan column were carved on a triangular stone slab set on top of the gate's 20 ton lintel (Fig. 8.9). Rising above the heads of all visitors, these kings of beasts suggested the power of this mighty city. The carved slab also had a structural function in addition to its obvious emblematic use. Because the

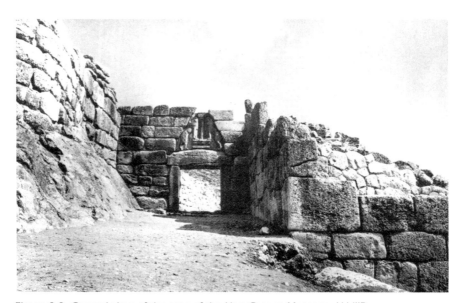

Figure 8.8. General view of the area of the Lion Gate at Mycenae. LH IIIB.

Figure 8.9. The Lion Gate at Mycenae. LH IIIB.

triangular block weighed less than the stone used for the city walls, it lessened the weight that pressed down on the gate's heavy lintel. At the sides of the triangular space, the wall's blocks were constructed as a corbelled arch. Corbelling, first used in the Aegean for the Minoan tholos tombs of the Early Bronze Age, was still the only way to span a space with an arch or a dome.

At the top of the Mycenaean citadel hill, the LH IIIB palace consisted of a cluster of rooms with a megaron as the largest set of chambers (Fig. 8.10). During this period, the megaron became the dynamic architectural unit that would assure its survival. It was used as the core for a series of rooms that differed from site to site, but the megaron's plan became the standard architectural form for the public part of the palace, making it the most important building in a community. The place of the megaron in the Mycenaean city can be illustrated by examples from Mycenae, Tiryns, and Pylos.

The palace at Mycenae, seen in Figure 8.10, stood on top of the city's hill on a terrace that was just south of the highest part of the site. The numbered rooms of the palace are described below.

1. A courtyard in front of the megaron was on a terrace at the south side of the hill's top, somewhat below the summit. It provided an almost square space that was open to the sky.

2. A shallow porch with a pair of columns supporting its roof acted as a transition between the open court and the middle room of the megaron.

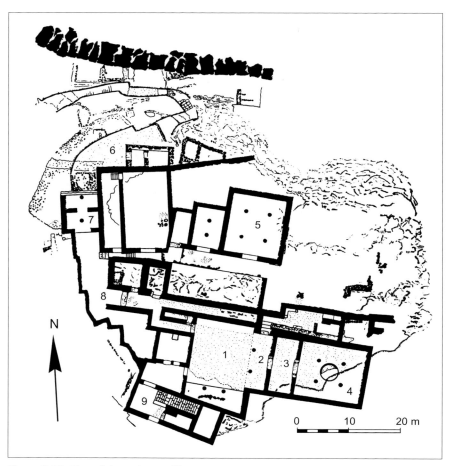

Figure 8.10. Plan of the palace at Mycenae, restored drawing by T.L. Shear, Jr.

3. The megaron's middle room had doors arranged on the build-
 ing's central axis.

4. The main room of the megaron had a central hearth with a cir-
 cular shape and four columns to help support the ceiling and
 some arrangement for the smoke to escape (like a lantern roof).

5. A square room with four columns, part of a set of three adja-
 cent rooms, was built higher on the hill as part of another archi-
 tectural complex.

6. A ramp at the top of the roadway leading up from the Lion
 Gate provided access to the area of the palace.

7. A gateway at the top of the ramp (the Northwest Gate) con-
 trolled access to the palace.

8. The West Passage led to the megaron on the lower terrace.

9. The Grand Staircase was added at the south as a second entrance to the megaron complex, leading up from the south.

The site of Tiryns was on the seacoast during the Late Bronze Age, and it was probably the seaport for Mycenae. Monumental Cyclopean walls (Fig. 8.11) protected the citadel. The plan of the palace area controlled both ceremonial access and defensive efforts (Fig. 8.12). The numbered areas of Tiryns are explained below.

1. The City Gate provided access from outside the citadel to a north-south passage leading north to the Lower City and south to the palace.

2. Houses were built in the Lower City as living quarters for some of the townspeople.

3. Two gates in the north-south passageway were fitted with doors set in massive doorframes (Fig. 8.13) in order to provide additional protection against anyone breaking through the city gate (and they would also have kept the people in the Lower City out of the area of the palace).

4. Galleries inside the city wall were roofed with corbelled arches (Fig. 8.14). Perhaps they were used to store the arrows, spears, and other weapons used to protect the city.

5. A gateway provided a last defense and led to an outer court in front of the megaron.

6. A courtyard was open to the sky.

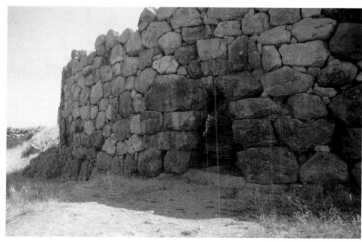

Figure 8.11. West wall of the palace at Tiryns showing Cyclopean masonry.

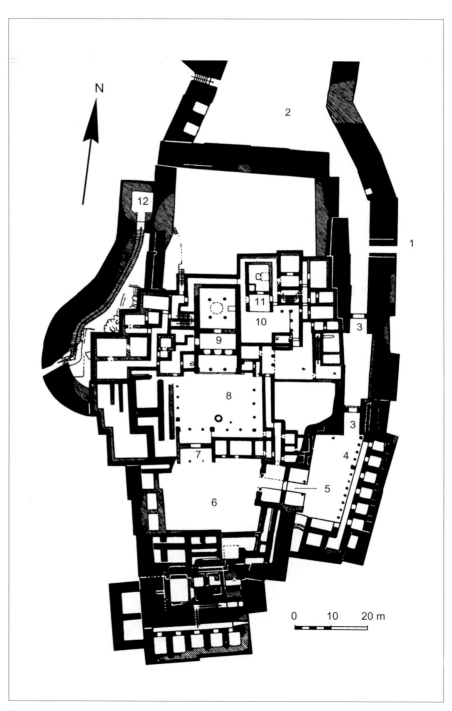

Figure 8.12. Plan of the palace at Tiryns, restored drawing by H. Sulze.

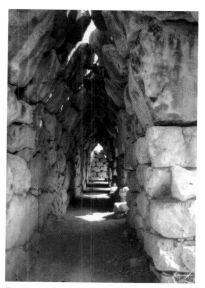

Figure 8.13. Doorjamb in the north-south passage inside the citadel at Tiryns.

Figure 8.14. View of the gallery inside the fortification walls around the palace at Tiryns.

7. A ceremonial gateway (or propylon) was between the outer and inner courtyards.

8. The court in front of the megaron had porches on three sides.

9. As at Mycenae, the megaron at Tiryns consisted of an outer porch with two columns, a middle room, and a large inner room ca. 10 x 12 m (32.5 x 39 ft) with a central hearth and a roof supported by four columns.

10. Another inner courtyard provided access to a smaller megaron.

11. The smaller megaron had only two rooms.

12. A passage cut in the bedrock led to an underground spring.

Although no defensive wall has been excavated at Pylos, the central buildings fit well with what is known about other Mycenaean palaces. In the epic poems of Homer, Pylos is the home of Nestor, the eldest of the Mycenaean kings. The following features can be seen on the palace's plan (Fig. 8.15):

1. The entrance (propylon) to the palace provided access to the interior courtyard.

2. A court that was open to the sky had porches on the north and east.

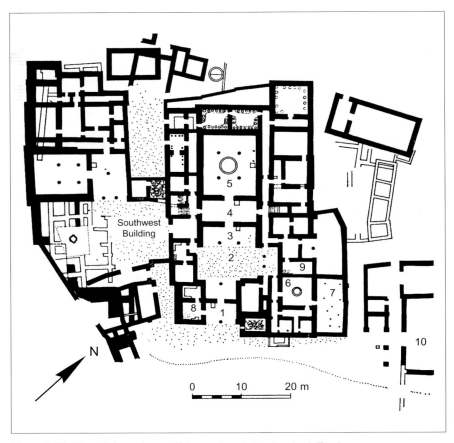

Figure 8.15. Plan of the palace at Pylos, restored drawing by J. Travlos.

3. A pair of columns in the front porch flanked the megaron's central axis.

4. The middle room had centrally placed doors.

5. As elsewhere, the megaron's main room (Fig. 8.16) was a large chamber with a central hearth and four columns. A base for a throne was at the east side of the room.

6. Another room with a central hearth did not have the canonical megaron plan.

7. An interior courtyard was open to the sky.

8. Archives were found in small spaces west of the propylon.

9. This room may have been a bathroom.

10. The Northeast Building.

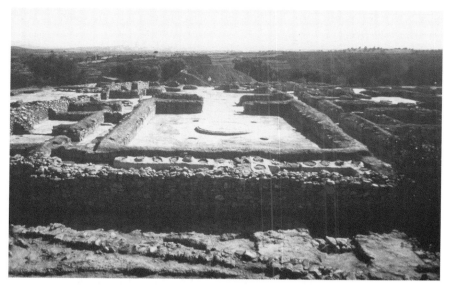

Figure 8.16. Megaron of the Palace of Nestor at Pylos. LH IIIB.

An example of an elegant Mycenaean house is illustrated in Figure 8.17. The building, called the House of the Oil Merchant, is located outside the citadel at Mycenae on a lower terrace where several other fine dwellings were situated. It has a room arrangement with a long corridor providing

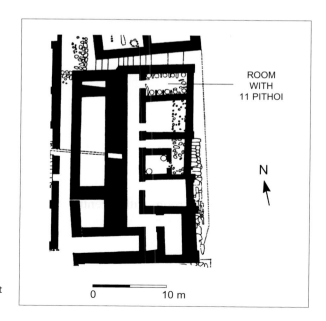

ROOM
WITH
11 PITHOI

N

Figure 8.17. Plan of the House of the Oil Merchant at Mycenae.

0 10 m

access to a series of rooms built alongside it. The main living quarters were on an upper floor.

Only the ground floor survives. The ground floor corridor ran north and south with eight small spaces at the east. Many pithoi were found in the building, including 11 situated around the walls of the room at the northeast end of the ground floor. In addition, about 30 stirrup jars and several Linear B tablets consisting of business documents dealing with oil and spices were discovered during the excavations. Taken together, this evidence suggests that those living in the building were involved with the manufacture and storage of perfumed oil, an important Mycenaean export.

With the growing prosperity of the Aegean region, tomb architecture became more monumental in size and more impressive in concept. Two classes of tomb became popular during the closing centuries of the Bronze Age. Members of the ruling elite were buried in tholos tombs, a grand new class of funerary monument that was far more elegant than the earlier Minoan round tombs. The other members of Mycenaean society were buried in chamber tombs, underground spaces approached by long passageways.

The Treasury of Atreus (Figs. 8.18–20) is a good example of a tholos tomb (in Greek mythology, Atreus was the father of Agamemnon, the Mycenaean king who ruled the city at the time of the Trojan War). The tholos tombs at Mycenae have been given names derived from the city's mythological rulers, but we really have no idea what individual was buried there. In fact, the Mycenaean tholos tombs were all robbed during antiquity, so we have none of the objects that would have been placed inside them when they were used. The date for the Treasury of Atreus is LH IIIB, in the 13th century B.C.

The tomb has a long walkway that leads from the exterior to a massive doorway (Fig. 8.18). Walls at the sides of this passage are built of horizontal courses of rectangular stone blocks. The long passageway (called a *dromos*)

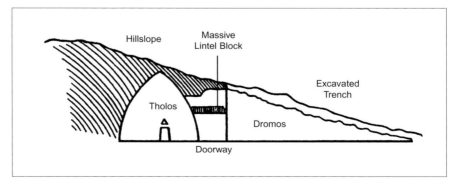

Figure 8.18. Drawing of the Treasury of Atreus at Mycenae. LH IIIB.

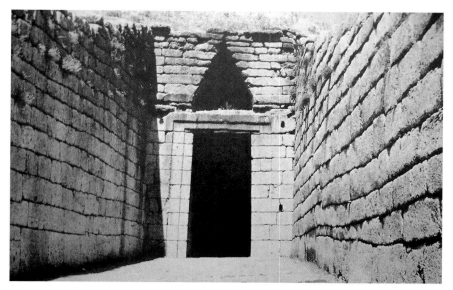

Figure 8.19. Dromos and facade of the Treasury of Atreus at Mycenae. LH IIIB.

provides an impressive architectural setting approaching the tomb's grand door.

The builders of this tomb tried to make it as impressive as possible (Fig. 8.19). Small relief sculptures were originally placed somewhere at the entrance facade (or possibly elsewhere), and half columns once flanked the doorway leading into the interior. A relieving triangle was above the doorway. Inside the chamber, the walls were massive at the base, and they rose in successive rings of stones, each smaller in diameter than the one immediately beneath it, to make a tall, corbelled dome (Fig. 8.20). A great lintel over the door helped support the walls. The interior of the dome rose more than 13 meters (over 45 feet high, which is more than the height of a four-story building).

Tombs like this were built by first digging a ditch-like channel into the side of a hill (Fig. 8.18). The corbelled dome was then constructed inside the channel so that the soil beside it helped support the sides of the corbelling. Stones could be dragged across the hill and slid into place, which was much easier than trying to lift them with ropes and winches. The largest stone blocks for the Mycenaean tholos tombs were extremely heavy (estimates for the weight of the lintel for the Treasury of Atreus run as high as 120 tons). When the tomb was completed and in use, the *dromos* was filled in and a mound of soil was placed over the exposed top of the dome so that the entire structure was not visible anymore in the landscape.

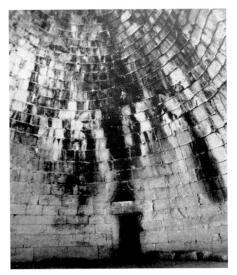

Figure 8.20. Interior of the dome of the Treasure of Atreus at Mycenae. LH IIIB.

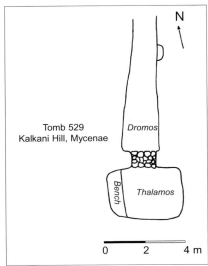

Tomb 529
Kalkani Hill, Mycenae

Dromos

Bench

Thalamos

N

0 2 4 m

Figure 8.21. Plan of a chamber tomb at Mycenae.

The common people were also buried in underground tombs, but they were not as elaborate as the tholoi (Fig. 8.21). Chamber tombs consisted of underground cavities carved out of the soil and soft bedrock with long passageways leading to their doors. The room for burial (called the *thalamos*) could be rectangular, circular, or somewhat irregular. Like the tholoi, the chamber tombs had an underground room that could be sealed off from the surface by blocking the doorway and filling the *dromos* with soil.

Sculpture

The sophisticated Mycenaean economic and political system led to increasing affluence among the elite members of the society. The earliest known example of monumental stone sculpture in the Aegean was a direct result of this new prosperity. The Lion Gate at Mycenae, inspired by Minoan iconography at a much smaller scale, would have greeted visitors to what must have been the most powerful of the Mycenaean kingdoms (Figs. 8.8, 8.9). The lions above the gate may have been inspired by eastern examples familiar either first-hand, from stories told by travelers, or from their reputation as powerful civic symbols (the capital of the Hittite Empire in Anatolia, for example, had a pair of lions flanking its city gate). The lions at Mycenae had a purely Aegean form with their front paws on a Minoan altar and a Minoan column between them.

The missing heads of the lions on the Lion Gate were added in another material, probably something like plaster or wood or a compact stone that could be sculpted with good, crisp details. Because they are no longer present, a few people have wondered if the heads were images of birds of prey, making the animals griffins instead of lions. Both lions and griffins flanked columns on Aegean seal designs.

For fine sculpture at a smaller scale, one can examine the group of three figures in the ivory carving shown in Figure 8.22. The two adults are women, but the child's sex is uncertain. Because both the female costumes and the style of the carving are Minoan, one may wonder if the artist was a Cretan, but the piece was found at Mycenae so it was certainly owned by a person from the mainland. The material is elephant ivory that was finely carved to show careful details. From later mythology, the two goddesses Demeter and Persephone and the young boy Triptolemos play an important role in teaching mankind about agriculture. A few scholars have suggested that some Bronze Age antecedent to the later myth might be illustrated here, but because the figures are removed from the myth by several centuries (and the sex of the child is not really known), the hypotheses about the group's identification are not necessarily accurate.

By LH IIIB, small Mycenaean clay sculptures had become very popular and also very schematic. Women were especially common as subjects for these images, which has suggested to many scholars that the intent was

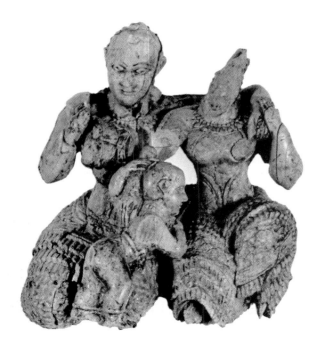

Figure 8.22. Ivory carving from Mycenae. LH I to III (possibly imported from LM I to II Crete).

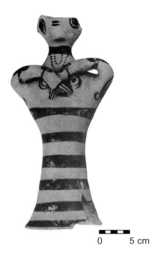

0 5 cm

Figure 8.23. Female figurine
from Mycenae. LH IIIA:2 to IIIB.

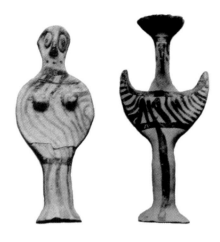

Figure 8.24. *Phi* and *psi* figurines from
Mycenae. LH IIIA:2 to IIIB.

often to portray a goddess. The example in Figure 8.23 comes from
Mycenae and is typical of these small female figures, some of which can
stand over 20 cm high. Because of the size, the woman has a hollow skirt
(a solid figurine would break when it was fired in the kiln).

Solid figurines in standardized shapes were much smaller. The pieces in
Figure 8.24, called *phi* (ϕ) figurines if the arms are across the body and *psi*
(ψ) figurines if the arms are raised because their poses look like the Greek
letters, were made by the hundreds. They were used in both houses and
tombs. Their exact purpose and meaning is not known.

Wall Paintings

Mycenaean palaces and important houses were decorated with colorful
wall paintings. Like the earlier examples that began the Aegean tradition,
the painters used both true fresco and painting on a dry wall, sometimes in
the same composition. The paintings were attractive, but their style was
very different from the Cycladic and Minoan wall paintings of LC I and
MM III–LM I.

The reconstruction of the palace at Pylos (Color Pl. 8B) shows how
colorful and attractive such an ediface must have been. The watercolor
shows the main room in the Pylos megaron as restored with four columns
around the hearth and an opening in the ceiling and roof to allow smoke
to rise and exit the building. The paintings on the walls are taken from

fragments found in the building's excavation, and the checkered floor, divided into squares by red lines, is also taken from aspects of the excavation. While the painting may be incorrect in a few details (such as the ceiling), the general effect must be right: this room was bright and colorful and filled with light.

The murals from Pylos provide some good information on the subjects and styles used for royal art during the 13th century B.C. (LH IIIB). The people at Pylos were interested in elite pastimes like religious rituals, hunting, and warfare. Their paintings especially celebrated heroic prowess with weapons, skills that would be very much in demand in the dangerous period at the end of the Late Bronze Age.

Details of hunting and fighting scenes are shown in Figures 8.25 and 8.26. In the scene of warfare (Fig. 8.25), combatants who are dressed in corselets and wear Mycenaean boar's tusk helmets fight against figures wearing animal skins. The Mycenaean warriors are armed with spears and swords. The barefoot men in animal skins are clearly the enemy, and most of them flee or die as a testament to the skill of the hometown troops. In the hunting scene (Fig. 8.26), men carrying spears across their shoulders but without helmets march off to hunt with a massive hunting dog.

Striking changes in style occurred in Aegean painting between LH I and LH IIIB. In contrast with the art from the beginning of the Late Bronze

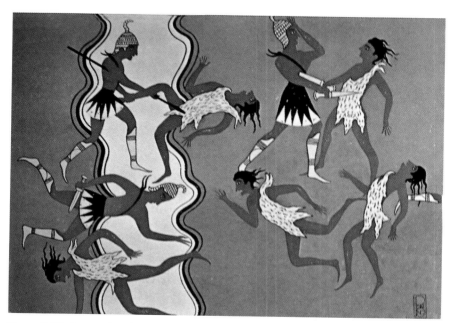

Figure 8.25. Fresco showing fighting, from Pylos, as restored by Piet de Jong. LH IIIB.

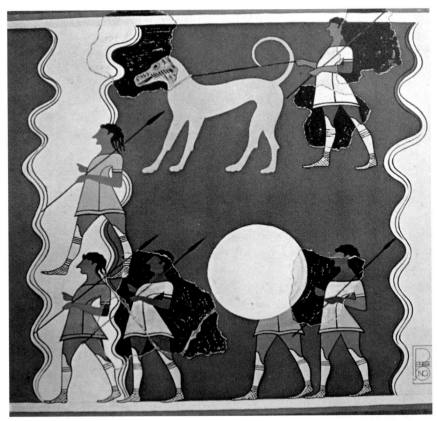

Figure 8.26. Fresco showing hunters, from Pylos, as restored by Piet de Jong. LH IIIB.

Age, the figures now lacked what would have previously been regarded as important details. Costumes were plain with little or no variation between different men. The background was a flat wall, sometimes with wavy lines to separate sections that had nothing to do with the scenes enacted in front of them. In fact, the whole sense of space was missing. Figures were painted higher or lower on the wall, or even sideways (perhaps to show death?) with no concern for the kind of landscape setting that one sees, for example, in the earlier Vapheio Cups (Fig. 7.16).

The tradition of heroic bravery in war and in hunting is also expressed in the paintings from other cities. A small fragment of a monumental wall painting from Tiryns illustrates the theme of the hunt for wild boars (Fig. 8.27). A boar with all four legs off the ground in the pose called the flying gallop is shown against a background of rather evenly spaced plants. Three hunting dogs chase the beast while the hand of a hunter with a spear and a second spear are just visible at the right of the fragment.

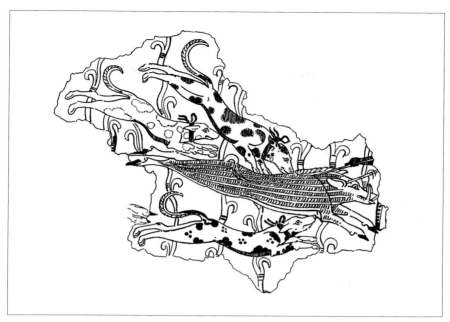

Figure 8.27. Boar Hunt Fresco, a fragment from Tiryns. LH IIIB. Scale 1:4.

Courtly life is celebrated in the palaces as well. The lyre player shown on one Pylos fresco is counterpoised with a large flying bird (Color Pl. 9). Perhaps his song takes flight, he has charmed the very birds of the air, or his music is as sweet as a bird's song; any number of symbolic associations could be used to explain the pairing. The scene is bright, cheerful, and decorative, acting as a fitting backdrop for a place where epic poems were sung. Even the animals of the hunt contribute to the Pylos ambience: alert hunting dogs, some with their mouths open as if barking, provide a reminder of their importance in the elite sport (Fig. 8.28).

The deities were not neglected either. A shrine at Mycenae contained images of women including the one in Color Plate 10A. This richly dressed figure, called the Mykenaia, might be a goddess. In other instances, the divinity is referenced in a more subtle way in the images of her animals, a lioness (or leopard) and a griffin shown on a wall at Pylos (Fig. 8.29).

It is interesting that among all these images, including many references to hunting, fighting, and other activities that were especially fitting for a group of elite warriors, the Mycenaeans never seem to have adopted the iconography of the powerful male king or god. In this characteristic, they followed the custom of the Minoans who only rarely used such images (for example, on the Master Impression, Fig. 5.20). The Mycenaeans portrayed their elite as rather anonymous individuals who fought or hunted as groups without

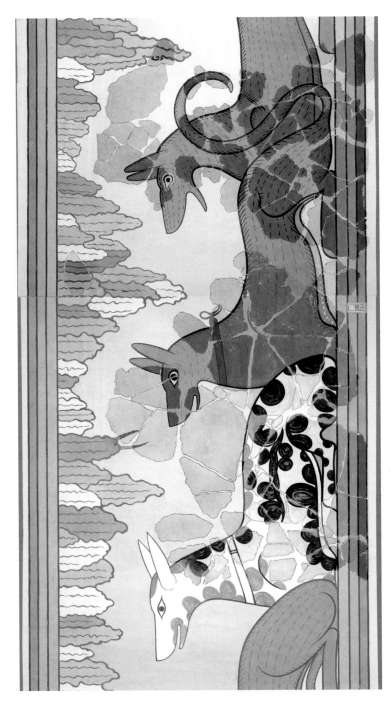

Figure 8.28. Fresco of hunting dogs, from Pylos, as restored by Piet de Jong. LH IIIB.

Figure 8.29. Fresco showing part of a row of griffins and lionesses, from the Palace of Nestor at Pylos, as restored by Piet de Jong. LH IIIB.

the overt references to the great leader that so dominated the Bronze Age art of Egypt, Syria, Anatolia, and so many other places in the East Mediterranean. If we did not have the Linear B documents from the same period as the paintings that clearly prove the absolute monarchies of the era, the art might lead modern scholars to draw completely wrong conclusions.

Comments

Mycenaean architecture makes many contributions to later history. The way the architectural traditions were developed says a lot about the Mycenaean architects and artists, and the attitude toward building design also demonstrates a set of principles that operated in the society in general. These principles were present in many aspects of Late Helladic life, but they can be seen especially clearly in the Mycenaen architectural space.

Late Helladic buildings formed an important link between the structures of earlier people and those of later times, but Mycenaean builders also filtered, refined, and improved on the traditions they inherited. Versions of the megaron plan, for example, were already present in the Late Neolithic period (Fig. 8.30a). The axial arrangement existed over a wide area in Europe, Anatolia, and elsewhere, and it was a common plan for Middle Helladic houses (Fig. 8.30b). In these early versions, however, the megaron assumed endless variations. The Mycenaean architects refined the plan and formalized it. Under their skilled hands, it became a precisely bilateral building with a rational plan whose entrance led directly to the hearth that was the structure's focal point. It was used for the royal palace, the largest and most important building in the community (Fig. 8.30c). In the 1st millennium B.C., with the Mycenaean kingdoms a thing of the past, the megaron retained its status as the most important building in the community, and it became the home of the city's deity as the Greek temple (Fig. 8.30d). From there it passed to Roman law courts and then to Christian churches because its axial form clearly communicated the importance of whatever was placed at its focal point.

Other Mycenaean architectural features were also adaptations and improvements on earlier traditions. The Mycenaean propylon was a gateway with an H-shaped plan with the cross-bar broken by a door and porches on the inside and outside (Fig. 8.10, no. 7). The guard on the inside and the visitors inquiring about entrance could both stand in the shade. The Mycenaean versions were not all identical. At Pylos, the porches had only single columns (Fig. 8.15, no. 1), but the fully developed plan at Tiryns (Fig. 8.12, no. 5) used pairs of columns to provide the same direct entrance system visible in the megaron. The Late Bronze Age version with pairs of

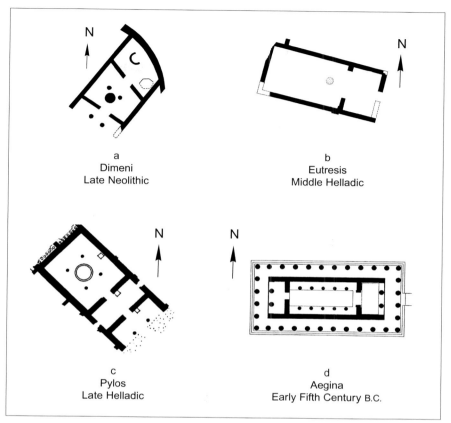

a
Dimeni
Late Neolithic

b
Eutresis
Middle Helladic

c
Pylos
Late Helladic

d
Aegina
Early Fifth Century B.C.

Figure 8.30. The development of the megaron plan from the Neolithic period to the Classical period.

columns typified the rational, bilaterally symmetrical system. It was adopted without serious changes for the gateways to 1st millennium B.C. religious precincts and other places.

The courtyard with an interior colonnade around its four sides, which was still being used as the main interior open space for Roman houses and can occasionally be found in use today in the 21st century, can also be traced back to the Minoan and Mycenaean periods (Fig. 8.12, no. 8). Its long architectural life is easily explained. Shade is desirable at the sides of an interior court both for the comfort of anyone visiting there on a hot and sunny day and for the cooler temperature the shade provides for the adjacent rooms by blocking the sun from shining directly on doors, windows, and walls.

All these examples suggest a problem-solving attitude that favors a logical approach without the indirect and sometimes ambiguous impressions provided by the architecture of several other societies: one can contrast the

Minoan bent-axis approach to religious architecture (Fig. 5.10) or the Minoan preference for intricate, even labyrinthine building plans for its palaces (Fig. 5.2). The Helladic taste for rational, well-organized thinking can be seen in subjects as different as artistic compositions on pottery and governmental bureaucracy as seen in the Linear B tablets. It is one of the attitudes that the Mycenaean culture conveys to later generations, and it is also one of the reasons that rational approaches are one of the bequests by their direct descendants, the Classical Greeks, to later societies.

Further Reading

Blegen, C.W., and M. Rawson. 1966. *The Palace of Nestor at Pylos in Western Messenia I: The Buildings and Their Contents*, Princeton.

Bouzek, J. 1985. *The Aegean, Anatolia and Europe: Cultural Interrelations in the Second Millennium B.C.*, Prague.

Cavanagh, W., and C. Mee. 1998. *A Private Place: Death in Prehistoric Greece*, Jonsered.

Chadwick, J. 1976. *The Mycenaean World*, Cambridge, UK.

Cline, E.H. 1994. *Sailing the Wine-Dark Sea: International Trade and the Late Bronze Age Aegean* (*BAR International Series* 591), Oxford.

Desborough, V.R.d'A. 1964. *The Last Mycenaeans and Their Successors: An Archaeological Survey c. 1200–1000 B.C.*, Oxford.

Dickinson, O. 1977. *The Origins of Mycenaean Civilisation* (*Studies in Mediterranean Archaeology* 49), Göteborg.

———. 1994. *The Aegean Bronze Age*, Cambridge, UK.

French, E. 2002. *Mycenae. Agamemnon's Capital: The Site and Its Setting*, Charleston, SC.

Furumark, A. 1941. *The Mycenaean Pottery: Analysis and Classification*, Stockholm.

Goldman, H. 1931. *Excavations at Eutresis in Boeotia*, Cambridge, MA.

Halstead, P. 1990–1991. "Lost Sheep? On the Linear B Evidence for Breeding Flocks at Mycenaean Knossos and Pylos," *Minos* 25–26, pp. 343–365.

Harding, A.F. 1984. *The Mycenaeans and Europe*, London.

Hirsch, E. 1977. *Painted Decoration on the Floors of Bronze Age Structures in Crete and the Greek Mainland* (*Studies in Mediterranean Archaeology* 53), Göteborg.

Hood, S. 1978. *The Arts in Prehistoric Greece*, Harmondsworth.

Hooker, J.T. 1977. *Mycenaean Greece*, London.

Iakovidis, S.E. 1983. *Late Helladic Citadels on Mainland Greece*, Leiden.

———. 2001. *Gla and the Kopais in the 13th Century B.C.*, Athens.

Immerwahr, S.A. 1989. *Aegean Painting in the Bronze Age*, University Park, PA, and London.

Killen, J.T. 1964. "The Wool Industry of Crete in the Late Bronze Age," *Annual of the British School at Athens* 59, pp. 1–15.

———. 1984. "The Textile Industries at Pylos and Knossos," in C.W. Shelmerdine and T.G. Palaima, eds., *Pylos Comes Alive*, New York, pp. 49–63.

Koehl, R.B. 2006. *Aegean Bronze Age Rhyta*, Philadelphia.

Lang, M.L. 1969. *The Palace of Nestor at Pylos in Western Messenia* II: *The Frescoes*, Princeton.

Loader, C.N. 2003. *Building in Cyclopean Masonry, with Special Reference to the Mycenaean Fortifications on Mainland Greece*, Jonsered.

Mee, C., and W. Cavanagh. 1985. "Mycenaean Tombs as Evidence for Social and Political Organization," *Oxford Journal of Archaeology* 3, pp. 45–61.

Mountjoy, P.A. 1986. *Mycenaean Decorated Pottery: A Guide to Identification* (*Studies in Mediterranean Archaeology* 73), Göteborg.

———. 1993. *Mycenaean Pottery: An Introduction*, Oxford.

———. 1999. *Regional Mycenaean Decorated Pottery*, Rahden, Germany.

Mylonas, G.E. 1966. *Mycenae and the Mycenaean Age*, Princeton.

Papadimitriou, N. 2001. *Built Chamber Tombs of Middle and Late Bronze Date in Mainland Greece and the Islands* (*BAR International Series* 925), Oxford.

Palmer, L.R. 1962. *Mycenaeans and Minoans*, New York.

Palmer, R. 1994. *Wine in the Mycenaean Economy* (*Aegaeum* 10), Liège.

Shear, I.M. 1987. *The Panagia Houses at Mycenae*, Philadelphia.

———. 2004. *Kingship in the Mycenaean World and Its Reflections in the Oral Tradition*, Philadelphia.

Shelmerdine, C.W. 1985. *The Perfume Industry of Mycenaean Pylos* (*Studies in Mediterranean Archaeology-PB* 34), Göteborg.

Taylour, W.D. 1983. *The Mycenaeans*, London.

Vanschoonwinkel, J. 1991. *L'Égée et la Méditerranée orientale à la fin du IIe millénaire*, Louvain-la-Neuve, Belgium, and Providence, RI.

Ventris, M., and J. Chadwick. 1973. *Documents in Mycenaean Greek*, 2nd ed., Cambridge, UK.

Vermeule, E. 1964. *Greece in the Bronze Age*, Chicago.

Vermeule, E.T., and V. Karageorghis. 1982. *Mycenaean Pictorial Vase Painting,* Cambridge, MA.

Wace, A.J.B. 1932. *Chamber Tombs at Mycenae*, Oxford.

———. 1949. *Mycenae: An Archaeological History and Guide,* Princeton.

Wardle, K.A., and D. Wardle. 1997. *Cities of Legend: The Mycenaean World*, Bristol, UK.

Warren, P.M., and V. Hankey. 1989. *Aegean Bronze Age Chronology*, Bristol, UK.

9

The Mycenaean Period in the Cyclades and Crete: LC II to III and LM II to III

At the end of the Bronze Age, considerable mainland Mycenaean influence can be recognized in many of the Cycladic islands and in Crete as well as at Miletus in western Anatolia, on the island of Rhodes in the Dodecanese, and at other eastern locations where Minoan features had existed for some time. This influence begins in earnest after LM IB/LC IB and reaches a peak in the 13th century B.C. It is present in architecture, pottery, and several other aspects of the material culture. Especially important for the interpretation of this change in affiliation is the fact that the new mainland features often replace existing items that were either local or inspired from Crete.

The strength of the Mycenaean influence must mean that the Aegean was now a part of a Mycenaean trading sphere that linked the Aegean with the wider world of the Mediterranean. Mycenaean pottery has been found at sites from Italy to Egypt and Syria, providing good evidence for the seafaring that carried a wide variety of products during this international age. Both luxury goods and ordinary commodities like foods and raw materials traveled on a regular basis from their sources to wherever they were needed.

The best evidence for this trade comes from shipwrecks. Two wrecks off the southern coast of modern Turkey, at Uluburun and Cape Gelidonya, have yielded substantial information on the products that were carried in the ships. Metals, especially copper, are the main items in both cases, but other commodities were also on board. The range of the items being transported on just two ships is enormous, suggesting that when a cargo vessel came into

port it could make a significant impact on what would be available to the local population. Various kinds of pottery, staple foods, spices, tools, raw materials for local workshops like exotic woods and glass ingots, and many other commodities could suddenly enter the local market provided that equally desirable items were available in exchange.

The first phase of this new chapter began immediately after the LM IB destructions in the Aegean and lasted until the destruction of Knossos during LM IIIA:2 (in the 14th century B.C.). Knossos and a few other places had elegant wall paintings, beautiful seals and other small objects, and an impressive pottery tradition called the Palace Style. The first phase was followed by periods when increasingly formal designs were in fashion. By the end of LM IIIB and LC IIIB (about 1200 B.C.), the old notions of copying nature were long forgotten.

Increasingly large amounts of iron came into use after 1200 B.C. during a period of instability and warfare. LH IIIC was partly a continuation of the preceding era because many earlier aspects of society continued to develop alongside new concepts brought into the Aegean from elsewhere, but the collapse of the Mycenaean economic system that occurred at this time represented a social break of significant impact. Warfare was widespread, and the destructions affected cities and towns on Crete and in the Aegean islands as well as on the Greek peninsula. Much of the 12th century B.C. was a very violent and uncertain period.

Architecture

The Mycenaean cultural expansion that began during the Shaft Grave period reached most parts of the eastern Mediterranean, but it was much stronger in the Aegean than in more distant places. The spread of mainland architectural practices, which is a good indication of the depth of the Mycenaean influence in regions that had had very different traditions in earlier times, took hold mainly in the Aegean. The eastern and western ports from Italy to the Eastern Mediterranean imported Mycenaean pottery and other objects, but with a few exceptions like Cyprus, they mostly resisted Aegean architectural traditions.

Mycenaean ideas in architecture can be recognized from several places in the Cyclades and in Crete. A good example is the town of Phylakopi on the island of Melos where a fine building modeled on mainland precursors was excavated at the beginning of the 20th century (Fig. 9.1). The building was about midway down the eastern slope of the hill where the town of Phylakopi was situated. The central space was a megaron composed of two spaces, an outer porch (no. 13 in Fig. 9.1) and a larger interior room with a plaster floor

Figure 9.1. Plan of the Mycenaean megaron at Phylakopi, Melos. LC III.

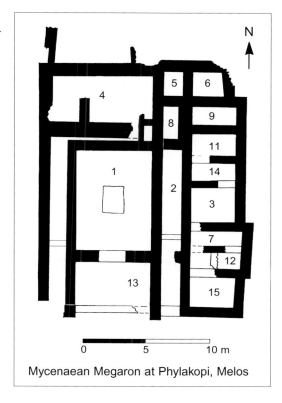

Mycenaean Megaron at Phylakopi, Melos

and a rectangular hearth near the center of the room (no. 1). The entrance was at the south. Although no traces of columns were excavated, they were probably originally present at the front of the porch where a long stone sill was found because the porch was six meters wide (almost 20 ft), and this long span would have required at least one and more likely a pair of supports. Additional columns or posts were surely needed inside the largest room as well. The megaron was not isolated. Like mainland palaces, it was built as the central part of a substantial building flanked by corridors and other rooms. Room 2 was a long hallway that provided access to a series of small spaces on the east, and another passageway on the west led to additional chambers north of the main hall.

Pottery

Mycenaean styles in pottery dominated many parts of the Aegean during the latter part of the Late Bronze Age. Stylistic influences from the Greek mainland accompanied new technological expertise so that vessels were more

Figure 9.2. Ephyraean goblet from the Temple Tomb at Knossos. LM II. Ht. 15 cm (5.9 in).

Figure 9.3. Palace Style jar from Knossos decorated with floral motifs within an ornamental field printed with a sponge. LM IIIA. Ht. 77.5 cm (30.5 in).

expertly turned on the potter's wheel and fired to a higher temperature than before to produce a better quality fabric. Along with these improvements in technology came new ideas about design and ornamentation. Artists abandoned the older Minoan concerns for lifelike rendering of plants and animals in favor of increasing abstraction.

The pottery of Knossos from LM II to LM IIIA:2, the first phase of mainland influence, is often called the Palace Style. This period is sometimes called the Final Palatial period. The pottery uses many of the older designs that had been in vogue in LM IB, but they are now put on the vases in different kinds of compositions.

The potters expressed the new ideas on several classes of vessels, especially on the ones used for drinking and for display. A Knossian version of the Mycenaean shape called the Ephyraean goblet (Fig. 9.2) was especially popular. This example used a large rosette on each side of the cup, a style of ornamentation borrowed from the mainland. Its sleek shape with the bowl flowing smoothly out of the stem must have been suitable for elegant banquets.

Palace Style jars were clearly intended for display, and many of their designs covered the entire surface of the vessel. The one in Figure 9.3 was given a floral pattern, but the background was covered with designs made with a sponge. This kind of background removed the plants from nature and gave the vase an overall effect. Vegetation and background had equal visual "weight" so the plants were not independent elements that grew out of the ground but interesting designs that alternated with other motifs. An

octopus decorates another example of a Palace Style jar (Fig. 9.4). Its body is not turned diagonally on the vase as earlier ones had been, and the creature is missing the suckers on its tentacles so it seems a little less lifelike. The large vase provides a good-sized field for the painter, and it is an impressive piece for visitors to enjoy. A large pithos from this same period (Fig. 9.5) has its floral decoration emphasized by the addition of three-dimensional clay reliefs for the stems and petals, but unlike the lifelike rendering on reliefs from earlier times (like the Lily Prince, Color Pl. 2), these three-dimensional patterns are not intended to make the design look more like an actual object. Instead, they help to join background and plant, creating an interesting overall effect on the large jar.

A figural style in ceramic decoration flourished in Crete in LM IIIA. Among the motifs were human figures and animals, which were subjects that had been excluded from pottery in LM I, perhaps because they were regarded as unsuitable for reduction to such a small and curved surface. Two examples can illustrate this style. The bird on a mug from the East Cretan town of Palaikastro shown on Figure 9.6 has its feathers eliminated and replaced by simple flat patterns. The pyxis in Figure 9.7, from Aptera in West Crete, shows a lyre player with his instrument in one hand and a branch in the other standing before an altar with two sets of the religious symbol called the Horns of Consecration. Double axes are placed between the horns, and birds fly

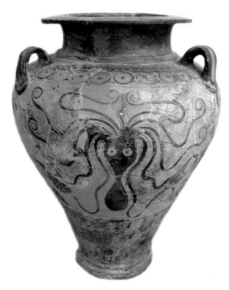

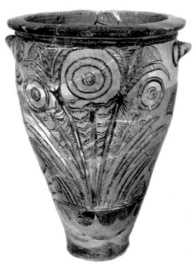

Figure 9.4. Palace Style amphora from Knossos decorated with an octopus. LM II to IIIA. Ht. 72.5 cm (28.5 in).

Figure 9.5. Relief vase in the Palace Style, from Knossos. LM IIIA. Ht. 98.5 cm (38.75 in).

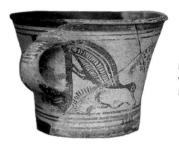

Figure 9.6. Mug from Palaikastro, decorated with a water bird and plants. LM IIIA:2 to IIIB:1. Ht. 10.7 cm (4.25 in).

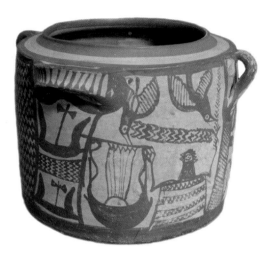

Figure 9.7. Pyxis from Aptera illustrating a scene in front of a shrine. A musician stands in front of an altar with two sets of Horns of Consecration with his lyre in one hand and a branch in the other one while birds fly down from the sky. LM IIIA:2. Ht. 15 cm (6.8 in).

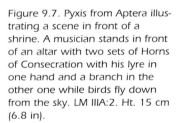

down from above. The references on the pyxis from Aptera, which are made less subtle by the inclusion of the horned symbols, are surely related to cult ceremonies enacted before a shrine. In both of these examples, only the main elements of the scenes are illustrated, and the treatment is very cursory.

This period also sees the end of the tradition of the Nilotic landscape. The palms and other plants on the Mycenaean conical rhyton found in a tomb at Ialysos on Rhodes (Fig. 9.8) are scarcely recognizable. They are stiff, highly abstracted images. All the elements that would suggest the natural world and its lush vegetation have disappeared long ago, and only symbolism remains.

Sculpture

The idea that an image was important as a focal point for religious belief was a prominent feature of later Greek religion, but as far as figures made of imperishable materials is concerned, the custom was observed rather

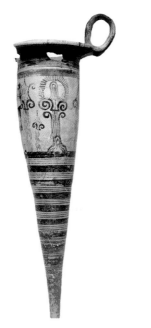

Figure 9.8. Full and detailed views of a conical rhyton from Ialysos, Rhodes, decorated with very abstract palm trees and other plants. LH IIIB. Ht. excluding the handle 51.7 cm (20.3 in).

intermittently during many centuries of the Bronze Age. Many female figurines were present during the Early Bronze Age, and perhaps the practice of having them never completely died out, surviving with images made of wood or other perishable materials so that it could have a revival in popularity in later times in a more permanent form.

A few sculptures of Mycenaean type are known from some of the Cycladic islands. Among the figures found in a shrine at Phylakopi on Melos is the large image shown in Figure 9.9. Called the Lady of Phylakopi, she stands 45 cm high (about 1.5 feet). Decorations of zigzags and chevrons imitate the decoration on LH IIIA pottery. The figure can be compared with examples from Mycenae on the mainland (Fig. 8.23), which leaves little doubt on the source of the imagery. Smaller clay figures also come from the same shrine, and some of them had been placed on top of a bench where they must have formed a focal point for the worship of the deities that were honored there.

Bench shrines continued to be used until the end of the Bronze Age. In Crete, they were associated with a religious image that has no Mycenaean parallels, which may mean a more local development. The Woman with Upraised Arms (Fig. 9.10) might have been a late manifestation of whoever was represented by the faience figurines used at Knossos at the beginning of

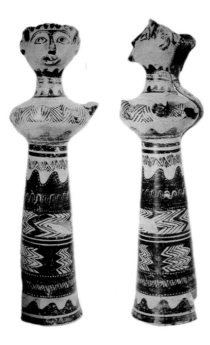

Figure 9.9. Front and side views of the Lady of Phylakopi. LC IIIA to IIIB. Ht. 45 cm (17.65 in).

the Late Bronze Age (Fig. 5.24). Certainly the pose with the raised arms was similar to one of the earlier figures, and the symbolism of snakes, which was prominent on the faience pieces, appeared in this later context along with the female figures, though not on every one. Beginning in LM IIIB and continuing into LM IIIC, multiple images of the Woman with Upraised Arms were placed in bench-shrines at Gournia, Gazi, Kavousi, Vasiliki, and elsewhere. They were used along with cylindrical stands that supported cups and bowls, fancier bowls called kalathoi that may have been used for offerings, and a few other items. The women often wore headdresses with birds, snakes, or other symbols (note the poppies on the crown of the sculpture from Gazi in Fig. 9.10). The images were always made of clay, and they had cylindrical skirts and simplified features.

Wall Paintings

Several of the best known Minoan paintings were on the walls at Knossos when the palace burned in LM IIIA:2 (the 14th century B.C.). Many of the paintings were monumental in size, and they were designed to enhance the beauty of the palaces and the prestige of their owners. Most of them stressed human actions rather than scenes of nature, and they often had symbolic qualities in addition to their aesthetic concerns.

A scene of acrobats performing with a bull, usually called the Toreador Fresco or the Bull Leapers Fresco (Color Pl. 10B), was one of several panels that showed similar scenes. If the painting followed Egyptian color conventions to show sexes, it depicted two women shown in white and a man painted reddish brown.

At the left, the first female figure stands with her arms grasping the horns of the bull, which charges forward with all four hooves off the ground in the flying gallop pose. A reddish brown figure, presumably a young man, does a handstand on the back of the bull while the second female figure has either just landed or is reaching out to assist the male figure as he springs off the animal's back. If the first female figure is supposed to be leaping from the horns to the back of the beast, the scene must be somewhat fanciful, but she may be simply grabbing the animal to control it while the man does his leap. The subject, which recalls the much earlier sculpture from Koumasa (Figs. 3.21, 3.22), had a long tradition in Minoan Crete. Several writers who have discussed the subject have suggested that the acrobatics may have involved ritual practices, perhaps symbolizing human domination over the powers of nature. Possibly the bull was sacrificed for a religious feast after the conclusion of the ceremony.

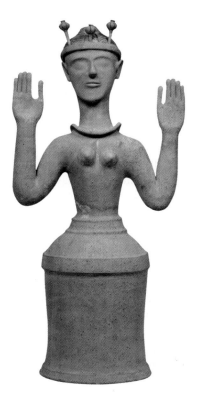

Figure 9.10. The Goddess with Upraised Arms from Gazi. LM IIIB. Ht. 77.5 cm (30.5 in).

Stylistically, the scene is much later than the LM I wall paintings in Crete and the LC I paintings on Thera. If the late patterns that imitate slabs of stone around the Toreador Fresco are compared with the imitations of stones from the LM I paintings (for example, Color Pl. 1B) or even from the smaller art of this general period like the offering table from the West House (Fig. 6.13), the later ones seem very artificial because of the mechanical repetition of their lines and shapes. An even more striking difference is the loss of the entire setting for the action in the late painting: all the figures float against a plain and featureless background with neither a ground line nor any element to show the outdoor location. The three human figures are extremely simplified, and only the convention of the skin color indicates any differences between them. These simplifications for both location and figures are very typical of Late Minoan III art throughout the Aegean.

A fragment of another figural scene is shown in Color Plate 11. The small portrait has been called the Petite Parisiénne because she wears lipstick on her lips and has a fancy hairstyle with a small curl hanging down in front. The large front-facing eye is a detail that adds a slightly naive look to the face. The Parisiénne depicts a woman of high status (perhaps a priestess or even a goddess) whose elite role is signaled by an emblem called a "sacred knot" behind her head and by the fact that she is seated and somewhat larger than the other human figures in the scene—the fragment is one of many small (mostly non-joining) pieces that came from a painting of seated figures being served drink and possibly food.

Because most of the large wall paintings that survive from this period are in small pieces, for a complete composition with many figures one has to look at smaller representations. The scene in Color Plate 12A is painted on a sarcophagus (a burial chest) used in a tomb at Hagia Triada. The context is a tholos tomb near the LM III settlement, and this important sarcophagus was one of the later burials placed in this sepulcher. The individual buried here must have been important because the rectangular sarcophagus for the body is carved of stone, covered with white plaster, and then painted using the same techniques usually reserved for walls. This very unusual sarcophagus shows a complicated scene. The exact subject is not entirely certain, but many scholars suspect it has to do with offerings to the deceased who is perhaps the man standing at the right. A decorated doorway suggests a tomb. In front of the tomb stands a man in a long white garment or wrap, and he seems to be preparing to receive the gifts brought by three men who walk toward him. Two of the men hold calves (or sculptures of calves), while the first man carries a long object that might be a boat. To the left of this group is a procession of three additional figures moving in the other direction, including a man who plays a lyre and two women who advance toward an altar. The woman on the left may be a priestess because she pours

a libation into a large vessel placed between two monumental double axes with birds on top of them. Her female companion brings two more containers filled with something, presumably the sacred liquid that is being offered to the gods or to the spirit of the man standing in front of his tomb. The scene suggests that burials were accompanied by processions, gifts, and offerings. The scene's style, with a bare white background and only a few props besides the human figures, can be compared with the Bull Leaping Fresco. Mycenaean artists and their patrons are mainly interested in human events and human actions during this period, not in landscapes or animals or anything that does not contribute to the human narrative. The very simplified tree at the right—with only three leaves—is a long way from the meticulous attention to natural details in earlier scenes like the ones from the West House on Thera (Color Pl. 5B) or one of the cups from Vapheio (Fig. 7.16b).

The other side of the sarcophagus (Color Pl. 12B) depicts a continuation of the burial rituals. A sacrificed bull tied on an altar has had its throat cut, and the blood drips down into a bucket. Is this the sacred liquid that is being transported to the double axe altar on the other side? A woman, surely a priestess or some other official, performs some ritual action at the right, on top of a small altar and in front of a tall shrine with Horns of Consecration and a tree growing from behind the horns. This whole scene takes place to the accompaniment of music being played by a musician at the left. The sarcophagus depicts a serious ritual. The scene is crowded with symbolic details including a vase displayed above the hands of the woman, a basket of what may be bread at the upper right, and two goats tucked under the bull's altar.

Other Arts

After the invasion of Crete by Mycenaean Greeks, the production of woven fabrics expanded in order to fill an increased demand for trade goods. Among the most important customers were wealthy clients in Egypt who wanted colorful textiles in large numbers. Linen, made from the flax plant, was the most common Egyptian textile because the Nile Valley did not raise many sheep. Flax did not take dyes very well (before modern chemistry solved the problems) so Egyptian cloth was often white. Elaborately patterned woolen textiles filled a need for colorful woven goods, and the Minoans had a long tradition of highly skilled weaving.

From the clay tablets written in Linear B excavated at Knossos, we know many of the details of the weaving industry from Mycenaean Crete. The palace at Knossos owned over 60,000 sheep (perhaps as many as 100,000). They were normally divided into flocks of 100 and assigned to

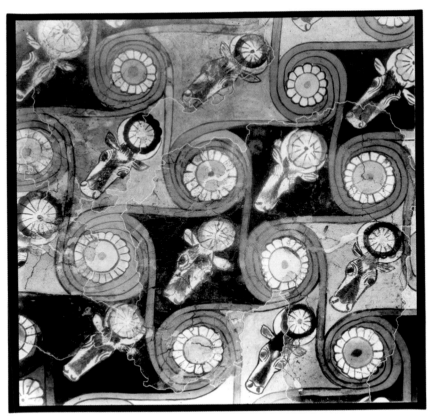

Figure 9.11. Painted ceiling from a room in the palace of Amenhotep III at Malkata, Thebes. Early 14th century B.C. Photograph courtesy of the Metropoliotan Museum of Art; Rogers Fund, 1911; no. 11.215.451.

individual shepherds who took them out to pasture and were responsible for keeping track of them until it was time to shear off the wool. Most of the sheep appear to have been castrated males (called wethers), which provide more wool than ewes (the ratio was about 6 wethers for each ewe). The records kept at the palace were very detailed and very specialized: different scribes recorded the inventory of wool and the records of the flocks that provided it. After the palace officials collected the wool, it was given to individual work crews to wash and dye it, spin it into thread, and then weave the thread into cloth. The groups of weavers consisted of women and children plus a minor official to supervise the work and assure that the quality was as expected. To meet their quotas in cloth, the weaving crews had to work long hours seven days a week. In return for their labor, the palace provided the workers with all their food, their lodging, and whatever else was needed.

The products of these weaving workshops are mostly known to us through the secondary source of Egyptian paintings in palaces and tombs. Egyptian artists copied the fabrics used as carpets, wall hangings, and coverings for ceilings in order to depict the sumptuous quality of elite Egyptian life. Among these illustrations are a number of images that must have been copied from Aegean fabrics.

One example, shown in Figure 9.11, comes from the robing room in the palace of Amenhotep III at Malkata, near Thebes in Egypt. It was painted on the room's ceiling. The design consists of a field of joined spirals with rosettes in their centers with frontal bulls' heads in the negative spaces between the spirals. Rosettes of Aegean type are placed between the horns of the bulls. Both the type of composition and the individual elements are Cretan. The period when Amenhotep III reigned, which would be LM IIIA by Minoan nomenclature, was the time when the workshop system described in the Linear B documents was at its height. Although the bull's head was a Minoan symbol, it could certainly also appeal to Egyptian tastes because it was also the emblem for the Egyptian deity Hathor. It is easy to see why Aegean fabrics, which were very different from what was available in the eastern part of the Mediterranean, were desirable as luxury goods for the finest of the royal palaces.

Comments

Under the patronage of the Minoan palaces, a small group of artists developed a highly naturalistic style at the beginning of the Late Bronze Age. The high point of this style survives today in a few art objects like the Harvesters Vase (Fig. 5.27) and the two cups from Vapheio (Fig. 7.16). At its best, on a cup from Vapheio (Fig. 7.16b), the style presents an illusion of three-dimensional space with a lifelike landscape setting and detailed treatments of both human and animal anatomy. Somewhat naturalistic rendering had had a long prior development in Crete before it reached this stage. Perhaps both artists and audience have to become committed to the belief that such a depiction in art is desirable before anyone will undertake the long hours of work necessary to reach the skill in artistic craftsmanship that is needed to achieve it. The naturalistic style was quite different from the official styles of the other high cultures of the middle of the second millennium B.C. in the Mediterranean basin, and even a casual observer can see the difference between it and the Egyptian figures from the tomb of Rekhmi-re with which it is contrasted here (Fig. 5.28).

In the long run, it was the simplified style of the Egyptian tradition that would prove more durable. Abstraction, simplification, flat images, and the

elimination of the non-essential (including background settings and any hint of three-dimensional illusion) were found to be more appropriate for the types of visual communication that Late Bronze Age art was expected to project. At the economic height of the Mycenaean period, the images from both Mycenaean and Minoan areas had much more in common with the simplified style of 18th Dynasty Egyptian paintings than they did Minoan naturalism. Landscapes, naturalistic details, and individual treatment of facial expressions would have to wait many centuries before Aegean artists would again accept them as important enough to incorporate into their artistic expressions.

Further Reading

Atkinson, T.D., et al. 1904. *Excavations at Phylakopi in Melos* (*Society for the Promotion of Hellenic Studies Supplementary Paper* 4), London.

Barber, E.J.W. 1991. *Prehistoric Textiles: The Development of Cloth in the Neolithic and Bronze Ages, with Special Reference to the Aegean*, Princeton.

Barber, R.L.N. 1987. *The Cyclades in the Bronze Age*, London.

Betancourt, P.P. 1985. *The History of Minoan Pottery*, Princeton.

Bouzek, J. 1985. *The Aegean, Anatolia and Europe: Cultural Interrelations in the Second Millennium B.C.*, Prague.

Cadogan, G. 1976. *Palaces of Minoan Crete*, London.

Caskey, M.E. 1986. *Keos II, Part 1. The Temple at Ayia Irini: the Statues*, Mainz on the Rhine.

Chadwick, J. 1976. *The Mycenaean World*, Cambridge, UK.

Davaras, C. 1989. *Guide to Cretan Antiquities*, 2nd ed., Athens.

Desborough, V.R.d'A. 1964. *The Last Mycenaeans and Their Successors: An Archaeological Survey c. 1200–1000 B.C.*, Oxford.

Dickinson, O. 1994. *The Aegean Bronze Age*, Cambridge, UK.

Evans, A.J. 1921–1935. *The Palace of Minos at Knossos*, 4 vols., London.

Evely, R.D.G. 1993–2000. *Minoan Crafts: Tools and Techniques* (Studies in Mediterranean Archaeology 92), 2 vols., Göteborg and Jonsered.

Faure, P. 1964. *Fonctions des cavernes Crétoises*, Paris.

Fitton, J.L. 2002. *The Minoans*, London.

Furumark, A. 1941. *The Mycenaean Pottery: Analysis and Classification*, Stockholm.

Graham, J.W. 1969. *The Palaces of Crete*, Princeton.

Index

Corridor Houses, 57, 55, 63
Cos, xxii
courtyards
 at Mycenae, 163
 at Pylos, 167
 at Tiryns, 165
 in cemeteries, 37
crocus, 85, 92, 93, 124–126
crucibles, 12
Cup of Nestor, 144, 145 Fig. 7.13, 147
cups, 18, 37, 41, 61, 62, 64, 100, 143–145,
 147–149, 192
Cycladic, Neolithic, 9, 10
Cycladic region, defined, 2
Cyclopean walls, 162, 165
cylinder seal, 97
Cyprus, 50, 156, 159, 160, 186

daggers, 11, 12, 95, 145–147, 152
deep bowl, 159
deer, 50, 147
Demeter, 173
depas, 22, 61, 62
development of the megaron, 181 Fig. 8.30
diadems, 23, 24, 48, 143
Dimeni, 54–56, 59, 60, 180, 181
 megaron, 181 Fig. 8.30a
 plan, 59 Fig. 4.4a
 selection of pottery, 56 Fig. 4.2
Dodecanese, xxii, 9, 185
dogs, 44, 45, 176–178
dolphins, 86, 121–123, 128, 130
double axes, 195
dragon flies, 143
Drakones, 28, 49
 seal, 49 Fig. 3.26
drowning men, 120
duck vase. See Acrotiri, Thera
ducks, 23, 149, 150

earrings, 13
East Ascent at Gournia, 78
East Magazines at Malia, 76
East Ridge Road at Gournia, 78

Egypt, 4, 50, 55, 92, 93, 97–100, 121, 122,
 161, 180, 185, 193, 195–198
Egyptian blue. See faience
Egyptian dates, 4
Eleusis, clay goblet, 134 Fig. 7.1
emery, 90, 100–102
Enkomi, Cyprus
 amphoroid krater, 160 Fig. 8.6
 deep bowl, 159 Fig. 8.4
entrance at Pylos, 167
Ephyraean goblets, 157 Fig. 8.1, 188 Fig.
 9.2
Epirus, 54
eruption of Theran volcano, 67, 85, 110
Euboea, xxii, 54
Eutresis, 137, 138, 181
 MH house plan, 138 Fig. 7.6, 181 Fig.
 8.30b

fabrics and weaving, 103, 106, 107, 110,
 155, 195–197
faience, 68, 72, 95–98, 100, 150, 192
fiddle-shaped figurines. See marble fig-
 urines
Fine Gray Ware, 39, 40
fish and fishing, 11, 117, 122, 146
flask, 87
flax, 195
Floral Style. See Special Palatial Tradition
Folded-Arm Figurines (FAFs), 15, 44, 45
fortifications, 12–14, 57–60, 138, 152,
 161–163, 185, 166
 at Dimeni, 58–60
 at Kastri, 12–14, 58–60
 at Lerna, 57–60
 at Mycenae, 138, 152, 161–163
 at Tiryns, 165, 166
 at Troy, 58–60
frying pans, 18–20
furnace at Phaistos, 76

Galatas, 69
galleries at Tiryns, 165
gazelles, 116

Platanos, 28, 88, 89

Poliochni, 13

potter's wheel, 57, 60, 83, 134

Priest King at Knossos. *See* Lily Prince

Procession Corridor at Knossos, 69

propylon, 180

Proto-Geometric period, 56

Pseira, 28, 35–37, 80, 81, 89, 105, 106, 157, 158

 basket-shaped rhyton, 89 Fig. 5.17

 cist grave (Tomb 5), 36 Fig. 3.7

 House of the Three Buttresses, 80, 81 Fig. 5.9

 rhyton with palms, 158 Fig. 8.2a

 textile patterns, 105 Fig. 5.34

 woman in elaborate costume, 106 Fig. 5.35

Public Square at Gournia, 78

punches, 11

Pylos, 54, 163, 167–169, 174–181

 battle scene, 175 Fig. 8.25

 description of plan, 167, 168

 hunters, 176 Fig. 8.26

 hunting dogs, 178 Fig. 178

 lioness and griffin, 179 Fig. 8.29

 Lyre Player Fresco, 177, Color Pl. 9

 megaron, 181 Fig. 8.30c

 megaron reconstruction, Color Pl. 8B

 plan of palace, 168 Fig. 8.15

 view of the megaron, 169 Fig. 8.16

Pyrgos Ware, 38, 39

pyxides, 18, 19, 44, 45, 189, 190

quartz (rock crystal), 48, 50, 90, 102–104, 149, 150

radiocarbon, 4

Rekh-mi-re, 98–100, 197

Rhodes, xxii, 185, 190

rhyta, 86, 89, 99–104, 143–145, 149–151, 157, 158, 190, 191

rings, 13

rock crystal. *See* quartz

rock shelters, 33

Roman arches, 35

Rome, 1, 81

roofs, 68, 79

rose, 93

Royal Cemetery at Ur, 17, 64

Royal Road at Knossos, 70

Royal Tomb at Isoparta, 136

saffron, 92, 93, 124, 125

Saffron Gatherer from Knossos, 92, 93

Sahara Desert, 29

Saliagos, xxii, 9, 15, 18

 chalice, 20 Fig. 2.10a

 marble figurine, 10 Fig. 2.1a

Samothrace, xxii

Samos, xxii

Santorini, 110

Sarcophagus from Hagia Triada, 194, Color Pl. 12

Sardinia, 155

sauceboats, 21, 22, 30, 60–64

scarabs, 50

scribes, 68

sea level changes since antiquity, 35

sea stars motif, 86

seafaring, 6, 9, 29, 51, 121,122, 133, 150–152, 155, 156, 185

seals and sealings, 49, 50, 62, 63, 67, 88–91, 110, 147, 186

selection of serpentinite vases, 103 Fig. 5.32

Seriphos, xxii, 12, 54, 109

Sesklo, 54

Shaft Graves at Mycenae, 135, 138–147, 149–151, 162, 186

sheep, 11, 30, 103–104, 195, 196

ships, 12, 50, 88–90, 121, 130

shipwrecks, 185, 186

short-lived Cycladic settlements, 11

shrines, 32, 33, 80–82, 126, 189, 190

 at Amnissos Cave, 82

 at Gournia, 78

 at Malia, 82

 at Myrtos, 32, 33

silver diadem. *See* Kastri, Syros

Siphnos, xxii, 54

Color Plates

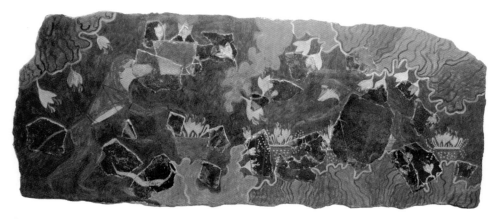

Plate 1A. Blue Monkeys Fresco from Knossos, as restored from fragments, MM IIIA.

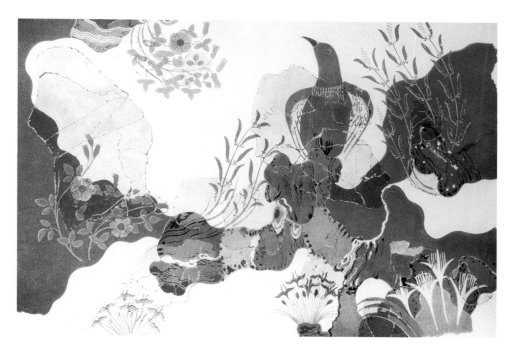

Plate 1B. Blue Bird scene from the House of the Frescoes at Knossos, as restored by E. Gilliéron Fils, LM I.

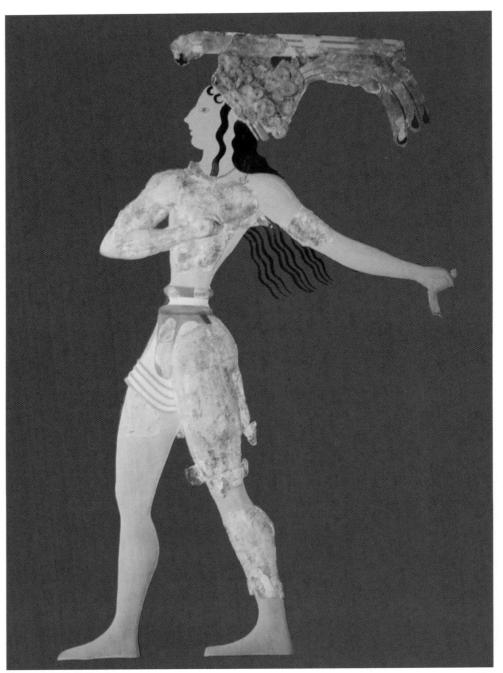

Plate 2. The Lily Prince Relief Fresco from Knossos, as restored from fragments by E. Gilliéron Fils, LM I.

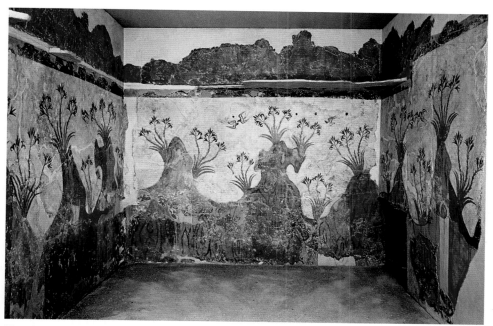

Plate 3A. The Spring Fresco from Room Delta 2 at Acrotiri, Thera, LC IA.

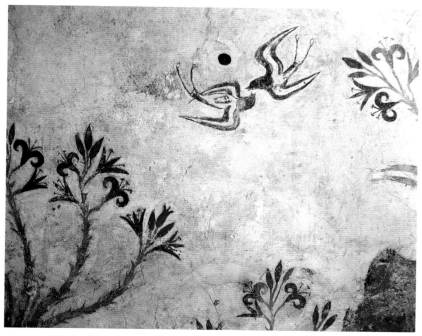

Plate 3B. Detail of the Spring Fresco.

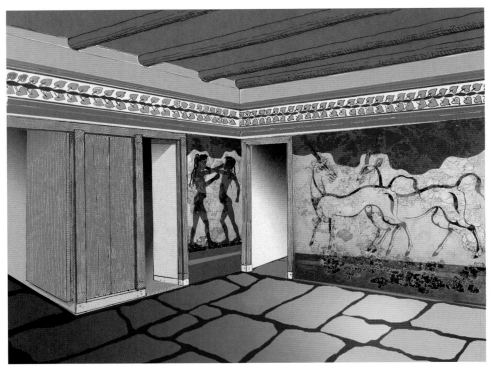

Plate 4A. Room B1 in House Beta-South at Acrotiri, Thera, LC IA. Computer reconstruction by C. Palyvou.

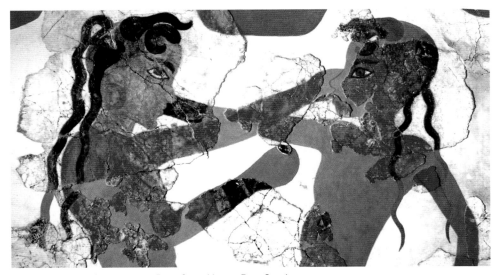

Plate 4B. Detail of the Boxing Boys from House Beta-South.

COLOR PLATES

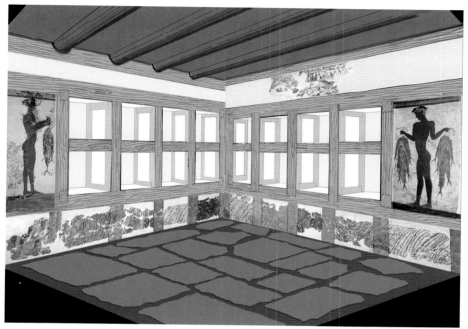

Plate 5A. Room 5 in the West House at Acrotiri, Thera, LC IA. Computer reconstruction by C. Palyvou.

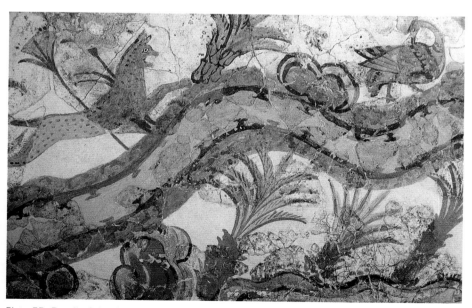

Plate 5B. Detail of the river scene in the Miniature Fresco from Room 5 in the West House.

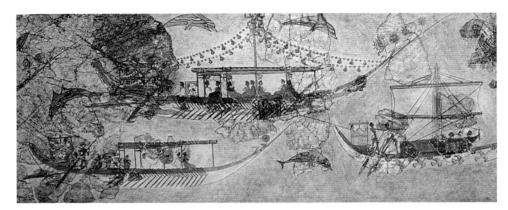

Plate 6A. The fleet scene from the Miniature Fresco in the West House at Acrotiri, Thera, LC IA.

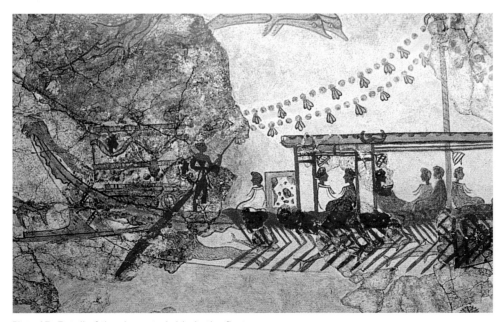

Plate 6B. Detail of the decorated ship in the fleet scene.

COLOR PLATES

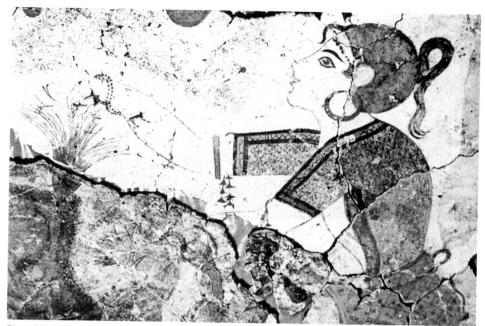

Plate 7A. Girl picking crocus stigmas from Xeste 3 at Acrotiri, Thera, LC IA.

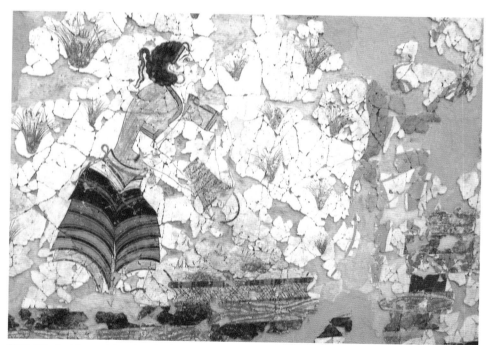

Plate 7B. A girl emptying her basket of crocuses and a monkey offering crocus stigmas to the enthroned goddess from Xeste 3 at Acrotiri, Thera, LC IA.

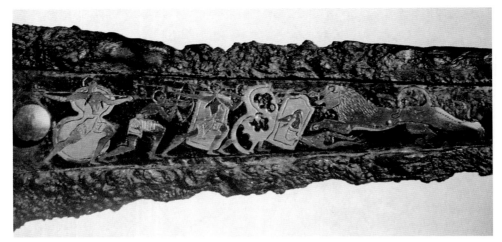

Plate 8A. An inlaid dagger from Grave Circle A at Mycenae, LH I.

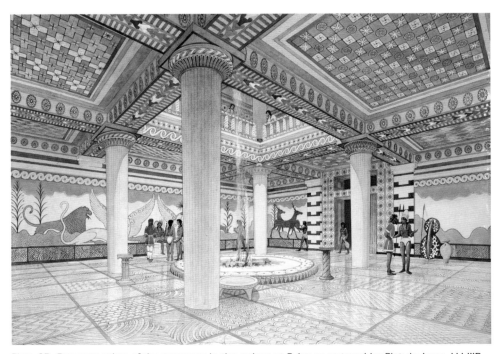

Plate 8B. Reconstruction of the megaron in the palace at Pylos as restored by Piet de Jong, LH IIIB.

COLOR PLATES

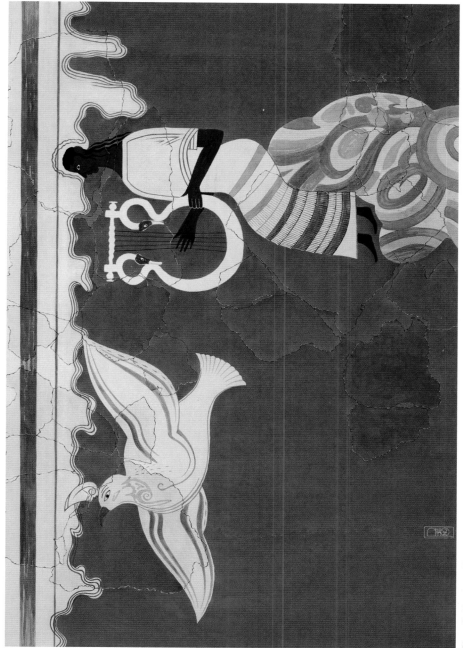

Plate 9. The Lyre Player and Bird Fresco from the megaron in the palace at Pylos, as reconstructed by Piet de Jong. LH IIIB.

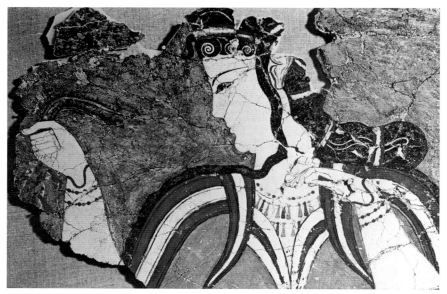

Plate 10A. The Mykenaia, a fresco of a Mycenaean woman or goddess from the cult center at Mycenae, LH IIIB.

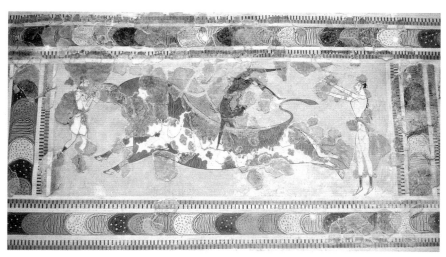

Plate 10B. The Bull Leapers Fresco from the Court of the Stone Spout at Knossos, LM IIIA.

COLOR PLATES

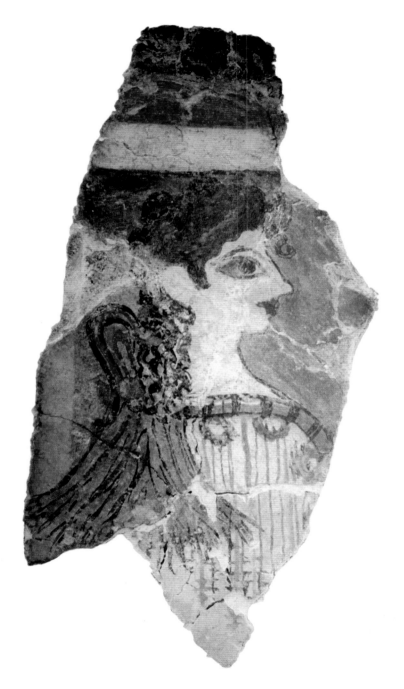

Plate 11. The Petite Parisiénne Fresco fragment from the Campstool
Fresco at Knossos, LM IIIA.

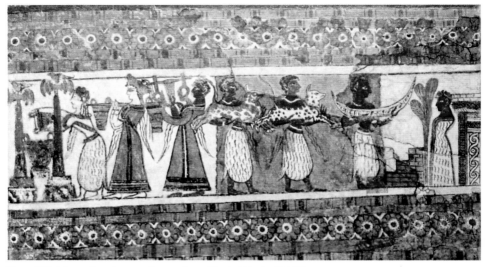

Plate 12A. The painted sarcophagus from Hagia Triada, LM IIIA.

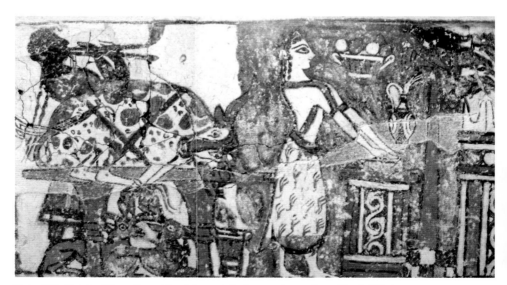

Plate 12B. Detail of the other side of the painted sarcophagus from Hagia Triada.

Introduction to Aegean Art